ON/OFF

New Electronic Products

Mel Byars

Research by

Brice d'Antras

Cinzia Anguissola d'Altoé

Sarah Lynch

Laurent Müller

 Laurence King

Published in 2001 by Laurence King Publishing
an imprint of Calmann & King Ltd
71 Great Russell Street
London WC1B 3BP
Tel: +44 020 7430 8850
Fax: +44 020 7430 8880
e-mail: enquiries@laurenceking.co.uk
www.laurenceking.co.uk

A catalogue record for this book is available from the British
Library.

ISBN 1 85669 249 3

Printed in Singapore

CONTENTS

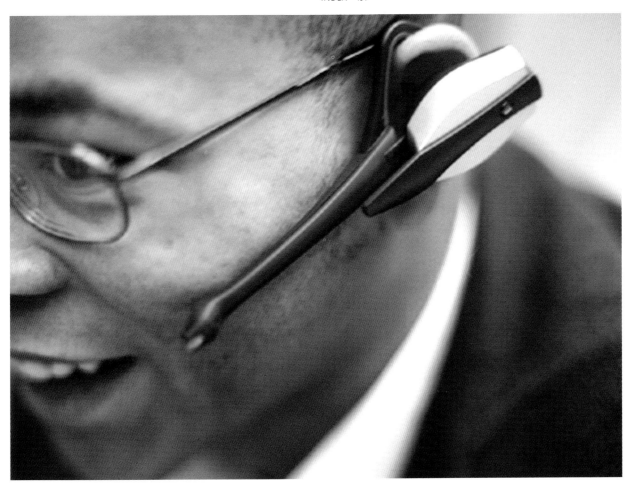

INTRODUCTION

I have organized this book based on how I have observed that people use books, not on how publishers and maybe other authors think that they ought to be used. And some books are used, not just read. I sneak around bookstores and watch how milling customers handle books, and, for the most part, at least in stores, how they inspect them, which is primarily from the front to the back. And they rarely read the dust-jacket flap text or information on the authors. Furthermore, if they are inspecting design books that have few or no pictures, most people will quickly close them and return them to the shelves.

And, so it is with this book, I have organized it so that you do not have to know much about electronics to appreciate the products, even though there is a great deal of technical information here. At least, I hope I have created it so. I want you to be able to get value from the book on the three levels I have intended, and none but the first really matters : (1) to peruse it, get a smattering of what is here, and be entertained by the intriguing products; (2) to come back again, linger on the pages where there are items that interest you, and look more closely; and (3) to read the text and description thoroughly.

Please do not think that the book is in any way an advertising medium, even though it may seem so. Do not assume that you should buy or that you need any of these products. No one person or manufacturer paid a fee to be included, and, if anyone attempted to influence my decisions concerning what to include or exclude, it had no effect; at least, I do not think so.

If the collection of objects has a symbiosis, it is that they are all electronic or electrical and are intended to simplify or improve life while, of course, making money for the manufacturers and designers. And I know the influence on us to have them is insidious. However, as a colleague pointed out, all the 20th-century time-and-labor-saving devices—vacuum cleaners, self-cleaning ovens, frost-free refrigerators, clothes- and dish-washing machines, and others—have actually created more, not less, work at home and necessitated more work at the office or plant in order to pay for them. This is or was because they changed our consciousness about cleanliness and efficiency. Before these appliances, people were more patient with or unconscious about dust and dirt in their houses and workplaces and on their clothes.

The problem with the intriguing electronic devices of today is that, even though they may be expensive or at least expensive in their collectivity, they hook us. We think we need them. Well, my goodness, while we were all well and good before they came along, now they are indispensable; are they not?

I am not sure how you feel about computers and e-mail technology, but I cannot do without e-mail and can no longer write anything of any length by hand. The happy aspect of e-mail is that it has encouraged people to write letters again—maybe illiterately, but write nevertheless. Something happened to letter writing; it dried up. I am not sure why it disappeared, but it has been resurrected from the dead. My guess is that its demise may have been due to its taking a long time to write a letter by hand, even in many ways by typewriter. And, if you wanted to make a typewritten copy in the past, there was that nasty carbon paper. When you finished the letter, typed or handwritten, there may have been mistakes in it because of the absence of computer spell-checkers. (My spelling is not good.) And then there was the annoyance of unsightly erasures. And what about the process of having to insert a letter into an envelope, stamp it, and then do something about getting it to the post office or letter box? When I grew up in South Carolina in the U.S., we had the same postman for my entire childhood. He picked up and delivered the mail—twice a

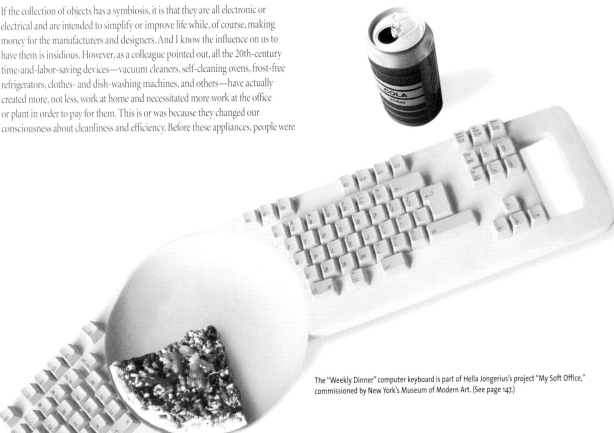

The "Weekly Dinner" computer keyboard is part of Hella Jongerius's project "My Soft Office," commissioned by New York's Museum of Modern Art. (See page 147.)

day—from the box on our porch. I knew his name; it was Mr Jeffcoat. Unfortunately, when dogs chased him, delivery was postponed to another day.

Then personal computers came along. (Thank you, God, for computers.) I worked on the IBM personal-computer advertising campaign in 1982 when I was an art director. Soon afterward, along came the fax machine. Even though fax machines had been developed a long time before, they were widely used in the 1990s. Now, they are passé, gone, fini. Oh, yes, you can buy them, but they need special features now to make them worthwhile, and, even so, who cares? A scanner and a PC can send a fax. Electronic equipment, like these fax devices, has recently been appearing and disappearing as fast as the power and size of personal computers has been increasing.

I remember writing *The Design Encyclopedia* from 1990 to 1993 on one of the little square Macintoshes. I could not see an entire page at one time on the screen and had to divide the text into many parts in order to be able to transport it to the publisher on floppy disks that held only one megabyte or so each. Then a year or so after I finished the *Encyclopedia*, I bought a new SyQuest machine that housed 44 megabytes, and it was expensive—over $400 (about £285 or 360 euros). Wow, what a great device it was then! Now, I use a drive that accommodates 100/250-megabyte Iomega disks as well as a 20-gigabyte drive with removable disks. I also have a 60-gigabyte external hard drive for storage should I lose my files somehow. This book, for example, is almost 2 gigabytes large with text and all the images, many of which were given to me in a digital format.

"Gigabyte"—or 1,000 megabytes—was not a word in anyone's vocabulary when I bought the 44-megabyte SyQuest. New technology is running so fast that it is difficult to keep pace with it. In fact, the 2004 class of university graduates, who were born in 1982:
• are too young to remember the space-shuttle explosion
• are not aware that bottle caps did not always screw off
• know nothing about Atari or vinyl record albums
• do not understand what "You sound like a broken record" means
• have never owned record players or vinyl-record albums
• do not know what "8-track" means
• were one year old when the compact disk was introduced
• never played Pac Man or know about Pong
• have always had answering machines
• never saw a black-and-white TV set or watched one with 13 channels or less
• have always had cable TV
• are unaware of a time when there were no VCRs
• never heard of Beta Max
• cannot imagine being without a remote controller
• do not know what a cloth baby diaper is
• were born the year the Walkman was introduced
• have always understood that "inline" means roller skating
• think that popcorn can only be cooked in a microwave oven
• have no consciousness of hard contact lenses
• do not remember McDonald's burgers in styrofoam boxes or why they were discontinued
• think there has always been MTV
• know little, if anything, about a typewriter.

If you are one of these future graduates or someone else who identifies with their awareness, please do not think that I am trying to insult you. I myself was no different as a graduate of 1960. I am offering the list to illustrate how the passage of technological developments is quick and breeds obsolescence, and that it is absurd how the electronic-device graveyard is being piled high with aged equipment. The development and introduction of magic machines and products is both dismaying and enervating. Have you ever looked at a box of clothes detergent that claimed it was "new and improved" and wondered why it was not improved before?

Many of these magic machines and a number of products both new and also improved—some inexpensive, but others not so—appear on the pages that follow.

A large number are about interconnectivity, the kind of interconnectivity that may have been best expressed by the author, Douglas Adams, who wrote *The Hitch Hiker's Guide to the Galaxy*. On the CNN TV network recently, shortly before he died, he was asked to describe the digital age in a single word. He suggested, "The one word that best defines the digital age is 'interconnectivity.' The dominating forms of communication of the 20th century—TV, radio, CDs, and so forth—were not interconnective." In other words, they gave us information, entertainers, and experts or famous people who told us what they thought (insinuating they were smarter or somehow better than us). And it all came to us in one direction.

But this is another century, and we have begun to think differently, or as the Apple advertisement says, different. While there are devices in this book that continue the time-saving, efficiency syndrome, many do indeed offer interconnectivity. However, if these tools for keeping us in touch, back and forth, obviates our distinct national and cultural differences, we will have sadly created a worldwide sameness in our human beingness.

My colleagues—Brice d'Antras in Paris, Cinzia Anguissola d'Altoé in Milan, and Sarah Lynch in New York—helped me to collect everything here. And these "helpers" are as qualified as I to write this book.

In addition to all the gadgets, some of the products make true contributions to betterment. There are, for example, fiber-optic eyeglasses for people with light-deprivation maladies, and a wristband to lessen motion and pregnancy sicknesses. There is a windup flashlight, or torch, that should be in every household, and a windup radio, produced by the same people, that was originally developed so that South Africans, lacking electricity and the money for batteries, could get information on Aids prevention. There are wireless jogging devices that monitor your health. There is a new dog tag, essentially an electronic card to hang around the neck of soldiers, that can contain their complete medical histories including X-rays thumbnails. And a GSM-and-GPS-combination phone will help the lost to be found, especially in remote areas, outside GSM areas, and even under snow.

So, you see, everything here is not of the gee-whiz ilk, though much of it is.

—Mel Byars

Because the technology of the hand-held organizer and interactive-screen device is a frequent feature of many of the products here, this drawing serves to illustrate how an organizer, as the example here shows, and certain computer screens are constructed. The science is also similar to that of money-withdrawal machines and point-of-sale terminals that respond to a finger rather than a stylus. These types of display screens, unlike but similar to those of television sets or computer monitors, call on four different reactors to recognize the touch of a finger or stylus. The screen appears to be flat, solid, and rigid, but it is not; it gives way in the area where pressed. The screen is a sandwich of two conductive surfaces that are very, very slightly separated, in most systems, by very small insulating particles. When a finger or stylus presses on the malleable top layer, it in turn touches the layer beneath and then an electrical contact is made. For example, on Palm™-type organizers, a finger, not only a stylus, can be used for a reaction. The drawing here by Marvin Klein of the Handspring Visor was adapted from one rendered by Frank O'Connell of *The New York Times*, details and information for which were provided by the staff of Handspring MicroTouch Systems Inc., Palo Alto, California, U.S.A. (Adapted art by permission.)

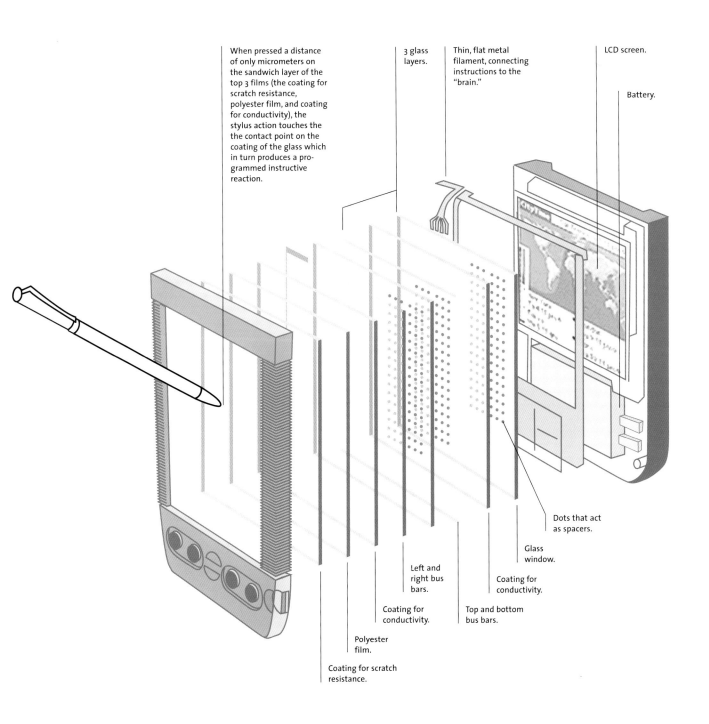

When pressed a distance of only micrometers on the sandwich layer of the top 3 films (the coating for scratch resistance, polyester film, and coating for conductivity), the stylus action touches the the contact point on the coating of the glass which in turn produces a pro-grammed instructive reaction.

3 glass layers.

Thin, flat metal filament, connecting instructions to the "brain."

LCD screen.

Battery.

Dots that act as spacers.

Glass window.

Coating for conductivity.

Left and right bus bars.

Top and bottom bus bars.

Coating for conductivity.

Polyester film.

Coating for scratch resistance.

ON/OFF

New Electronic Products

HOUSEHOLD
APPLIANCES

"AUDREY™" INTERNET APPLIANCE

Intended for home use, the "Audrey" makes quick access to pre-selected informational Internet sites possible without the use or knowledge of a complex PC. Staying in touch via e-mail and keeping track of plans, appointments, and events via the calendar is made easy. The household appliance, introduced in the year 2000, also offers the convenient ordering and purchasing of household goods and services by accessing a wide range of e-commerce vendors. Unfortunately, the "Audrey" failed to interest the public and was discontinued a year after its introduction.

FEATURES:

- Usability when removed from the shipping carton without preprogramming or complicated preparation
- Activation as easy as a turning on a radio
- Instant creation of an ISP account with the designed provider, ATT WorldNet®
- Replacement of household-records clutter
- Cordless keyboard or hand-held pen-type stylus for writing
- Attachment of two Palm™ hand-held organizers to interface with the "Audrey" color-coded calendar
- Reception of system-software upgrades transparently and automatically
- Access to sports, world-news, financial, and entertainment/TV-listing sites, and area-specific weather sites (see some examples page 16)
- Facilitation of the purchasing of beauty products, electronics, video rentals, takeout food, groceries, laundry/cleaning, cooking utensils, and spirits
- Holding of credit-card numbers securely on file
- Reception of music stations the world over and in stereo via the RealAudio broadcast site and sound-transference technology
- Replay/transmission of voice e-mail messages via the stereo speakers
- Accommodation of external speakers (optional)
- Notification of received e-mail message via the light-blinking stylus
- Refreshment of incoming e-mail messages and Web sites periodically throughout the day
- Two USB ports for a printer to be connected
- Built-in V.90 56K modem with two telephone-connection RJ11 jacks

DESIGNERS: IDEO, San Francisco, California (hardware); Razorfish, New York, New York, USA (software interface)
MANUFACTURER: 3Com Corporation, Santa Clara, California, USA

Cabinet available in five colors: ocean, meadow, sunshine, linen, or slate.

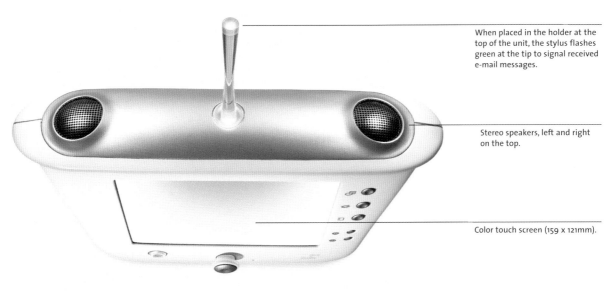

When placed in the holder at the top of the unit, the stylus flashes green at the tip to signal received e-mail messages.

Stereo speakers, left and right on the top.

Color touch screen (159 x 121mm).

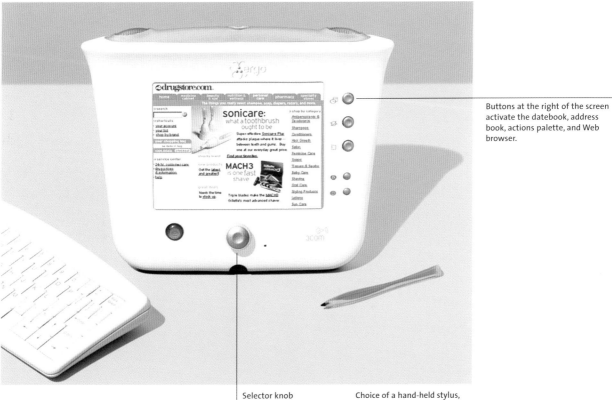

Buttons at the right of the screen activate the datebook, address book, actions palette, and Web browser.

Selector knob scrolls pre-selected Internet channels across the bottom of the screen like a film-strip.

Choice of a hand-held stylus, right, for writing or an infrared (cordless) keyboard, left, for typing. The keyboard can be hung on the back of the unit for storage when not in use.

CONTINUED ▶

"AUDREY™" INTERNET APPLIANCE (CONTINUED)

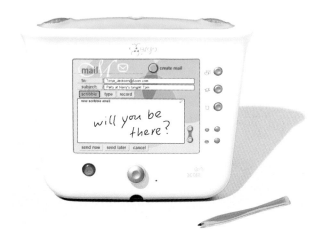

MAIL: e-mail receiver/sender (handwritten). Writing/indicator by stylus (lower right) or writing by a traditional keyboard (previous page).

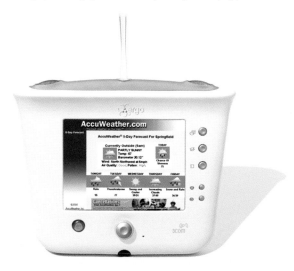

ACCUWEATHER.COM: weather and forecast.

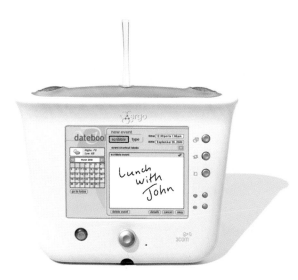

DATEBOOK: calendar, clock, date, "scribble event."

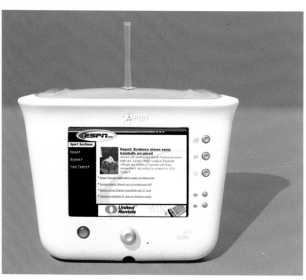

ESPN.COM: sport news.

"LEON@RDO" INTERNET APPLIANCE

The "Leon@rdo" is a household and Internet interconnected system that ties in the refrigerator, ovens, and other appliances made by Wrap, a company originally part of Merloni Elettrodomestici. Merloni was the first ever to make household appliances capable of Internet connectivity, and, to that end, it launched Ariston Digital in December 1999. The WRAP (Web-ready appliances protocol) technology that the "Leon@rdo" intelligent system calls on was developed by Merloni in cooperation with other firms.

FEATURES OF THE "LEON@RDO" UNIT:

- Easy plug-and-play use
- Information that is conveyed on a household-electricity or GSM network or through a household telephone line between appliances or to the outside world
- No need for a central computer to manage data
- No keyboard or mouse
- Touch-screen controls
- One-plug operation
- Breakdowns, like absence of electrical current or plumbing breaks, signaled to the Digital Assistance Center
- Adjusted electrical consumption and, thus, energy savings
- Cupboard supplies and food expiration dates are tracked
- Full Internet access and services such as a mailbox, agenda, notepad, and calendar

DESIGNERS: IDEO, Palo Alto, California, USA
MANUFACTURER: Wrap S.p.A., Fabriano (AN), Italy

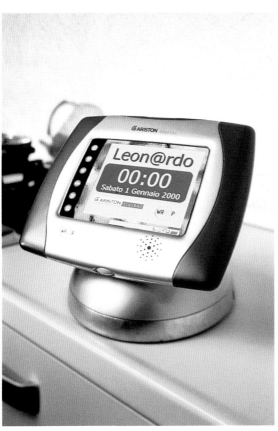

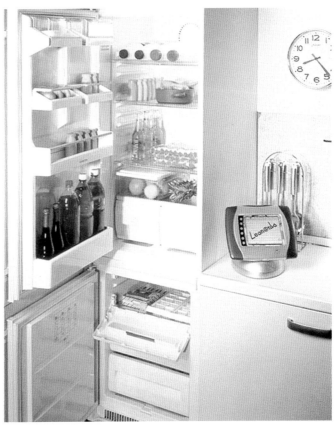

"WEB TOUCH® EASY"
INTERNET DEVICE

Since most people have neither a sophisticated knowledge of computers nor the desire to learn about them, the "Web Touch Easy" was devised to make access to the Internet as quick and easy as using a telephone. It offers users the ability to shop, purchase leisure-time services, bank at home, and acquire other domestic aids and goods.

FEATURES:
• "Plug and play" out of the packaging carton
• One-touch access directly to the Internet
• Built-in 56 KB per second, V90 modem, connecting via a unique RTC (analogic) telephone line
• Parallel port for a printer connection and printing capability
• Web-navigation key
• Integrated keyboard
• Color screen, VGA 7.5 in. (640 x 480), 256 colors, adjustable luminosity, screen-saver sleep mode
• Sound card, compatible ISO 7816 1-2-3 (optional)
• Internet-site-access protocol supports: HTP.1.1, HTTPS, SSL3 (40 & 128 bits), HTML 3.2, Java applets, Java scripts, cookies, mail to, multi-window
• E-mail send/receive with one key; protocol support: SMTP, POP3; text, HTML, GIF & JPEG images
• Access to Minitel services in France
• Colors: olive grey, sable yellow

ENGINEERING: Atlinks, An Alcatel/Thomson multimedia Joint Venture Company
MANUFACTURER: Alcatel, France

Photography copyright © Thomas Duval

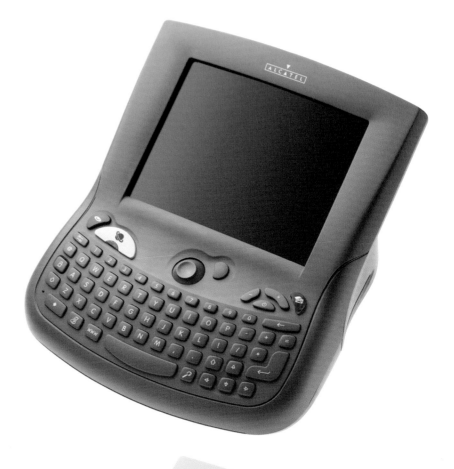

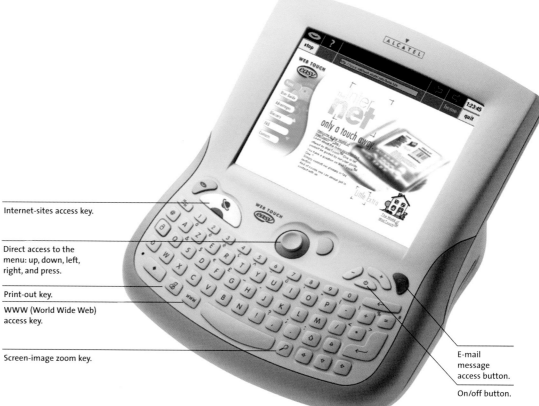

Internet-sites access key.

Direct access to the menu: up, down, left, right, and press.

Print-out key.

WWW (World Wide Web) access key.

Screen-image zoom key.

E-mail message access button.

On/off button.

"H610" CORDLESS SCREEN DEVICE

The "H610" cordless, portable communicator, whose wireless operation is made possible by Bluetooth technology, is intended for use as a complete home communications center. The "H610" is one of Ericsson's cutting-edge mobile communicators which were featured in the Paramount film *Tomb Raider* and offered as future products but are actually in production now. Like similar models, the "H610" eliminates the hassle of logging onto the Internet with a home computer.

FEATURES:
• Phone
• Internet link and browser
• Sending/receiving of e-mail and voice mail
• Address book
• Small base station to communicate without cord attachments
• Compact, full-color display screen
• Touch or pen activation of commands and functions via the virtual keyboard

DESIGNERS: Ericsson staff, Stockholm, Sweden
MANUFACTURER: Telefonaktiebolaget L. M. Ericsson, Stockholm

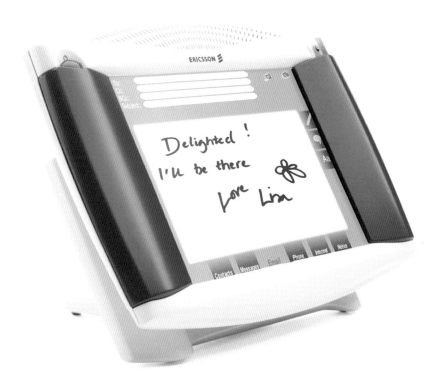

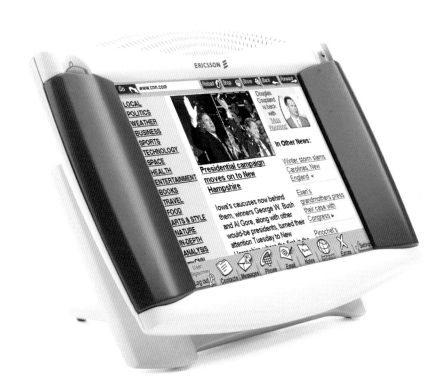

"MICRO-ACTION" TRANSLUCENT RAZOR, "FREE STYLE" SERIES

Norelco is a brand of Royal Philips Electronics that is sold in the US, but elsewhere under the Philips name. Philips introduced the first single-head rotary razor in 1948, and the Tripleheader® razor, the modern electric razor, in 1967. The "Micro-Action Free Style" razor, the least expensive in the Norelco range, was unveiled in the year 2000 in an effort to appeal to the young male market.

FEATURES:

- Individual floating head with Lift-and-Cut® technology, featuring 45 lifters and 45 self-sharpening rotating blades
- Micro Grooves in each shaver head to align the blades closer to the skin
- Protective razor head cap
- Full-width pop-out cutter for trimming beards, moustaches, and sideburns
- Reduced noise and vibration
- Colors: grape, watermelon, lime, blueberry
- Dimensions: 153 x 50 width x 50 mm at head and 25 mm at handle

DESIGNERS: Philips Product Development Group
MANUFACTURER: Norelco Consumer Products Company, a division of Philips Electronics North America Corporation, a subsidiary of Royal Philips Electronics N.V., Eindhoven, The Netherlands

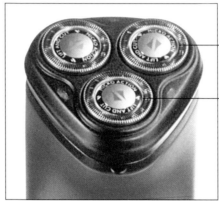

Protective head cap (not shown).

Each head incorporates 45 lifters and 45 self-sharpening blades that rotate.

Micro Grooves align the blades in each shaving head to get closer to the skin's surface.

Transparent polypropylene housing in a choice of four colors.

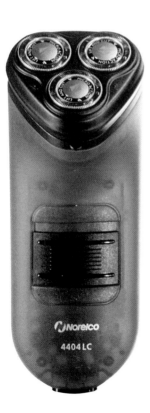

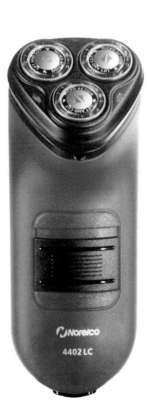

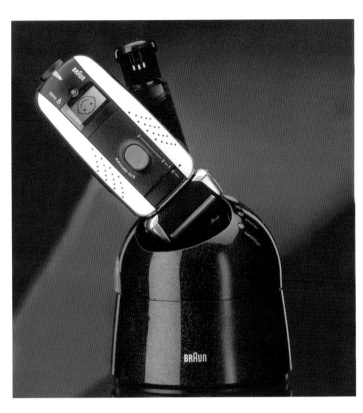

"SYNCHRO" RAZOR

While electric razors may not shave as closely as metal-blade hand razors, the technology keeps being advanced—in the case here, by Braun, the world's best-selling foil-shaver brand. This particular electric-shaver model, the "Synchro" which was introduced in the year 2000, is automatically cleaned, conditioned, and charged while it rests in the base unit.

FEATURES:
• Four-way-motion (up, down, left, right), pivoting shaving head
• Increase of the shaving area by 60% over traditional foil shaving
• Replaceable Clean&Charge unit automatically cleans, conditions, and dries the shaver and recharges the batteries
• Refill-alert button to signal when the cleaning cartridge needs replacing
• Cartridge snap-in feature for easy, quick replacement
• Lemon-scented cleaning solution

DESIGNER: Roland Ullmann, Design Department, Braun GmbH, a subsidiary of The Gillette Company, Walldurn, Germany
MANUFACTURER: Braun GmbH

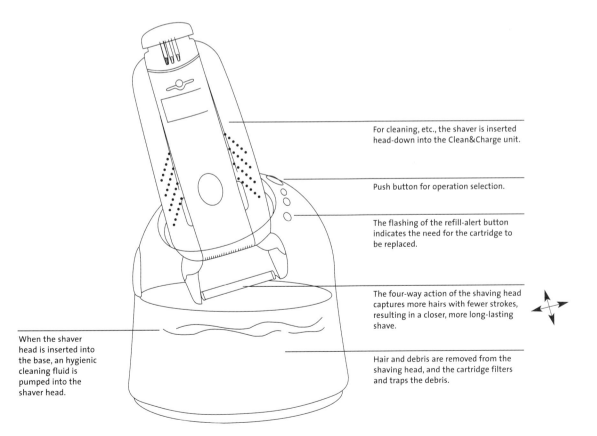

For cleaning, etc., the shaver is inserted head-down into the Clean&Charge unit.

Push button for operation selection.

The flashing of the refill-alert button indicates the need for the cartridge to be replaced.

The four-way action of the shaving head captures more hairs with fewer strokes, resulting in a closer, more long-lasting shave.

When the shaver head is inserted into the base, an hygienic cleaning fluid is pumped into the shaver head.

Hair and debris are removed from the shaving head, and the cartridge filters and traps the debris.

"SMART BATH" SYSTEM

This bath concept is based on an intelligent monitoring system that saves water and makes maintenance easier. It grew out of the "Intelligent Bathroom," the master-of-arts-thesis project of industrial design students Arni Aromaa and Sauli Suomela. It was realized with the Oras Group Ltd in 1997–98 under the aegis of the Faculty of Product and Strategic Design, University of Art and Design, Helsinki. The designers wanted the high-tech principles of conservation to be congruent with the language of simple, organic, natural forms, shaped by water.

FEATURES:
- Intelligent water system that integrates the bathroom into the facilities-management system of an intelligent building
- User-friendly products and interfaces
- Heat-treated Finnish aspen wood flooring
- Chromium-plated brass fixtures
- Acrylic fittings and laminated fiberglass

DESIGNERS: Arni Aromaa and Sauli Suomela, Paragon Design Ltd, Helsinki, Finland
MANUFACTURER: Prototype by Oras Oy, Rauma, Finland

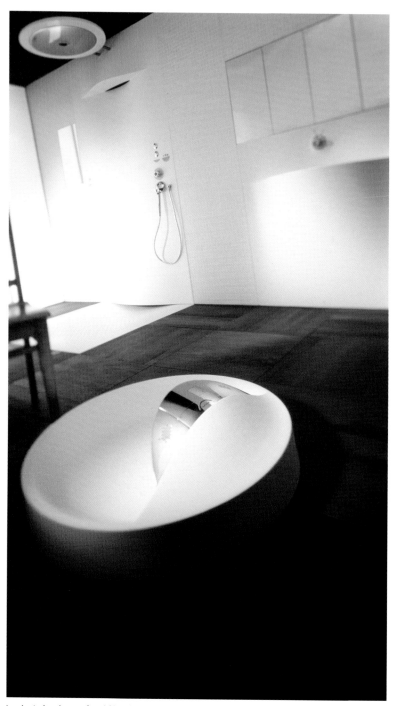

Laminated and seam-fused fiberglass for window, shower, and sink (in the background), so that the area appears as a continuous flowing surface.

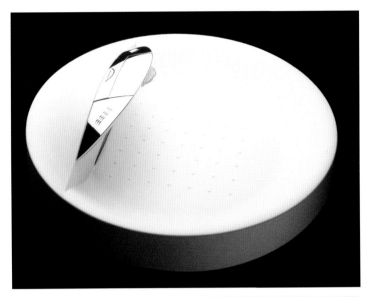

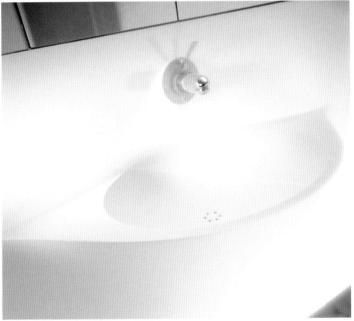

The fittings of the tub, sink, and shower are chromium-plated brass and a pleasant, colorful acrylic plastic. The surfaces and basin are laminated fiberglass. Individually adjustable water temperatures are automatically kept constant.

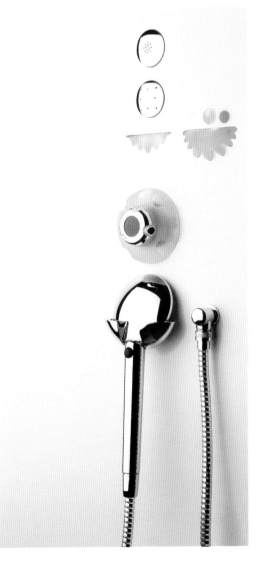

"CONTRAROTATOR™ CR01"
CLOTHES WASHER/DRYER

Entrepreneur James Dyson, who has been interested in both design and technology, became well-known for his range of vacuum cleaners which he followed in 2000 with the "Contrarotator" washing machine. Realizing that soaking clothing is not an efficient cleaning method, the "CR01" washer was developed to move fabric around, opening weaves to the detergent. Dyson engineers found that 15 minutes of hand washing performed better than 67 minutes by "AAA" washing machines, or most of those on the market today. Thus, the "CR01" was configured to simulate washing by hand. In addition, the machine also incorporates other advanced, or improved, features. Two color combinations of the cabinet are available (one shown here).

FEATURES:
• 7 Kg capacity, handling very large duvets; 60% greater than "AAA" machines
• 14 Kg of washing in about 2.5 hours, less than half other machines' times
• Large rubber-bellows seal (at the door), preventing trapping and damage
• Wide door opening
• Cleanest wash results at 40° C
• Electronic controls
• Stainless-steel water heater
• Computerized weight and distribution detector
• Noise reduction
• Protection against leaks and flooding

DESIGNERS: Staff engineers, Dyson Limited, Malmesbury, Great Britain
MANUFACTURER: Dyson Limited, Malmesbury

Two aligned anti-magnetic, steel-alloy drums replicate hand washing by rotating in opposite directions. Fabrics are flexed rather than the action of traditional machines that "drop and flop." Drum-to-drum bearing (in yellow) protect fabrics.

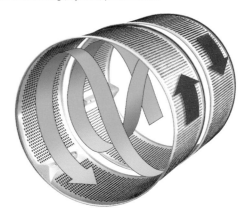

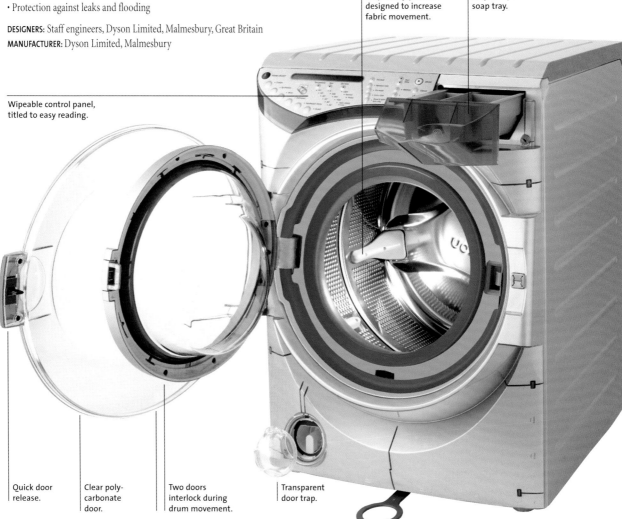

Proprietary paddle designed to increase fabric movement.

Easy-to-open soap tray.

Wipeable control panel, titled to easy reading.

Quick door release.

Clear poly-carbonate door.

Two doors interlock during drum movement.

Transparent door trap.

Machine-mover handle.

"ELITE™" CLOTHES WASHER
WITH "CALYPSO™" WASHING MOTION

Fifty per cent of American homes has at least one appliance by Kenmore, a Sears, Roebuck & Co. product. And the washer here, the "Elite," was made possible by a new technology developed by a Sears and Whirlpool partnership. It contains no central agitator and produces a gentle action on fabrics. Instead of immersing laundry in a full water bath, the new "Calypso" washing motion incorporates a washing plate that produces a special wave-like motion to gently lift and bounce clothing through a waterfall of soapy water. Also, the elimination of an agitator made it possible to enlarge the washing space so that clothing would have more room to move around.

FEATURES:
• "Calypso™" washing motion that simulates a wave-like action
• "Calypso™" washing plate to bounce clothing
• 8.2 Kg and 3.3 liter capacity
• Filter to trap dirt and particles, eliminating clothes' sitting in dirty wash water
• High efficiency rating: uses 50% less water and 65% less energy, compared to most other average washers
• Electronic controls
• 9–10 hr wash-delay timer
• Gentler cleaning of silk and wool than most other average washers
• Colors: white, bisque, graphite
• Companion to the Kenmore "Elite King Size" dryer, 7.2 cu ft. capacity, with automatic heat controller

DESIGNERS: Staff of the consortium of Sears, Roebuck & Co. and Whirlpool Corporation
MANUFACTURER: Sears, Roebuck & Co., Chicago, Illinois, USA

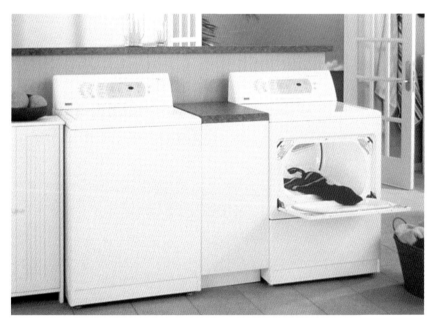

Top-loading "Elite" washing machine (left) and companion front-loading "Elite King Size" dryer.

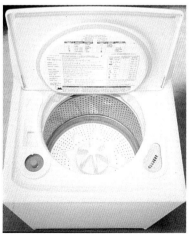

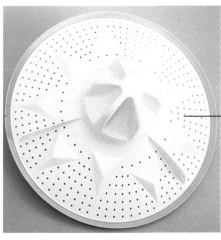

"Calypso" washing plate eliminates the use of a traditional tower agitator. The washing plate bounces the clothes and creates a gentle, wave-like washing motion.

"MÉMOIRE D'HOMME"
NUMERIC WRITING DEVICE

A lightweight portable writing unit, this device combines traditional manual handwriting with data-processing text-and-drawing technology. It is composed of a surface, like a thick sheet of page; a pen; a portfolio housing that protects the elements in transport; and a battery. The unit's technology is highly sophisticated and not easily understood and even more difficult to explain.

WRITING ELEMENT: The writing surface is composed of two interactive layers. One of them is an electronic ink system made up of microcapsules, a few microns in diameter, that form a kind of frost, like springtime frost on a plant leaf. Each capsule contains one black and one white hemisphere. Writing or the writing pen creates impulses that cause the capsules to rotate. The rotation places the black capsules on the top, and the written message appears on the writing surface in the same manner as pixels show up on a computer screen. Also, the capsules draw in a frost that eliminates the stiffness on an LCD or computer screen. However, neither the writing nor the image emits light, contrary to that on a traditional computer screen. Reading the writing is easy because no ambient light is required, as is necessary when reading print on paper.

PEN: The writing surface of the microprocessor recognizes the pen's informational emissions.

BATTERY AND BATTERY ACCUMULATOR: The battery is located inside the writing sheet. To recharge it, one of the two double-contactor points, located in opposite top corners of the underside of the sheet, is inserted into the battery accumulator while the writing surface is still in use.

INTERFACE CAPABILITIES: Writing or drawing can be transferred to other like writing devices near by. High-frequency waves make this possible; they also allow data transference to a computer or to a Web site for downloading.

FEATURES:
- Elastomeric 4 mm writing surface
- Microcapsules of one black and one white hemisphere, rotating so that the black capsules appear on the writing surface
- Pen that transfers electromagnetic impulses to the micro-capsule reactor
- Polymeric battery
- No room light required for reading
- Interface capability with computers and other identical writing instruments

DESIGNER: Cédric Ragot, Paris, France
MANUFACTURER: Prototype by the designer

The black portfolio case houses the removable white writing surface.

The polymeric battery, located inside the sheet, is recharged when one of two corners, with yellow contactor points, is inserted into the battery accumulator while the writing surface is in use.

Battery accumulator.

On the rear side of the writing sheet (below), there are yellow contact points through which the battery, located within the sheet, is recharged.

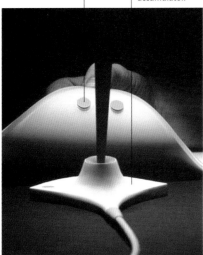

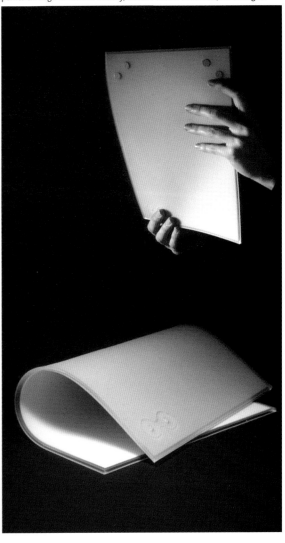

The movement of the pen, which rests in the battery accumulator (top left), is recognized by the microprocessor. Note the view (bottom) of the pen's top portion.

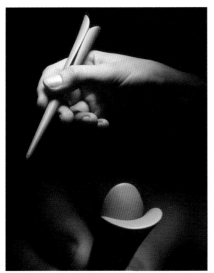

"MACROWAVE" PROJECT

The Whirlpool company has come a long way since its founding in 1911 in Benton Harbor, Michigan. And an example of its progress is the "macrowave" microwave-design invitational competition, the results of which were shown at the 2000 Triennale in Milan, Italy. Since the purpose of the imperative given to the eight European designers was to design a microwave oven whose manner of operation should be self-explanatory, likewise, no explanations are provided here.

FEATURES:
• Microwave ovens of the future according individual designers' visions

DESIGNERS: As individually noted
GENERAL MANAGER: Newton Gama
TEAM MEMBERS: Tammy Barros, Anna Luiza Cavalcanti, Sergio Corumba, Rodolfo Floeter, William Garcia, Richardo Kolb, Liliana Monguilod, Rogério Negrão, Guilherme Nehring, Jorge Pietruza, Fernondo Pruner, Ari Shimizu, Claudio Silva
PROTOTYPE COORDINATION: Luigi Di Bartolomeo, Whirlpool Cassinetta, Italy
PROTOTYPE FINISHINGS: Stefano Bogni, Besozzo, Italy
MANUFACTURER: As individually noted, prototypes for Whirlpool Europe s.r.l., Comerio (VA), Italy
Photography by Stefano Porro, Milan, Italy

"MICRO TOP"

DESIGNERS: Mario Fioretti with Team Latin American Region Industrial Design
MANUFACTURER: Prototype by Mauricio Moreira, Modelshop, LAR, Brazil

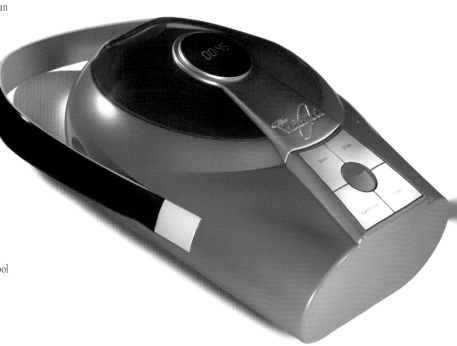

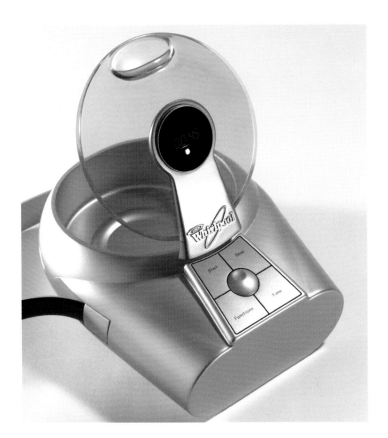

"CHEF"

DESIGNERS: Konstantin Grcic with Clemens Weisshaar
MANUFACTURER: Prototype by Formenti G. & C. S.a.s., Busto, Italy

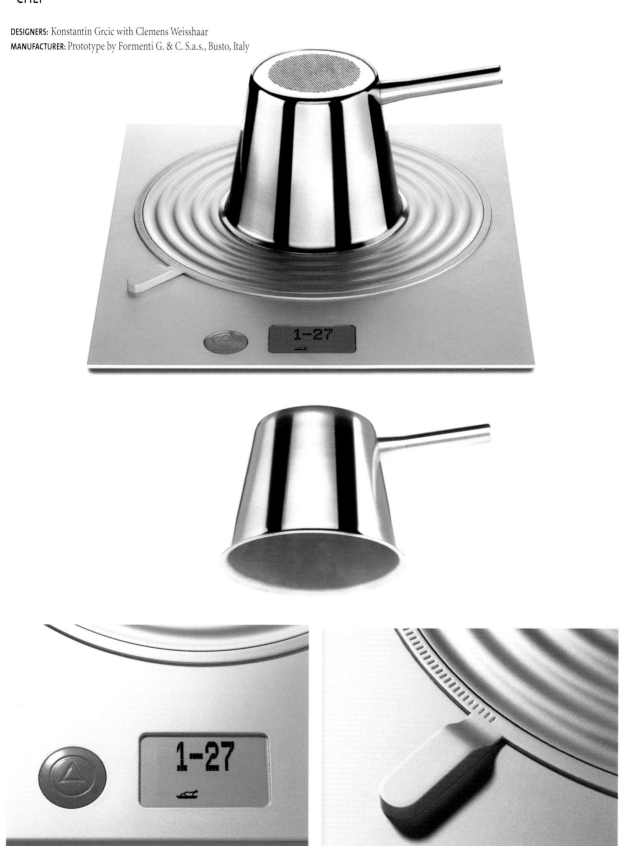

CONTINUED ▶

"MACROWAVE" PROJECT (CONTINUED)

"PICARD"

DESIGNER: Jacco Bregonje
MANUFACTURER: Prototype by Mario Goffredo, Whirlpool Cassinetta, Italy

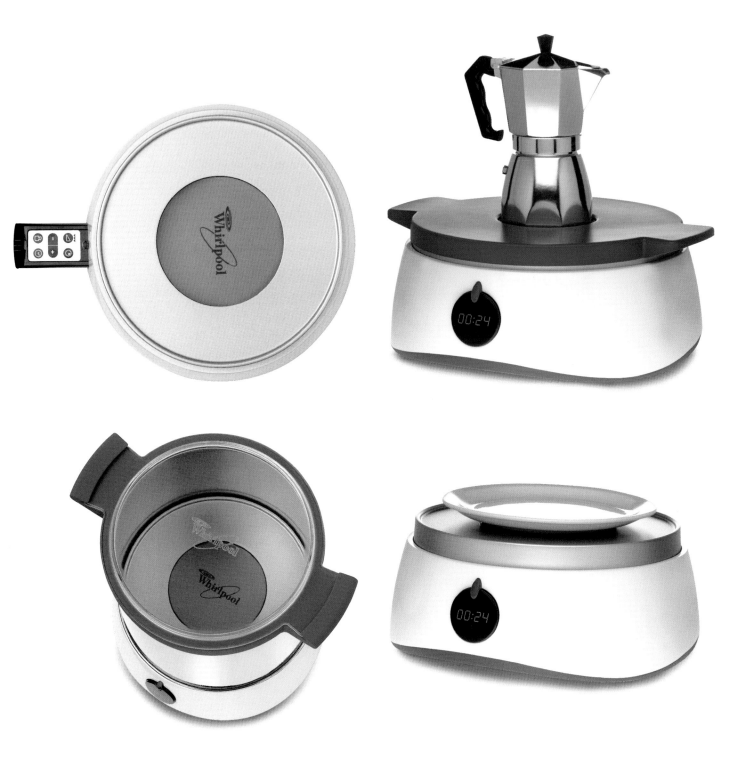

"P.I.C. N.I.C"

DESIGNERS: Riccardo Giovanetti with Antonio Fascione
MANUFACTURER: Prototype by Maurizio Marian, Milan, Italy

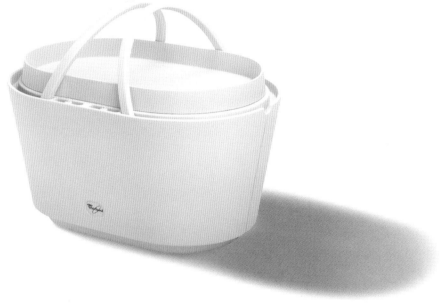

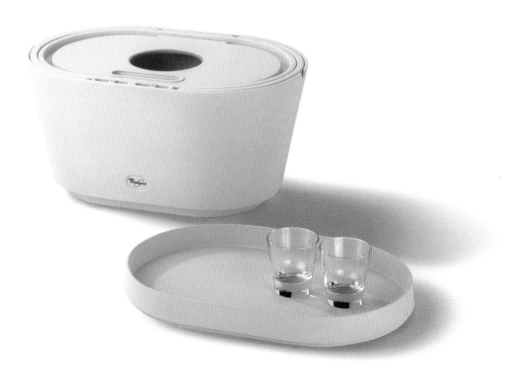

CONTINUED ▶

"MACROWAVE" PROJECT
(CONTINUED)

"SOUND WAVE"

DESIGNERS: James Irvine with Steffen Kaz
MANUFACTURER: Prototype by Formenti G. & C. S.a.s.

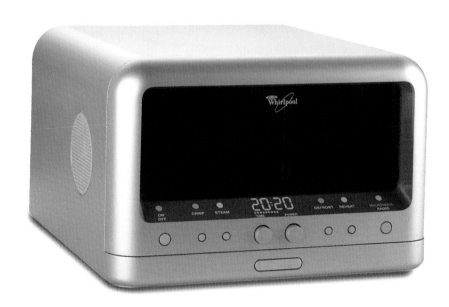

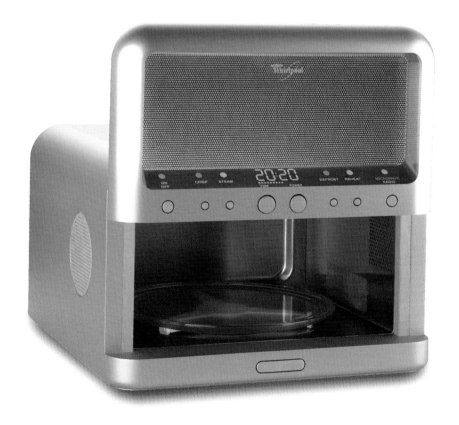

"TROLLO"

DESIGNER: Björn Goransson
MANUFACTURER: Prototype by T Design AB, Jonkoping, Sweden

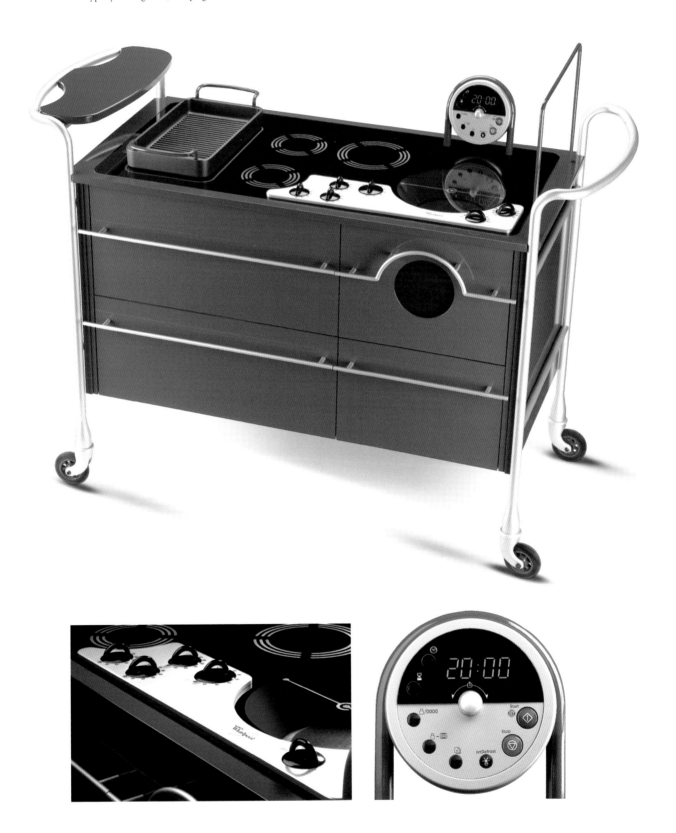

CONTINUED ▶

"MACROWAVE" PROJECT (CONTINUED)

"POTS & PANS"

DESIGNER: Christophe Pillet
MANUFACTURER: Prototype by Zooi S.n.c., Milan, Italy

"VERTIGO"

DESIGNER: Mark Baldwin
MANUFACTURER: Prototype by Millennium Models, Benton Harbor, Michigan, USA

"DREAM PRODUCTS"

In addition to its own eponymous name, Groupe Moulinex produces a number of household appliances under the Krups, Swan, and Mallory brands. In an effort to stay at the forefront of product development, the items in the "Dream Products" program illustrate the kind of advanced thinking about what might become the appliances, or more likely the kitchen systems, of the future.

FEATURE:
• Kitchen system of the future

DESIGNERS: Nicolas Blaise ("Kitchen Unit"), Nicolas Blaise and L. Quirin ("Bag Pipe"), and B. Leverrier ("Expresso Compact")
MANUFACTURER: Prototypes by Developpement Produit, Groupe Moulinex, Paris La Défense, France

In the interactive kitchen, the wireless appliances which include a microwave oven (right and below) are voice-activated. There are no manually controlled buttons or levers on the oven or combination countertop/cooking surface (below). Only the LED window at the upper right, built into the wall, signals the time and on/off.

The wooden movable shelf incorporates a thin built-in motor that drives the food processor. Specifications: 500 watts, variable-reluctance motor, two speeds, 15,000 turns per minute, rotates by an integrated cable, HF telecommander.

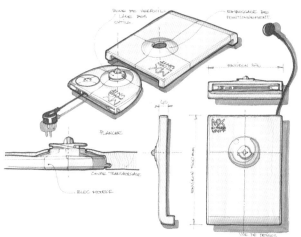

The kitchen system pivots around the wireless, but electrical, mobile shelf (above left and right). All the appliances—including the microwave oven, food processor, movable shelf, and monitor—feature only one manual command: the on/off button. All other instructions are voice driven.

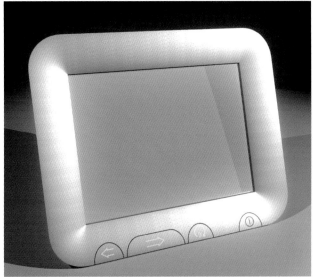

The display screen (left)—with only four manual commands for (1) the previous screen, (2) forward screen, (3) volume, and (4) on/off—downloads recipe pages and other information, pertinent to food preparation, from the Internet. A voice guides the cook through the preparation of a dish.

The "Expresso Compact" makes one or two cups of espresso coffee. Specifications: 15 bar steam force, 280 x 200 x 250 mm, 1 Kg capacity of the coffee receptacle, 1 liter capacity of the water tank.

The coffee-ground bind swivels outward.

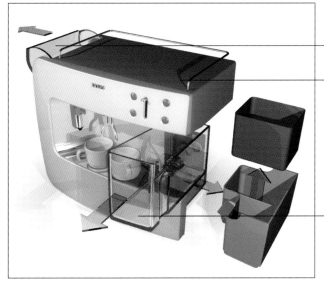

The removable serving tray is heated from beneath.

The impact-resistant glass-like water reservoir is horizontally removable and has no cover.

CONTINUED ▶

"DREAM PRODUCTS"
(CONTINUED)

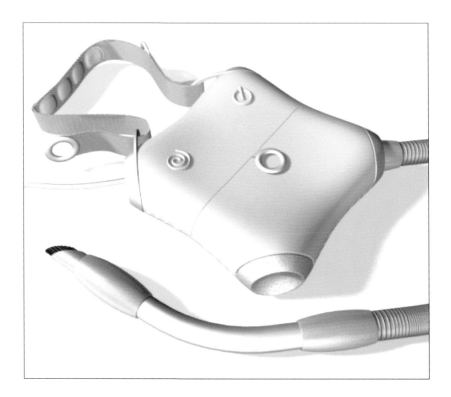

The "Bag Pipe" vacuum cleaner is worn by a strap like a handbag. Small, flat, and powerful, it appears to be a cushion at first sight. Specifications: 1400 watts, 330 x 330 x 100 mm, 3.2 Kg.

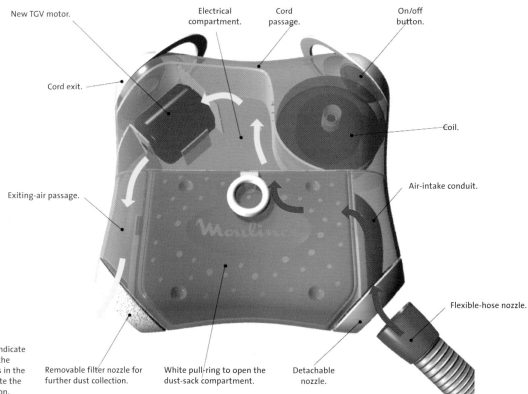

New TGV motor.

Electrical compartment.

Cord passage.

On/off button.

Cord exit.

Coil.

Exiting-air passage.

Air-intake conduit.

Flexible-hose nozzle.

Red arrows in the drawing indicate the intake air flow, prior to the collection of dust and debris in the sack. The blue arrows indicate the exiting air, after the collection.

Removable filter nozzle for further dust collection.

White pull-ring to open the dust-sack compartment.

Detachable nozzle.

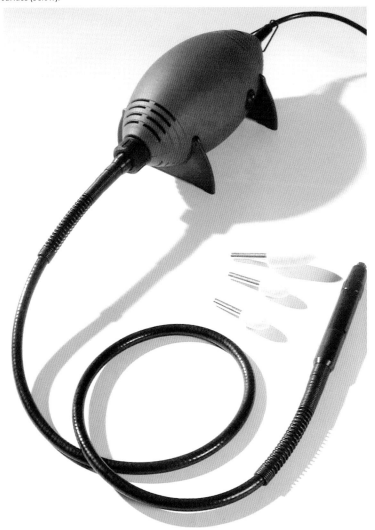

The motor can be hung from the waist, keeping the user's hands free for operating the drill bit. A choice of hooks or feet permits the motor's hanging from a belt (above) or resting on a flat surface (below).

"FLEXXI TRONIC" PORTABLE MOTOR

This unique, highly sophisticated motor, designed in 2000, is electronically controlled and turns a highly flexible tube to which a selection of bits can be attached. To be used like any drill for polishing, the unit can be suspended hands-free from the user's waist and the end of the flexible drive placed in almost any position.

FEATURES:

- Appropriate for use by a number of professions from sculptors and stone workers to mechanics and carpenters
- Portability
- First motor to compensate for the torque by locating a microprocessor in the gears
- Electronically controlled variable speeds
- Injection-molded fiberglass-reinforced polyamide housing and interchangeable elastomeric base
- Dimensions: 200 mm long x 105 mm diameter

DESIGNER: Philippe Comte and Bruno Tainturier, Guliver Design, Paris, France
MANUFACTURER: Moviluty, Le-Perreux-sur-Marne, France

"WELLA WOW" HAIR STYLISTS' ACCESSORIES

The haircare-products firm Wella Italia began a project in 1997 that has been exploring the evolving attitudes toward professional hair stylists. Continuing the investigation, Wella took a look at four separate sectors of the haircare business; one was the High-Tech Salon. To imagine how hyper-advanced hairdresser tools might be configured in the future, Wella commissioned Gabriele Pezzini. His proposals were unveiled in the High-Tech Salon section of Wella's "Wella Wow" stand at the 1999 Cosmoprof fair in Bologna, Italy. Pezzini's intriguing inventions include a number of laser-driven devices—a comb, hair lightener, and pair of scissors—as well as a hair dryer.

FEATURES:
• Predictions of haircare products of the future
• Examples of advanced technology and design solutions
• Use of ready-made manufacturing materials that are flat or rolled or colored with films or that can be sandwich assembled
• LED display screens
• Use of infrared technology

DESIGNER: Gabriele Pezzini, Pezzini Global Design, San Benedetto del Tronto, Italy
MANUFACTURER: Wella Italia Labocos S.p.A., Castiglione delle Stiviere (MN), Italy

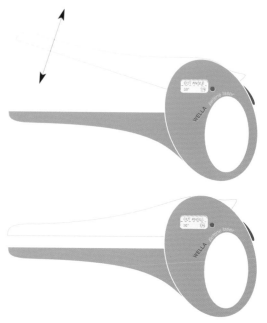

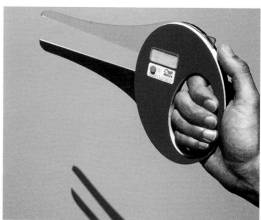

"DUCK" LASER SCISSORS
Hair-cutting scissors that can cut hair at an angle. The blade is opened and closed (or raised and lowered) on the hair strands, and, when a switch is pressed, a laser beam cuts them. Thus, the structure of the hair is not stressed.

"LIGHTCURVE" LASER COLORANT
This device can either bleach hair or dye it—all to a predetermined shade. The formula, which can be kept on file, of a specific client's color is chosen on the LCD display screen and then touch-activated.

"FASTNET" LASER COMB
This intelligent comb can diagnose the health or condition of a person's hair. The readout display informs the stylist of the appropriate treatment that may be required.

"ARM-FON" HAIR DRYER
Worn on the forearm, this leaves a hairdresser's hands free for working on a client's hairdo. A warm orange light dries the hair, and a special sensor assures that it is never overheated or burned. One of a new generation of batteries lightens the weight of the unit that is either silent or can play music.

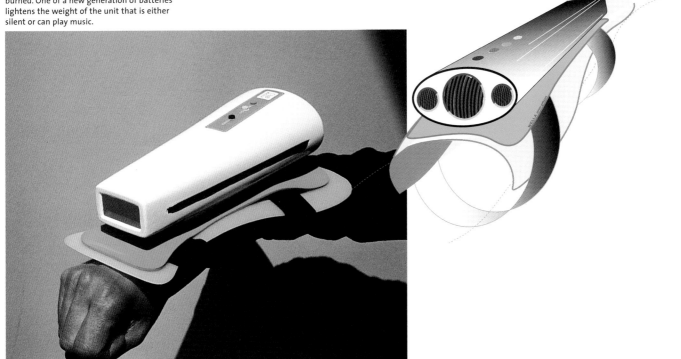

"MCL103—NESS COLLECTION" ALARM CLOCK

The numbers that show the time on this clock—designed in 1999 and manufactured from 2000—appear to float in space, thanks to the clear polycarbonate material. The time readout is made possible by liquid-crystal technology. The full cell of a number is composed of seven strokes; see the "8," which is full and has all seven strokes. When some of the strokes of a full number are turned off, like the two vertical strokes on the left of a full number to form a "3," then they become clear on this clock face, and the time, date, and year graphics appear to be suspended in air when they are actually embedded in the layers of the clear-plastic sheet.

FEATURES:
• Clear clock face
• Embedded black liquid-crystal graphics
• Mini-processor, signaling the readout
• Aluminum case and face plate
• Easy time and date adjustments
• Dimensions: 50 x 74 x 50 mm

DESIGNER: Jean-Marie Massaud,
Paris, France
MANUFACTURER: Back GmbH,
Leinfelden, Germany

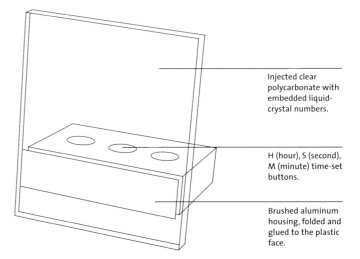

Injected clear polycarbonate with embedded liquid-crystal numbers.

H (hour), S (second), M (minute) time-set buttons.

Brushed aluminum housing, folded and glued to the plastic face.

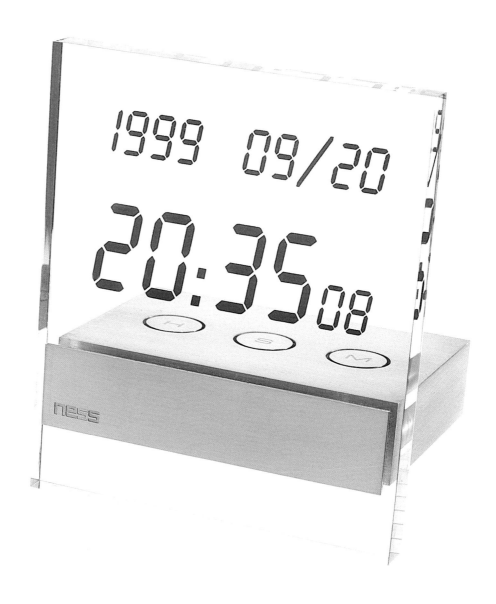

LIGHTING

"ON AIR" FLOOR LAMP

This lighting fixture turns on and off and brightens by what appears to be invisible forces. Because the "On Air" lamp, designed in 2000, is not yet in production, the designers are keeping the technology a secret. Evidently the electrical charge produced by a finger's being rotated around the rim of the diffuser bowl, supported by a steel rod and base, controls the dimming and on/off mechanism.

FEATURES:
• PMMA (polymethyl methacrylate) diffuser bowl
• Circular fluorescent tube
• Steel rod, plate, and base
• Dimensions: 1200 x 300 mm

DESIGNERS: Jean-Michel Policar and Elsa Frances, Paris, France
MANUFACTURER: Prototype made possible by a grant from V.I.A., Paris. Produced by Jean-Philippe Hazard, Hazard Product, Montreuil-sous-Bois, France. Electronic conception and develop-ment by M. Vigneron, Ermes, Boissy-Sous-Saint-Yon, France

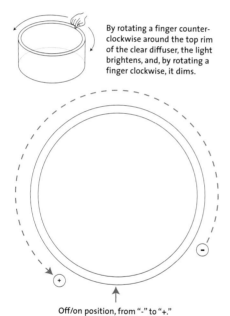

By rotating a finger counter-clockwise around the top rim of the clear diffuser, the light brightens, and, by rotating a finger clockwise, it dims.

Off/on position, from "-" to "+."

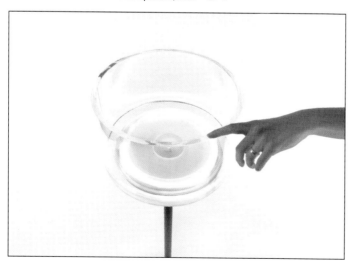

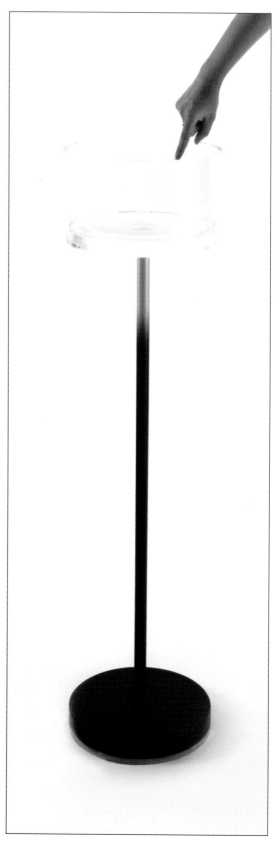

"©REWINDABLE LIGHT CONCEPT"

This lighting fixture is not a fixture at all. "A time measurer," according to the designer, who developed the concept in 1999, it serves the metaphorical notion that rewinding an object and creating electricity would essentially offer infinite life to a "product." Thus, in this case, you would buy light, not an object. Of course, the "©Rewindable Light Concept" is just that, a concept, a virtual image, a metaphor, or, more precisely, software that transmits the image of an illuminated light bulb, with the aid of a CPU, to a display screen, like the one shown below by Toshiba. The designer explains: "The image of a light bulb is used to bridge all that we know about light, light sources, and the history of light. [This is a] light that you can take with you when going to friends' for dinner or, maybe soon, that can be downloaded or rented via the Internet."

FEATURES:
• Illumination that you buy, not a lamp that is an object
• Software installed in a CPU and shown on a display screen
• Usable with any computer
• Brightness regulated by a TV remote controller

DESIGNER: Arik Lévy, Ⓛ design, Paris, France
MANUFACTURER: Concept by the designer

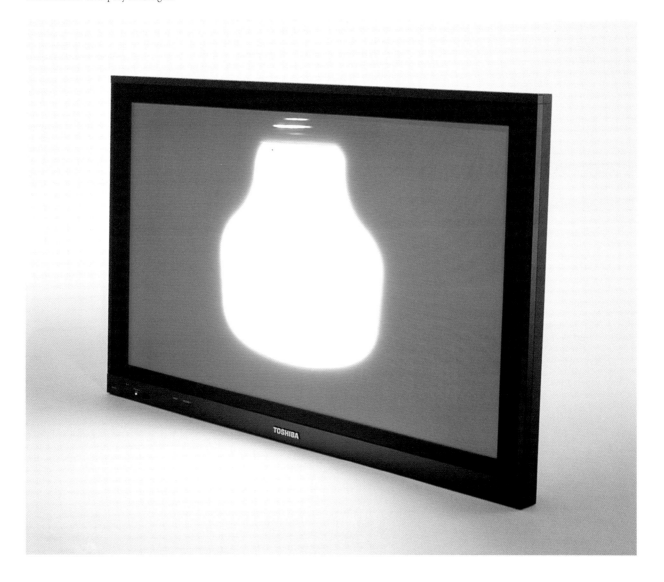

"20/20" FLASHLIGHT (OR TORCH)

This flashlight is powered by a state-of-the-art generator, originally developed for Freeplay radios (see pages 94–95). It features both a high-efficiency xenon bulb and a long-lasting LED bulb. Electrical energy is produced by hand cranking the handle to store power in the built-in battery. Or an AC/DC electrical adapter will recharge the battery. The clear polycarbonate housing means the unit holds no mechanical secrets. However, there is an opaque version available in yellow.

FEATURES:

• Hand crank for storing electricity in the built-in battery—a 30-second or about a 60-turn wind-up for 10 minutes of shine time on the LED bulbs
• DC battery, B-motor textured carbon-steel spring (spring life +10,000 cycles)
• Alternative source of power—AC/DC adapter for a battery charge of up to 45 minutes of shine time
• Efficient, permanent xenon-filled bulb developed especially for the 20/20 (an extra bulb included), or Indium Gallium Nitrate ultra-bright white LED bulb (no replacement required)
• Colors: transparent blue, clear, matte yellow
• Dimensions: 229 x 127 x 102 mm
• Weight: 1.1 Kg

DESIGNERS: Freeplay in-house design engineers, Freeplay Energy Ltd, Capetown, South Africa
MANUFACTURER: Freeplay Energy Corporation Ltd, London, United Kingdom

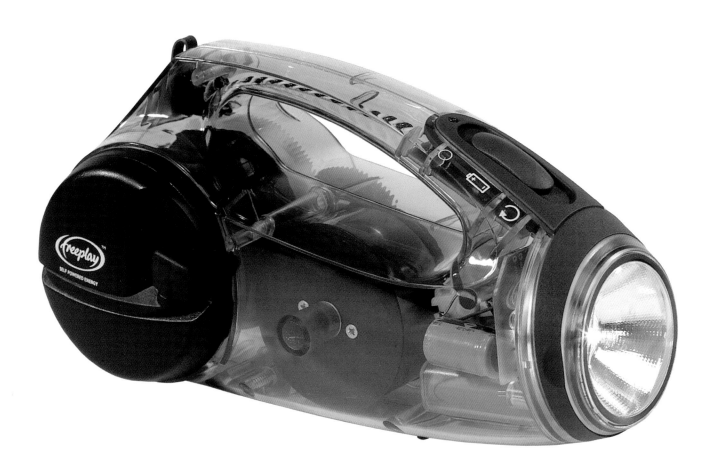

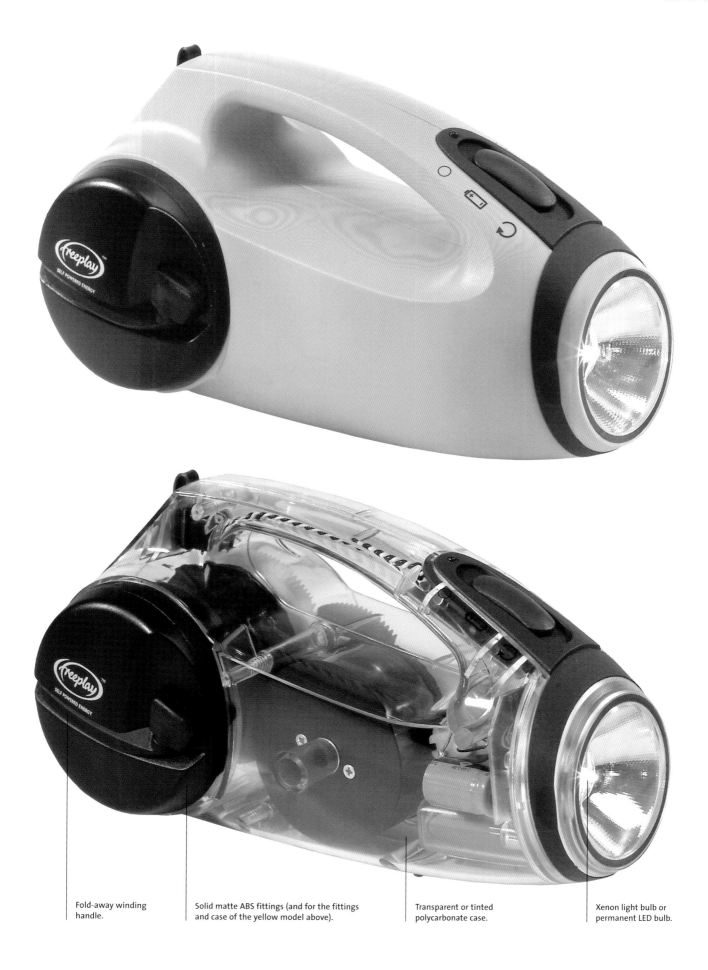

Fold-away winding handle.

Solid matte ABS fittings (and for the fittings and case of the yellow model above).

Transparent or tinted polycarbonate case.

Xenon light bulb or permanent LED bulb.

"RISE AND SHINE®" NATURAL-LIGHT ALARM-CLOCK LAMP

According to the manufacturer of this lighting fixture, the circadian rhythm of the body causes people—and animals too—to wake as the sun rises and to drift off to sleep as it sets. The "Rise and Shine" lamp simulates the cycle by offering gradual dim-to-darkness as well as dim-to-full-brightness modes. Also built into the unit is a choice of eight sounds simulating nature and the outdoors.

FEATURES:
- Combination of a bedside lamp, dawn/sunset simulator, and sound-therapy
- Natural-spectrum light bulb that will reduce glare and eye strain
- Choice of eight nature sounds
- Dimmable digital clock
- Snooze option and alarm-chimer to be used as a back-up
- 9 volt battery to be used as a back-up
- Ergonomic control buttons that adjust light brightness and sound levels
- Natural-color fabric shade
- Dimensions: 545 mm high x 369 mm diameter

PRODUCTION: Verilux®, Inc., Stamford, Connecticut, USA

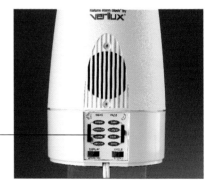

On the rear side, controls such as "wake," "fade," "display," and "cycle," plus eight sound choices.

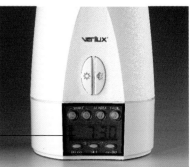

On the front, controls including an LED digital clock.

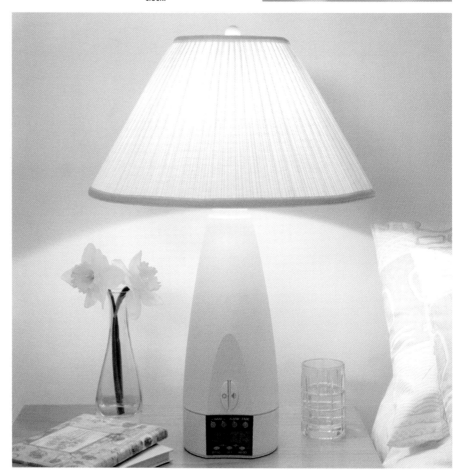

ROBOTS

"P3" OR "ASIMO" HUMANOID ROBOT

Honda's fully workable "P3," introduced in the year 2000, is a response to a long-in-coming human-like robot. For a number of years, there have been robots that manufacture products like automobiles. In fact, Honda's production includes 81.3% devoted to autos and 11.8% to motorcycles. As a result, it has had extensive experience in the development of robots. However, these machines have not looked like the kind of robots that science fiction has encouraged us to expect. The "P3" or "Asimo" (Advanced Step in Innovative Mobility) not only looks like a human—or more specifically an astronaut—but presumably will handle the domestic, even technical, chores none of us wants to or knows how to perform.

FEATURES:
• Highest performance of any extant bipedal robot today
• Movements powered by servomotors with a 2 km/hr walking speed
• Jointing like human limbs, but no spinal column
• Ability to climb up and down stairs while recognizing step heights
• Balance control to cope with uneven and sloping surfaces
• Complex software that monitors temperature, the battery-charge level, joint positions, torque, and initiation of coordinated movements
• Operation up to 25 minutes on a battery charge
• Hands that support up to 9 Kg each
• Backpack for a battery and for a computer that balances and coordinates the moving figure
• Two video cameras
• Microphone and speaker
• Dimensions: 1600 tall, 600 shoulder height, 550 mm deep (adult model)
• Weight: 130 Kg

DESIGNERS: Future Technology Research staff, a division of Honda Motor Co., Ltd, Tokyo, Japan
DEVELOPER AND MANUFACTURER: Prototype by Honda Motor Co., Ltd, Tokyo

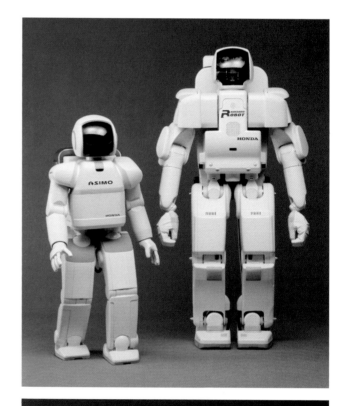

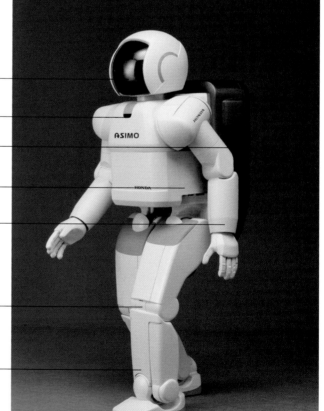

Two video cameras, functioning independently and recognizing stair heights.

Microphone and speaker.

Carbon backpack contains a four-processor high-performance computer for balance control and a battery.

Magnesium skeleton and rigid back, but no spinal column.

Long arms to reach the floor when the knees are bent.

16 joints, individually selected with independent movement.

The figure can stand on one leg and walk sideways, turns somewhat awkwardly compared to human motion, and can climb and descend stairs.

"ROBOMOW RL500" ROBOTIC LAWN MOWER

One of several similar robotic lawn mowers available today, the "Robomow RL500" requires electric guide wires to be installed on a lawn's perimeter so that flowers and shrubbery will be protected and the machine will not wander away. Depending on obstacles, grass height, slopes, and humidity, the mower will cut 2500–3200 square feet of lawn on a single electrical charge. For manual operation, a controller keypad can be attached to the machine via a cord, but this mode, after all, would defeat the robotic purpose.

FEATURES:
• Fully automatic
• 540 mm cutting width
• Each of three blades, with its own quiet motor, rotates at 5,800 revolutions per minute
• Automatic increase of motor power when tall grass is encountered

• Two clean 12-volt sealed, cyclic, lead-acid, maintenance-free batteries (2 x 24 volts, 17 AH) with 2 to 2.5 hour operating time on a 24-hour charge
• Two drive wheels, each with its own electric motors (2 x 75 watts, replaceable) and gears operating at different speeds and in different directional turns
• Mowing motor: 3 x 150 watts input, 5,800 r.p.m., replaceable
• Removable manual controller to override inside parameter instructions
• Proprietary Roboscan technology
• Dimensions: 890 x 665 x 315 mm
• Weight: 22.6 Kg (machine) and 12.6 Kg (battery)

DESIGNERS: Friendly Robotics Research and Development Team, Friendly Robotics, Kadima, Israel
MANUFACTURER: Friendly Robotics, Kadima

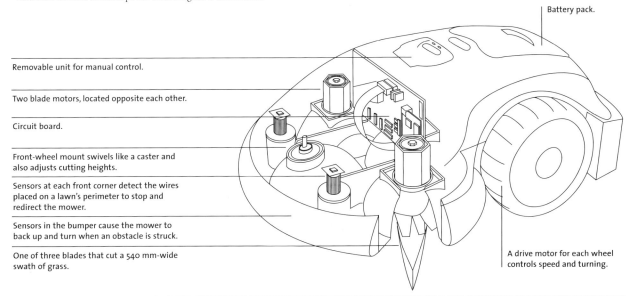

Battery pack.

Removable unit for manual control.

Two blade motors, located opposite each other.

Circuit board.

Front-wheel mount swivels like a caster and also adjusts cutting heights.

Sensors at each front corner detect the wires placed on a lawn's perimeter to stop and redirect the mower.

Sensors in the bumper cause the mower to back up and turn when an obstacle is struck.

One of three blades that cut a 540 mm-wide swath of grass.

A drive motor for each wheel controls speed and turning.

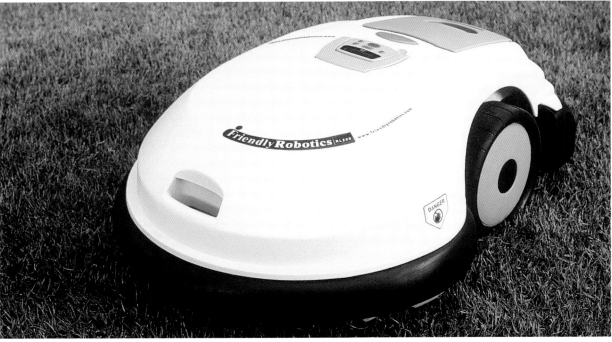

PSA (PERSONAL SATELLITE ASSISTANT)

NASA's PSA is a softball-sized floating robot that operates autonomously on board a manned spacecraft in pressurized micro-gravity interiors. It monitors the physical environment, acts as a communications device, enhances the crew's ability to perform its duties, and serves as a prototype for the design of future collaborative robots.

FEATURES:
- Video-display screen
- Wireless link
- Micro propulsion
- Environmental sensor
- Inventory scanner
- Solar cell
- Range finder
- Camera for video conferencing
- Atmospheric sensor
- Motion sensor
- Search light
- Speaker and microphone

SCIENTISTS/INVESTIGATORS: Yri Gawdiak (principal investigator), Maarten Sierhuis, Hans Thomas, and William J. Clancey, NASA, Ames Research Center, Moffett Field, California, USA; Jeffrey M. Bradshaw, The Boeing Company, Seattle, Washington, USA, and Institute for Human and Machine Cognition, University of Florida, Pensacola, Florida, USA, and The Boeing Company

MANUFACTURER: The Boeing Company, Seattle, for NASA, Ames Research Center

NASA Ames researcher Yri Gawdiak, principal investigator on the PSA project.

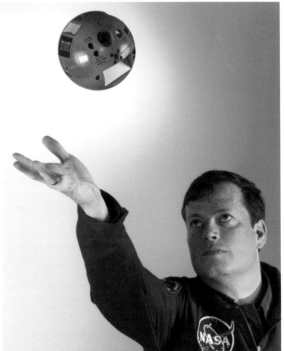

Photograph by Tom Trower, NASA Ames Home Page, http://george.arc.nasa.gov/dx

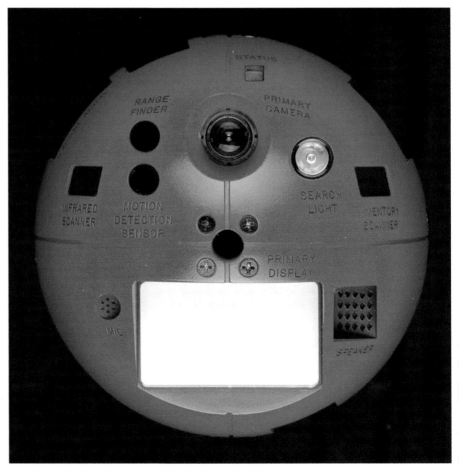

Approximately 130 mm in diameter, the the floating PSA incorporates a number of sensors and communication devices.

Photograph courtesy NASA Ames Home Page

The skeleton of the PSA before being fitted out.

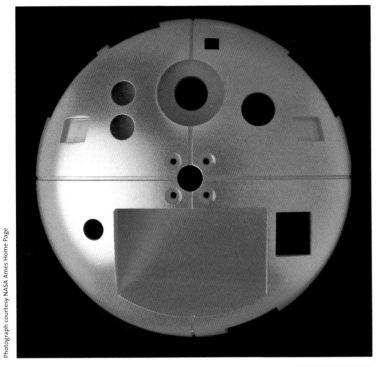

Photograph courtesy NASA Ames Home Page

Photograph by Tom Trower, NASA Ames Home Page, http://george.arc.nasa.gov/dx

NASA's PSA is an example of the next generation of advanced informational technology that followed the WNE (Wireless Network Experiment), developed at NASA in 1995 for the International Space Station. PSA-type units were found to be viable when astronauts on board *Atlantis* discovered, during the STS-76 mission, that wireless-computer radio signals did not interfere with the electronic equipment on either the Space Shuttle or the Russian space station *Mir*.

"DC06" ROBOTIC VACUUM CLEANER

A highly sophisticated household helper, the "DC06" vacuum features a double-air-intake action and a highly evolved computer-guidance system. For this machine, Dyson engineers developed an advanced micro-processor to instruct the SR motor. SR is a new generation of electrical-motor technology that eliminates carbon emissions and lasts two times as long as conventional brush-type motors.

FEATURES:

• Proprietary Dual Cyclone action, as with other Dyson vacuum cleaner models, for efficient pick-up action
• Powerful battery packs
• Floating cleaner head for close floor contact
• Speed choices
• Remembrance of where the unit has cleaned and where it is to go afterward
• 57 electronic sensors to survey the terrain
• Three built-in computers that make decisions 16 times per second

DESIGNERS: Staff engineers, Dyson Limited, Malmesbury, Great Britain

MANUFACTURER: Dyson Limited, Malmesbury

The vacuum cleaner glides around a room in a logical manner, not in helter-skelter or zig-zag paths. (The path of the "DC06" is indicated in the image by black geometric lines.)

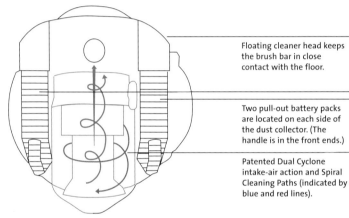

Floating cleaner head keeps the brush bar in close contact with the floor.

Two pull-out battery packs are located on each side of the dust collector. (The handle is in the front ends.)

Patented Dual Cyclone intake-air action and Spiral Cleaning Paths (indicated by blue and red lines).

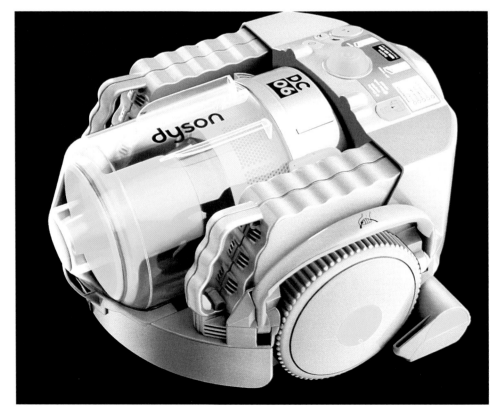

TELEPHONES AND COMPONENTS

"CHATBOARD™" TELEPHONE KEYBOARD

When attached to any one of 13 mobile-phone models, the Ericsson keyboard eliminates the use of the small keys found on all mobile phones. Claiming to answer the demands of what the firm calls "Generation Y," or young users, the "Chatboard" was introduced in Hong Kong in 1999. The attachment—as well as an extensive range of MP3, earphones, and other devices—is part of a campaign by Ericsson, a 125-year-old firm, to retain its position as the world's leading supplier of telecommunicators.

FEATURES:
• Function keys for SMS (short message service), e-mail sending/receiving, Internet accessibility, attachments, and a phone book
• Compatibility with 13 Ericsson mobile-phone models
• Personal e-mail address provided through the Chatboard Web site
• Standard QWERTY keyboard configuration with shift characters to serve international alphabets

DESIGNERS: Staff designers, Telefonaktiebolaget L. M. Ericsson, Stockholm, Sweden
MANUFACTURER: Telefonaktiebolaget L. M. Ericsson, Stockholm

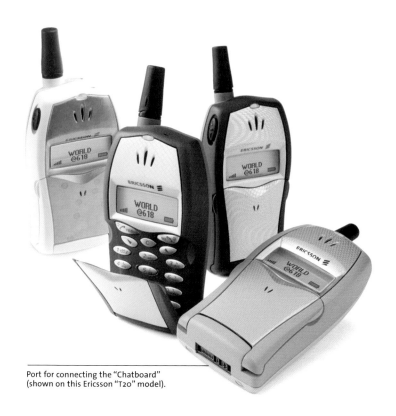

Port for connecting the "Chatboard" (shown on this Ericsson "T20" model).

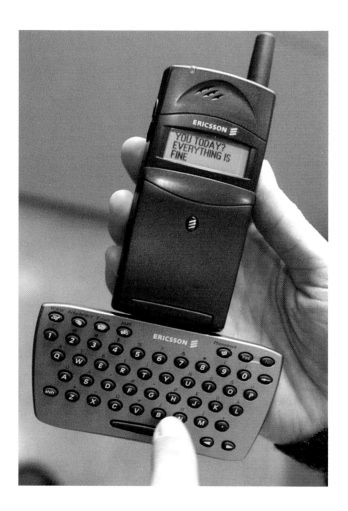

The Chatboard snaps on the bottom of "A2628s," "A2628sc," "T20sc," "T28z," "A2618s," "A2618sc," "R310s," "R310sc," "T28sc," "R320s," "R320sc," "T28 WORLD," and "T20s" Ericsson mobile phones.

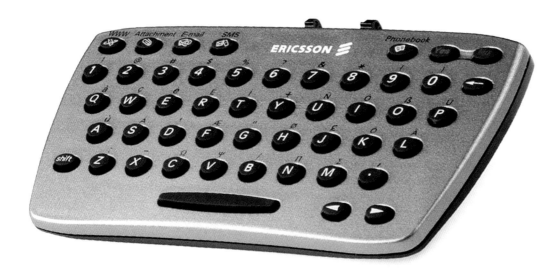

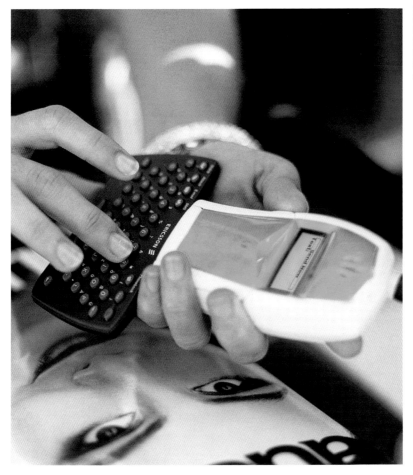

Ericsson "T20" features WAP mobile chat technology for access to news, chatting, e-mail, information searches, retrieval, e-commerce, a calendar, maps, and position-based services. And the Swatch® Internet-time program divides the day into 1000 beats, eliminating all time zones, showing the same time everywhere, with the day beginning at "000" and ending at "999."

"BEOTALK 1200" TELEPHONE

The "BeoTalk 1200" is a smart telephone answering machine, designed in 1999, which combines a number of sophisticated features in a stylish case. Its most notable attribute may be the ability to respond to certain, specified incoming phone calls with one of three different custom-recorded messages.

FEATURES:
- Settings of incoming ringing times from one to 99 seconds
- Automatic deletion of the oldest messages to make room for up to 50 others
- Call rejection while providing a busy signal to the caller
- Total message speech time up to 15 minutes
- Identification of the incoming number with one of three custom messages
- Remote controller
- Digital functionality, eliminating tapes and moving parts
- Only three visible frequently used buttons, when the operation panel lid is down
- Tabletop or wall placement
- Time and date indicator
- Dimensions 185 x 36 x 131 mm
- Weight: 500 g

DESIGNER: Henrik Sörig Thomsen, Århus, Jutland, Denmark
MANUFACTURER: Bang & Olufsen, Copenhagen

Brushed aluminum surface.

The receiver is placed behind the fascia when not in use.

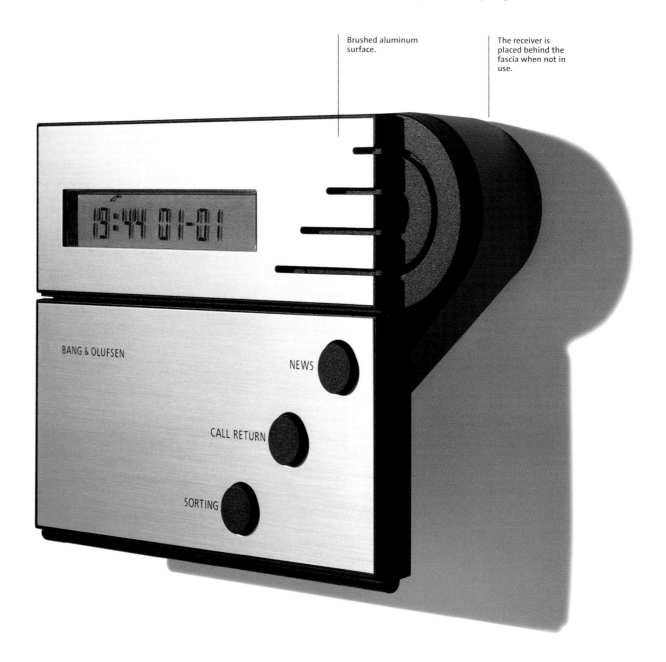

NEWS

CALL RETURN

SORTING

BANG & OLUFSEN

"ESC!" GSM-GPS PHONE

Whether in the city or in a remote locale, the GPS and maps of this navigational phone wirelessly guide its users—inside or outside the GSM range—to their destinations or out of harm's way. (See also the Casio GPS wristwatch on page 107 and the Rand McNally GPS hand-held device on pages 122–123.)

FEATURES:

• GPS dual-band technology that resumes connection as soon as possible and can be equipped with an optional high-gain cross-country antenna
• Water and shock resistance
• Reinforced stainless-steel case, protected with an elastomeric plastic
• Small and lightweight

• EFR (enhanced full rate) for optimal voice quality and up to ten days of standby operating time on rechargeable, lightweight lithium-ion batteries (from 6- to 10-hr talk time depending on the battery type)
• Friend Finder that tracks other users of "Esc!s" on a map or guides them to the searcher's location
• Access to e-mails and Web sites via a PC with a built-in 14.4 KB per second GSM data and fax modem
• Predictive T9-text input for fast and easy text messages and notes
• Connection to Arbonaut® mobile map service for easy downloads of maps from Geodata and other suppliers via any PC or Web browser
• Dimensions: 129 x 49 x 23 mm
• Weight: 150 g

MANUFACTURER: Benefon Oyj, Salo, Finland

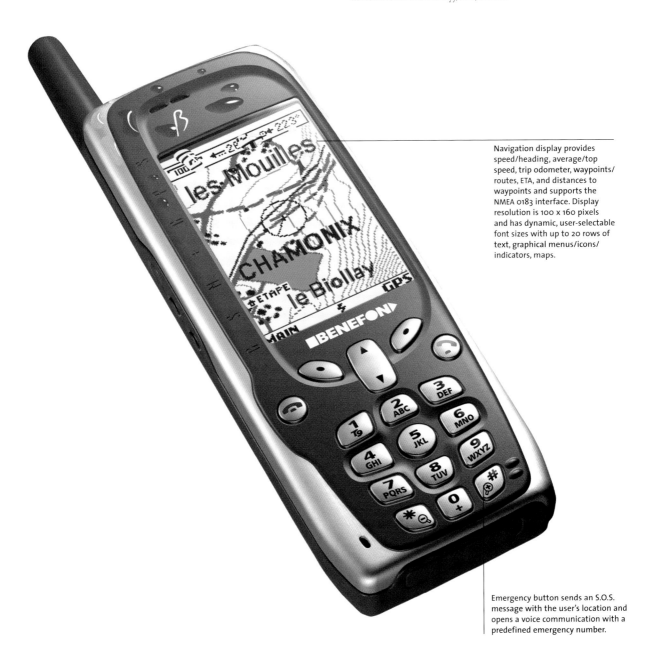

Navigation display provides speed/heading, average/top speed, trip odometer, waypoints/routes, ETA, and distances to waypoints and supports the NMEA 0183 interface. Display resolution is 100 x 160 pixels and has dynamic, user-selectable font sizes with up to 20 rows of text, graphical menus/icons/indicators, maps.

Emergency button sends an S.O.S. message with the user's location and opens a voice communication with a predefined emergency number.

"BLUETOOTH HBH-10" HEADSET TELEPHONE

The "HBH-10" headset telephone was the first Bluetooth device produced by Ericsson, the company that developed the technology. The wireless system became part of SIG (the Bluetooth Special Interest Group), a consortium of 1,700 companies that free share the technology. The "HBH-10" can be worn up to 10 m from a Bluetooth adapter on an Ericsson mobile telephone. According to the research of ABI (Allied Business Intelligence), 65% of mobile handsets shipped in 2002 will be equipped with Bluetooth nodes.

FEATURES:
• Compatible with "A2618s," "R310s," "T20s," "T28s WORLD," "T28s," and "R320s" Ericsson telephone models
• Bluetooth—radio link attached to a telephone for a 10 m or shorter distance to an Ericsson telephone
• Phone numbers dialed via voice activation and headset push button, or phone push button
• Weight: 30 g

DESIGNER: Staff designers, Telefonaktiebolaget L. M. Ericsson, Stockholm, Sweden
MANUFACTURER: Telefonaktiebolaget L. M. Ericsson, Stockholm

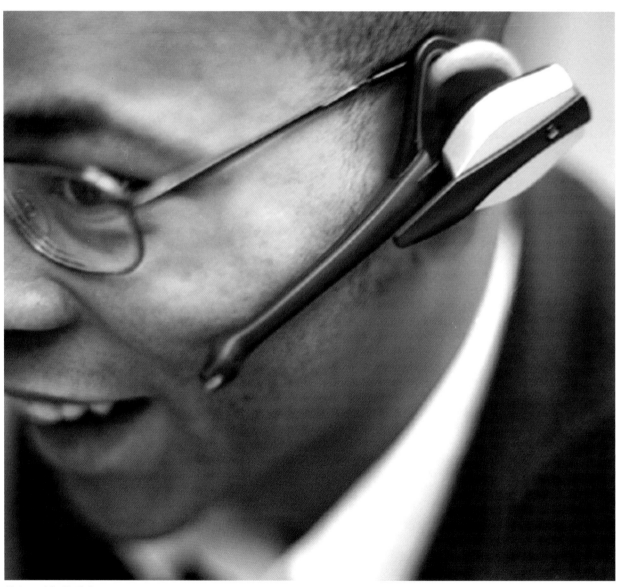

Photograph by Martin Bogren

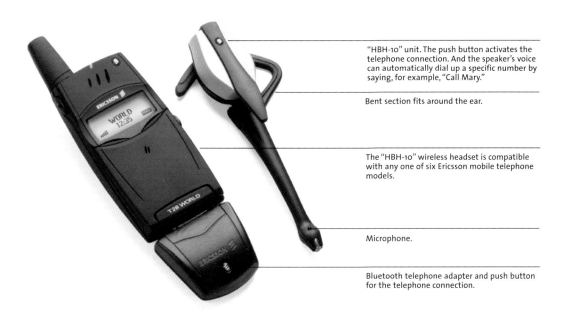

"HBH-10" unit. The push button activates the telephone connection. And the speaker's voice can automatically dial up a specific number by saying, for example, "Call Mary."

Bent section fits around the ear.

The "HBH-10" wireless headset is compatible with any one of six Ericsson mobile telephone models.

Microphone.

Bluetooth telephone adapter and push button for the telephone connection.

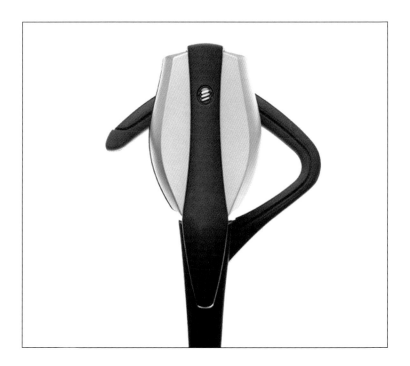

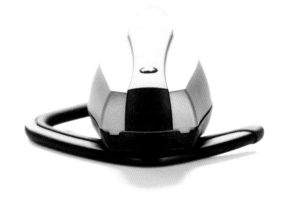

"ONE TOUCH™ 700/701" MOBILE TELEPHONE

Alcatel is the fifth largest mobile-telephone manufacturer in the world and the third largest in Europe. It sells one of its GSM-type telephones, in the "One Touch" range, every two seconds. They, like the top-of-the-line "700/701" model shown here, include some of the industry's most advanced features such as interactive, personalized WAP (wireless) technology.

FEATURES:
- Voice memo and voice recognition
- Built-in vibrating alert in addition to the ringing alert
- Personal agendum and multi-field directory that includes one-touch storage of addresses, phones numbers, and e-mail addresses
- New user-to-machine technology with graphic animation, menu icons, and adaptive fonts
- Hands-free speaker

- Large display screen
- Upgradable memory
- Two digital clocks
- SATK Class 3 release 98
- WAP 1.1 program
- Colors: moon white, shark grey, navy blue, aqua grey
- Dimensions: 103 x 42 x 20 mm
- Weight: 88 g (volume: 82 cc)

DESIGNER: Olivier Beune, Provin, France
MANUFACTURER: Alcatel Business Systems, Colombes, France
Photography copyright © Thomas Duval

Voice-function activation button for voice memos and voice dialing, at the side of the unit.

Large LED display screen, up to eight lines of text and images.

Delete button.

DriveKey™ for direct access to the menu operates in five directions: up, down, left, right, and press.

On/off button and red LED indicator.

Redial (memory) button and green LED indicator.

When the flip-cover is opened for access to the keypad, the unit is automatically activated.

Antenna and inner wiring.

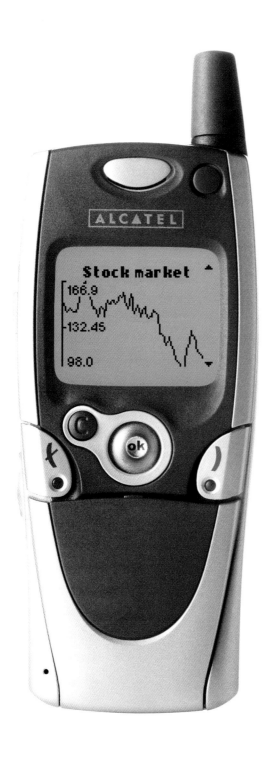
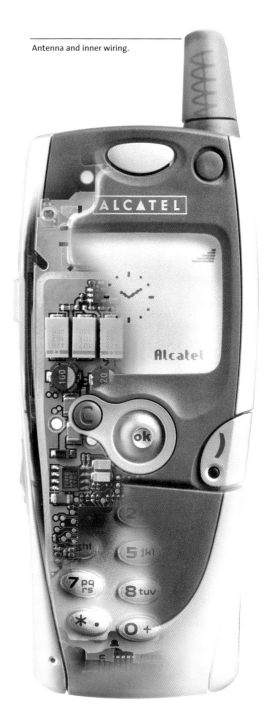

The "700/701" mobile communicator and organizer with its flip-cover closed to cover the key pad (left) and a view of its circuitry (right).

COMMUNICATION-DEVICE CONCEPTS SPONSORED BY ALCATEL

In order to remain in the forefront of design and technology, Alcatel works with young designers because they are best connected to what-might-become trends and advanced thinking. The managers of Alcatel know that design students are the next wave of professional designers and solve problems with surprising freshness, no matter how naïve and raw. Alcatel's managers regularly invite a group of students from a range of schools worldwide to present their ideas for the design of communication devices, not just of telephones. This is an effort to encourage thought—rather than practical solutions—free of the doctrinaire considerations that may constrain Alcatel's practising designers.

FEATURES:
• Participating students from Shih Chien University, Taipei, Taiwan; École Nationale Supérieur de Création Industrielle (a.k.a. Les Ateliers), Paris, France; The Hong Kong Polytechnic University, School of Design, Hong Kong, China; Escola Superior de Disseny Elisava, Barcelona, Spain
• Results of an active program of Alcatel's working with schools
• Pedagogical fees paid to the schools but not to individual students
• Solid technological knowledge that is shared with the students by Alcatel's professionals
• Valuable insights into the future of design imparted to Alcatel's professionals by the students
• A continuing free and open exchange between students and professional designers after the completion of the project
• Only students' first names are published
• Presentations of the student projects at major technological fairs

DESIGNERS: First names listed with captions here; abbreviations indicate "SCU" for Shih Chien University, "LA" for Les Ateliers, "HKPU" for The Hong Kong Polytechnic University, and "ESDE" for Escola Superior de Disseny Elisava.
MANUFACTURER: Prototypes by Alcatel Business Systems, Colombes, France

ELISA (ESDE): This Internet telephone placard, to be worn around the neck, was designed to be foolproof and simple.

MIREA AND YLENIA (ESDE): Attached to the wrist, this device offers information access, telephone communication, and a wide range of other features.

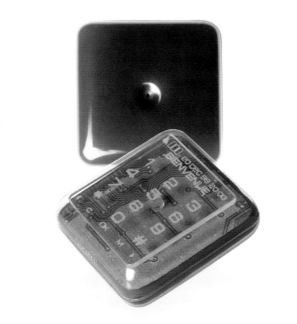

CHIARA (LA): The squishy cushioning on this communicator is a soft, pleasant-to-the-touch silicone layer.

ADRIANA AND PEPA (ESDE): Like a snake, this bracelet-phone offers wireless communication and information acquisition, including picture-phone reception.

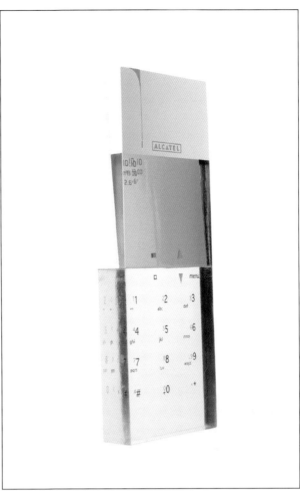

FRÉDÉRIC (LA): For the narcissist, a mirrored screen facilitates self-admiration, and a holographic keypad offers the effect of immateriality.

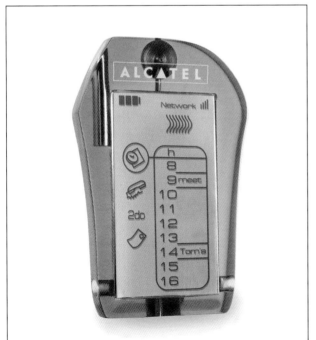

DAMIEN (LA): Shock-resistant and waterproof, this transparent unit is tough and small but features a large screen.

WAI KA (HKPU): This hat-communicator offers hearing and talking through the speakers and microphones built into the underside of the brim, and visual navigation via the see-through visor incorporated into the front of the brim.

CONTINUED ▶

COMMUNICATION-DEVICE CONCEPTS
SPONSORED BY ALCATEL
(CONTINUED)

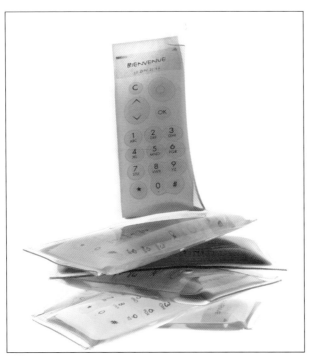

LOUISE (LA): A one-piece mobile phone with a deliberately limited life is suspended in a gel and intended for communication on emotional occasions like New Year's Day, Valentine's Day, and birthdays.

MANUELLE (LA): This relay communicator (like the wand in relay running) and Internet-access device is intended for group use. Equipped with a lengthwise charger, the screen is horizontal.

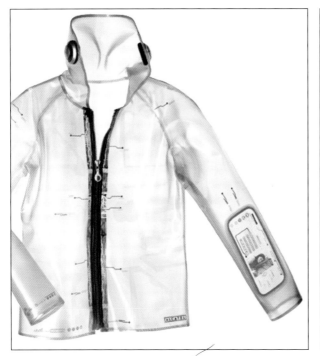

KWOK HO (HKPU): The see-through plastic jacket keeps its wearer-on-the-go in touch. The communicator—the version here for a right-handed wearer—is built into the sleeve for easy push-button access.

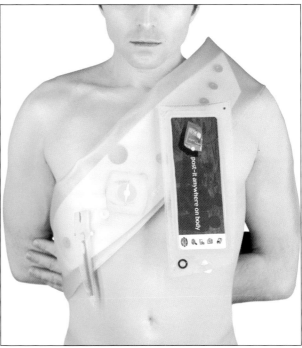

YU MAY (SCU): This mobile telephone as a fashion statement features a textile and a flexible screen that form a fabric swag. The ensemble can be worn as a headscarf, waistband, cummerbund, ear piece, or muff.

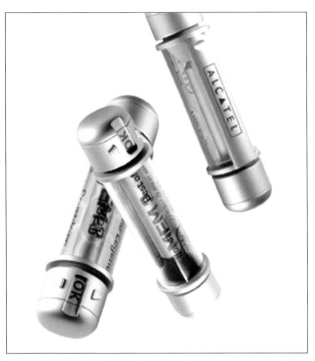

LUIS AND RICARD (ESDE): Packaged like a cosmetics accessory, the capsule-like communicator is easily transported in a pocket or purse.

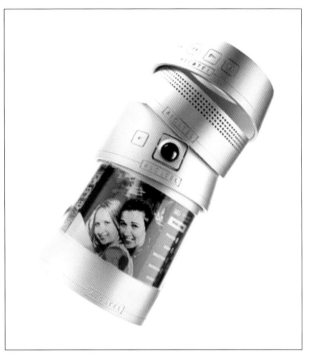

MILLY (HKPU): Bangle bracelets and technology are married in these wireless, full-system, communication-image devices that serve as fashion accessories.

YUNG (SCU): This portable music studio, mixing suite, and reverberator with ear-muff-like wireless headphones download MP3 music, remix, rebalance with a personal FX selector, and can send the results to friends.

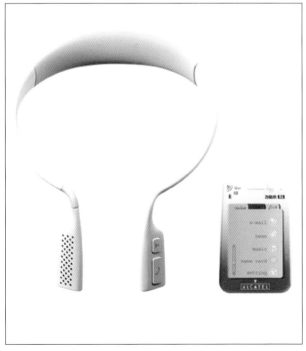

LINUS (HKPU): The neck yoke features a soft neck-rest and flexible-neck speaker/mike, facilitating hands-free talking while walking. The yoke wirelessly interfaces with the hand-held communicator unit.

SMARTPHONE CONCEPT

The smartphone here is one of a number of new telephones and other communication devices developed by Ericsson as part of its "Future/ Concepts" program. This desk phone features a large touch screen for browsing the Web, conducting video conferences, and using GPS applications. Designed for use in a home or office, the unit includes a speakerphone to support the hi-fi music player. The base station is compatible with DECT. (DECT, like GSM, is a wireless network supported by WAP which is a specification that allows instant access to information via a hand-held wireless device.)

FEATURES:
• Larger-than-traditional touch screen
• MP3 music player
• Base station for DECT
• High-quality speaker
• Easy to use

DESIGNERS: Staff designers, Telefonaktiebolaget L. M. Ericsson, Stockholm, Sweden
MANUFACTURER: Telefonaktiebolaget L. M. Ericsson, Stockholm

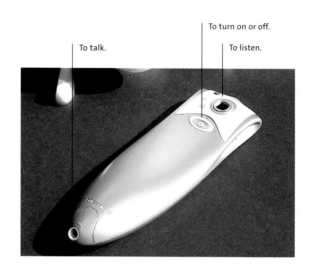

To talk.

To turn on or off.

To listen.

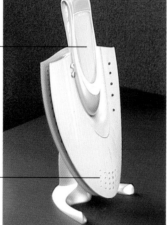

Display screen is usable whether or not the phone unit is in the cradle.

Large speaker for MP3-acquired music playing.

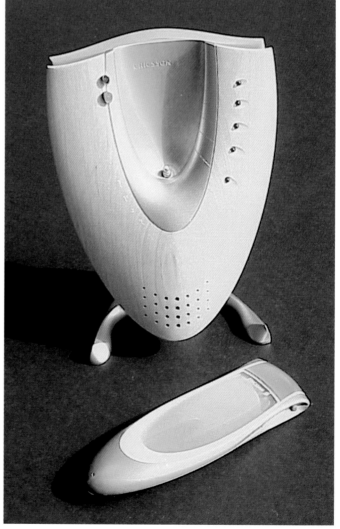

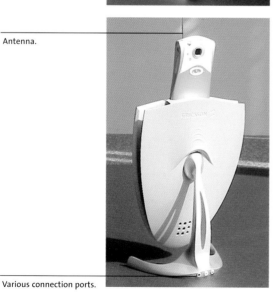

Antenna.

Various connection ports.

"POLYCOM 45" TELECONFERENCING UNIT

The "Polycom 45," as its name implies, was created for intra-office conference communications. It is easy to operate. In addition to normal telephone conferencing, a user simply places an Internet call and dials up the server to connect. Based on extensive research by the design firm, the "Polycom 45" exploits the valuable features of Internet-phone capabilities while eliminating unnecessary ones like speed dialing.

FEATURES:
• Central hub with primary controls and an additional unit with more listening and talking features
• Satellite units that are attached to the central hub
• Portable and easy to set up
• Both regular telephone and Internet conferencing capabilities
• Good sound quality and the elimination of near-speaker microphones that interfere with sound reception
• Conference-calling features and design
• Improved feedback to affirm basic input instructions
• Simple configuration of the input button

DESIGNER: Ziba Design, Portland, Oregon, USA
MANUFACTURER: Polycom, San Jose, California, USA

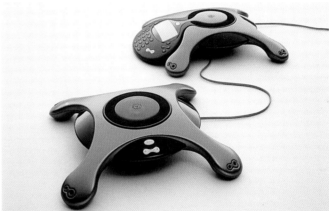

For use in large conference rooms, the listening and talking capability of the central hub (with a control pad, below) can be augmented by a compatible unit (top). Construction of both devices: ABS, polycarbonate, urethane, rubber, and metal mesh.

Back-lit dome signals on or off activity.

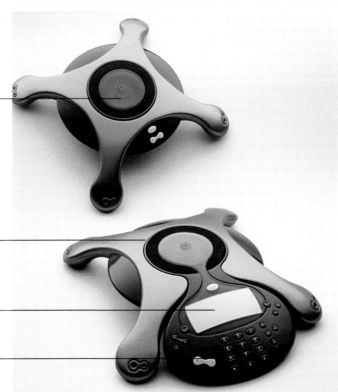

Sound quality is maximized by a centrally placed speaker (surrounded by 95% open area and covered by wire mesh) that redirects the sound to the participants in a room.

LED graphic display.

Controls designed specially for conference calling.

"CORDLESS III" TELEPHONE

This telephone was designed for the home or office but no doubt it will be more frequently found in the former. Swatch's "Cordless III" phone, introduced in 2001 and available in three versions, is true to the company's light-hearted approach to design. Considering the quantity and sophistication of the features, the unit is surprisingly compact; however, it is available only in Austria, Germany, Italy, and Switzerland.

FEATURES OF "CORDLESS III" STANDARD VERSION:
- Up to 80 hours of standby time or seven hours of talk time
- Phone book for 20 entries
- Caller ID (CLIP/CLIR)*
- Redialing of last five numbers
- Charge metering and call-duration display*
- Programmable prefixed number*
- Digital voice-quality and confidentiality (DECT)
- Up to 300 m range outdoors; 50 m range indoors
- Colors: blueberry blue and apelsin orange

FEATURES OF "CORDLESS III" COMFORT VERSION:
- Hands-free talking facility
- Voice-activated dialing
- Phone book with up to 150 numbers/names
- Menu-guided operation in six languages for all functions (Dutch, English, French, German, Italian, Turkish)
- Caller ID (CLIP/CLIR)*
- Backlit four-line graphic display
- Up to 150 hours standby or up to 15 hours continuous talk time
- "Babyphone" (or optional second handset) function
- Colors: blueberry blue and buttercup yellow

FEATURES OF "CORDLESS III" WITH ANSWERING MACHINE:
- Integrated digital answering machine
- Message listening with the handset or from the base station
- Hands-free talking facility and open listening
- Voice-activated dialing
- Phone book with up to 150 names with numbers
- Menu-guided operation in six languages for all functions
- Caller ID (CLIP/CLIR)*
- Backlit four-line graphic display
- "Babyphone" function
- Colors: blueberry blue and emeraldiño green

(* Features that may not be available in all countries.)

DESIGNER: Staff designers, Swatch®, a company of the Swatch Group, Biel, Switzerland
MANUFACTURER: Swatch®, Biel

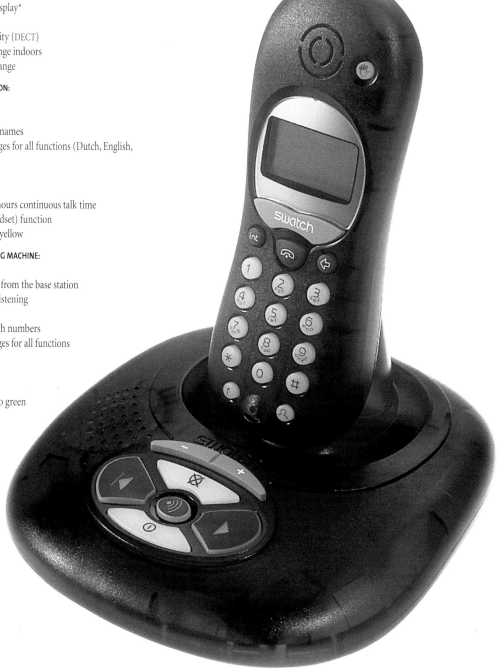

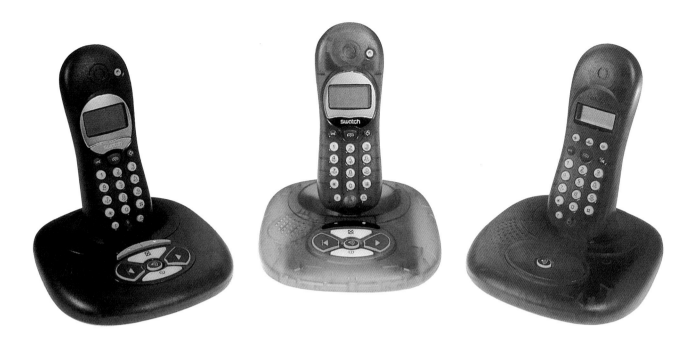

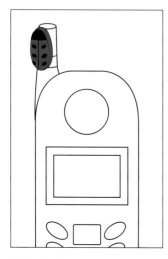

"ZEROPA®" RADIATION-LIMITING DEVICE

There has been much discussion concerning claims that certain electronic waves or impulses emitted by mobile phones can cause harm to the users. Some scientific organizations have conducted tests with mixed results. However, the claims do not concern whether SAR (specific absorption rate) occurs in humans but rather if the absorption is adverse to health. Nevertheless, the "Zeropa" or tiny ladybug-like ceramic piece was developed to diminish the absorption or the transference of mobile-phone electromagnetic waves, such as microwaves. The motif of the "Zeropa" purportedly represents a ladybug, the insect that kills other harmful insects, or, as here, harmful radiation.

FEATURES:
• Shaped for best effect
• Laboratory-tested, patented special ceramic compound
• According to the manufacturer, reduction of mobile-phone electromagnetic waves from 2.3 mW per g to 1.37 mW per g (lower than 1.6 mW per g recommended by the US Federal Communications Commission)
• According to the manufacturer, reduction of mobile-phone-induced headaches, giddiness, fatigue, and hot flashes
• Colors: white and black, red and black, yellow and black
• Dimensions: 10 x 20 mm

INVENTORS OF THE CERAMIC COMPOSITION AND MANUFACTURING METHOD:
Sung-Yong Hong, Seoul, Republic of Korea; and Chang-Ho Ra, Buchon-Shi, Kyeongki-Do, Republic of Korea
MANUFACTURER: Britannia Health Products Limited, Sevenoaks, Kent, United Kingdom

The peel-off self-adhesive strip allows the "Zeropa" to be adhered to a mobile phone, preferably on the top portion or on the antenna.

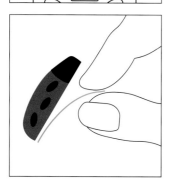

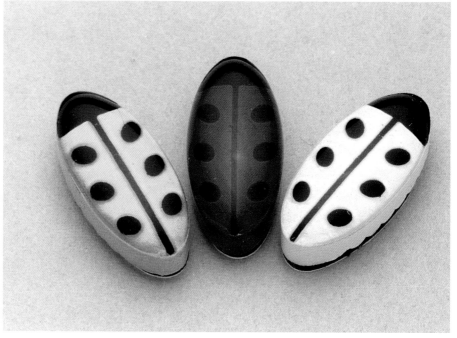

TELEVISIONS AND COMPONENTS

"WYSIUS SPL 2000"
HOME ENTERTAINMENT SYSTEM

Thomson's "Wysius SPL 2000" system, designed in the year 2000, includes the thinnest wall-mounted TV monitor available. In addition to the "Navilight" remote controller, other components make the playing of videos, DVD recordings, and TV programs possible through a sophisticated amplifier and high-design speakers.

FEATURES:
• 42 inch-diagonal plasma TV screen with 30% brighter picture and improved luminosity for better color definition
• 16-times zoom capability for viewing part of a screen image
• 89-mm-thick wall-hanging TV monitor, weighing 33 Kg
• Silver and translucent design
• Silent fan that eliminates background noise
• Home-cinema experience
• Digital VCR player with camcorder connectivity, editing facilities, and old-tape readability
• DVD player that offers high-picture and good-sound definition
• 500-watt RMS amplifier with DTS decoder, Dolby Digital 5.1, Dolby Pro Logic, and Dolby 3 stereo, radio tuner, six DSP modes to simulate various acoustic environments
• Five-unit wall, stand, or shelf-mounted speaker configuration

DESIGNERS: Tim Thom design department, Boulogne, France
MANUFACTURER: Thomson multimedia, Boulogne

NAVILIGHT SYSTEM
Universal 4-in-1 remote controller features back lighting for use in the dark. It controls all advanced functions and program setting of the "Wysius" components—amplifier, VCR, satellite decoder, and DVD reader—and is compatible with a range of other equipment.

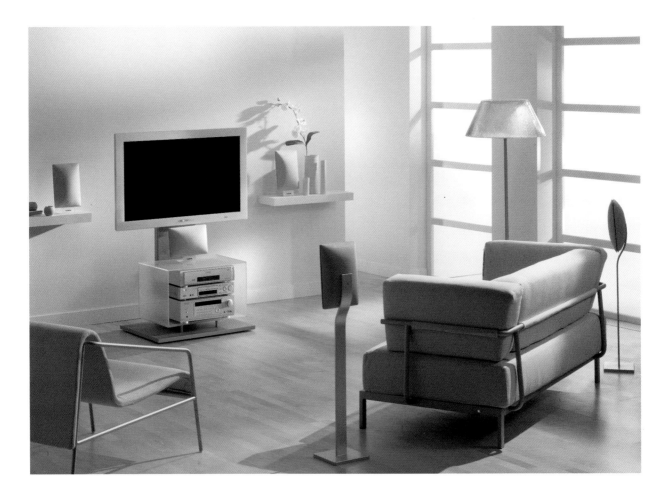

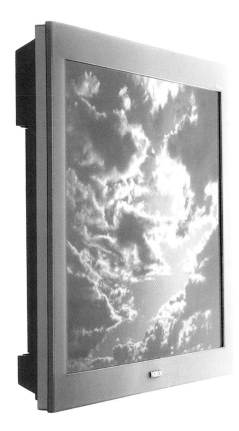

├─ 89 mm ─┤

"WYSIUS" 3RD-GENERATION SCREEN
Thomson's plasma screen is the thinnest ever designed, at 89 mm thick, in contrast to traditional monitors of the same screen size that measure 800 mm deep and weigh much more. The screen features a 16:9 wide ratio, 42 inch diagonal size, flicker-free projection, and black-matrix process. A 300-micron-thick layer of phosphors is deposited on the inner surface of the screen glass.

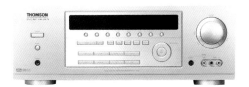

AMPLIFIER/TUNER "DPL 2000"
Offers easy connection to all types of audio/video equipment (TV, VCR, DVD, satellite decoder, plasma screen) and a DTS decoder. Features Dolby Digital 5.1, Dolby Pro Logic, Dolby 3 stereo with automatic format detection, 500 watt RMS power.

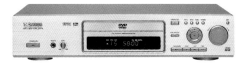

DVD "DTH 4500"
Reads DVD videos, CD videos, audio CDs, most recordable audio CD-R and CD-RW audio, and music compressed in MP3 format. Features built-in double digital 5.1 channel audio decoder (Dolby Digital and MPEG-2 audio), fast-forward play, and digital zoom (2x or 4x) and is compatible with the 5.1 channel Digital Theatre Sound System.

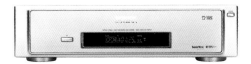

VCR "DVHS"
Is based on MPEG-2 decoder and encoder and records 7 to 21 hr on one tape. Is compatible with VHS and SVHS analogue formats and reads old tapes. Optimizes, due to real-time digitalization, and removes imperfections. Features front ports that facilitate digital DV camcorder connection.

SIX LOUDSPEAKERS "SPL 2000"
Offer superior sound quality. Installation is furnished in modules. Four speakers (shown below on each side) can be suspended, mounted, or placed on supplied stands.

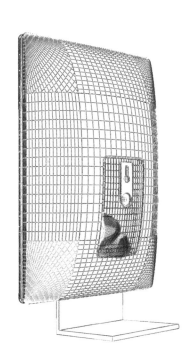

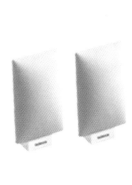

"LC-28HD1" 711 MM FLAT-SCREEN TELEVISION

A top view of Sharp's "LC-28HD1" television monitor (facing page) dramatically illustrates its slim, 152 mm depth which incorporates side-placed speakers. This is the first 711 mm LCD television that is compatible with digital HDTV broadcasts. It also features the largest LCD screen available—and equivalent to a 30-inch CRT television. Both the image contrast and brightness are the industry's high at a resolution of 1280 dots x RGB x 768 lines and a luminance of 450 cd/sq m. The unit is capable of interfacing with the components of an audio/video system as well as with a personal computer.

FEATURES:

• Flat 711-mm-diagonal screen
• 160° horizontal and vertical viewing angles with high luminance and contrast
• Built-in stereo speakers
• Multi-system compatible; AC adaptor; remote controller
• CPU connection by a D-sub 15 terminal
• Modular design that allows for flexibility, depending on the applications
• Separation of the display panel from the audio/visual center which makes it possible to closely wall hang the monitor without messy wires
• 152-mm-deep monitor
• Aluminum case and base
• Low electrical consumption
• Bose 2 x 12.5 watt stereo system
• Dimensions: 691 x 448 x 152 mm (without the base)
• Weight: 10.3 Kg

DESIGNER: Toshiyuki Kita, Osaka, Japan
MANUFACTURER: Sharp Corporation, Tokyo, Japan, in collaboration with Bose/Kabushiki Kaisha

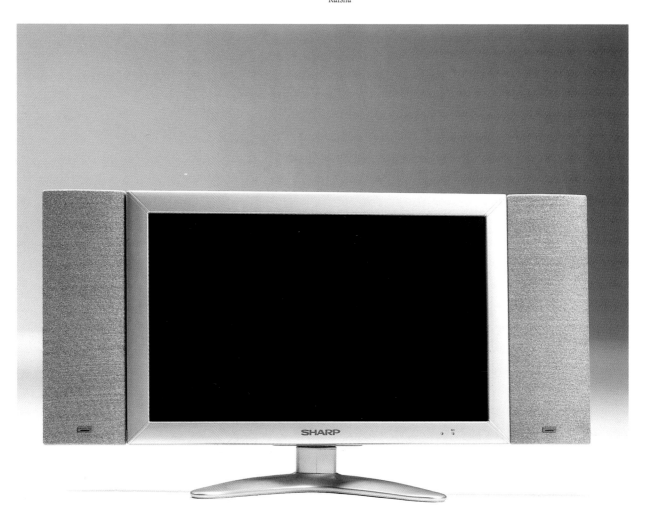

Aluminum case (front and back) of the 152-mm-deep screen, excluding the aluminum "boomerang" stand.

Located on the rear side, controls and connectors to other media systems, or a personal computer via a D-sub 15 terminal.

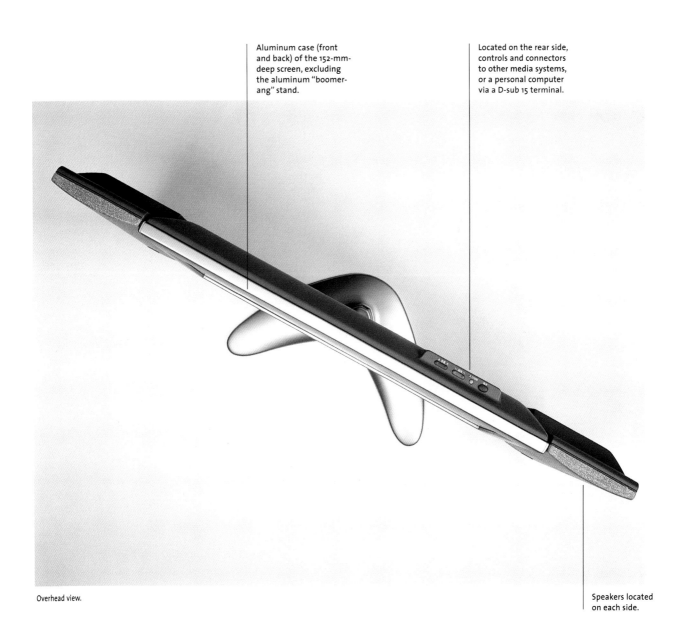

Overhead view.

Speakers located on each side.

"LC-15A2U" AND "LC-20A2U" FLAT-SCREEN LED TELEVISIONS

Sharp's LED television screens are exceptionally clear and bright and can be viewed from oblique side angles. And, as the images below illustrate, they are very thin—for example, the "LC-15A2U" model is 45 mm thick. Even though 254 and 305 mm versions are offered, only the 380 and 504 mm examples are shown here.

COMMON FEATURES OF THE LCD-SCREEN MODELS:
• Wide viewing angles
• High brightness
• Built-in 181-channel tuner
• 9,000 kelvin color temperature
• Sleep timer
• Optional wall-mounting brackets

FEATURES OF "LC-15A2U":
• 380 mm diagonally measured screen area
• 60,000 hr lamp life
• 2.5 watt stereo amplifier with three speakers

• V-chip technology for limiting child access
• Color: silver finish
• Dimensions: 359 x 311 x 45 (screen depth) mm
• Weight: 4.7 Kg

FEATURES OF "LC-20A2U":
• 504 mm diagonally measured screen area
• 360 cd/sq m brightness
• 240:1 contrast ratio
• 40,000-hr lamp life
• 3D digital comb filter
• V-chip technology
• Speaker-grille covers, sets of 3 different colors
• Color: silver finish
• Dimensions: 710 x 404 x 48 (screen depth) mm
• Weight: 10.4 Kg

MANUFACTURER: Sharp Electronics Corporation, Tokyo, Japan

Screen thickness of the "LC-15A2U": 45 mm.

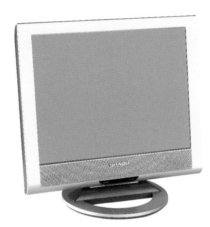

Screen thickness of the "LC-20A2U": 48 mm.

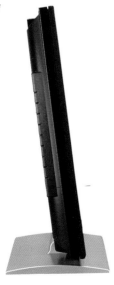

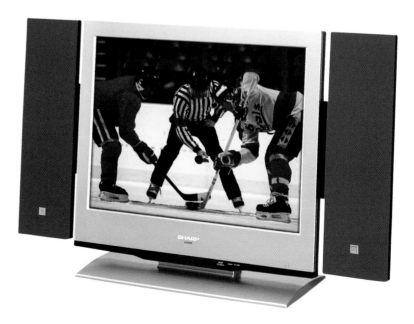

"HANDKERCHIEF" TELEVISION

The "Handkerchief" television, while more substantial than a handkerchief, is a folded-leather unit that is augmented by the benefits of flat-screen technology. That this pocket-size TV unit—one of the products in the designer's Soft Series—was designed in 1990 is testament to the designer's foresight.

FEATURES:
• Wallet-like folding case and polycarbonate TV housing
• Color television screen
• Antenna
• Battery-pack-and-speaker unit
• External ports

DESIGNER: Emilio Ambasz, New York, New York, USA
MANUFACTURER: Sharp Corporation, Tokyo, Japan, with Brionvega, Italy

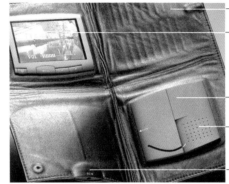

Black full-grain leather.

Miniaturized color flat-screen TV.

Battery pack.

Speaker.

External ports.

Injection-molded polycarbonate TV, battery-pack, and speaker cases.

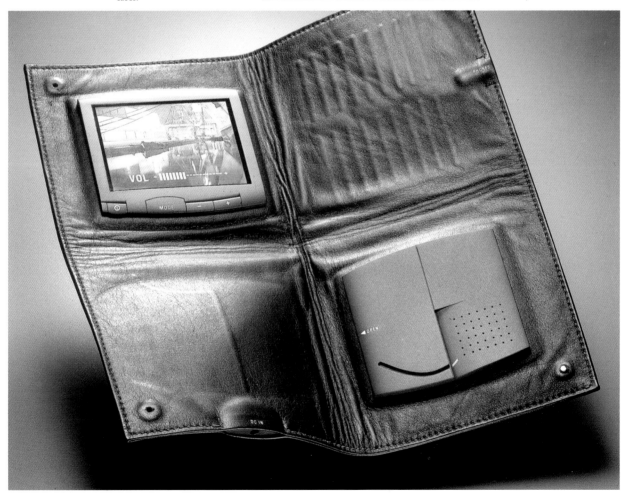

"TV55"
TELEVISION ANTENNA

HDTV (high-definition television) transmission is not delivered by cable. Instead, a special antenna is required, and it can be, at the least, problematic. This antenna has been optimized for high-definition television reception and provides clear, powerful reception. It can be installed inside or outside a building. The helical-coiled reception element makes the compact, sleek profile possible while providing the power of a larger antenna. The adjunct amplifier (not shown) calibrates the requirements of HDTV reception.

FEATURES:
- Installation indoors or out
- Durable construction and materials
- Slim profile that permits installation under the eaves of a roof, on a window sill, in other narrow spaces, or almost any place—inside or outside, even on the roof of an automobile or in an attic or closet
- Broadband helical characteristics
- Reception of VHS and VHF frequencies, even low ones
- Adjunct Dual-Mode™ ultra-low noise amplifier that offers a choice of test-gain settings for maximum reception
- Direct connection of the amplifier to the antenna for the shortest signal path and, thus, lowest noise
- High-gain setting mode for very weak signal reception
- Connection of a threaded F-connector to the RG6 cable for the assurance of high-quality signal transmission

OTHER FEATURES:
- Element type: helical, coiled broadband single element
- Operational band width: 54–806 MHz
- Amplifier gain: 10 dB (utilizing patented Terk technology)
- Power supply: 12 volts DC, 100 Ma, U.L. tested
- Output gain: 75 ohms
- Weather resistance: silicone sealant
- Accessories, including mounting hardware and cables
- Dimensions: 1169 x 89 x 57 mm

DESIGNERS: Industrial-design team, Terk Technologies Corporation, Commack, New York, USA
MANUFACTURER: Terk Technologies Corporation, Commack

Weatherproof hermetic-sealed silicone coating.

High-quality polyvinyl chloride case.

"TRK-S2" AND "TRK-S22" SATELLITE DISH ANTENNAE AND "VS-4" VIDEO SELECTOR

These dishes were developed specifically for the reception of signals through a receiver unit from DIRECTV, the leading satellite-television broadcaster in the US. For a fee, DIRECTV provides access to hundreds of channels with digital-quality picture and sound. There are others throughout the world that offer similar services. Terk's "TRK-S2" features one dual-output LNB, and the "TRK-S22" two dual-output LNBs. (LNB is a technology for receiving certain bandwidth signals from satellites.) The "VS-4" video selector minimizes the wiring and makes it possible to connect up to four different receivers, depending on the antenna. This also makes it possible for more than one person to watch television on different sets; play video games or video or DVD tapes; or use a camcorder.

FEATURES OF THE "TRK-S2":
• One dual-output LNB to allow a connection to two receivers
• Easy installation
• Resistance of severe weather, 50–75 mile per hr winds, and rust

FEATURES OF THE "TRK-S22":
• Two dual-output LNBs to allow a connection to four receivers
• Digital-quality picture and sound

MANUFACTURERS: Various, including Hughes Network Systems, Thomson Consumer Electronics (RCA), and Sony under DIRECTV license

FEATURES OF THE "VS-4" VIDEO SELECTOR:
• Simultaneous connection and separate operation of up to four audio and/or video components and a set of powered speakers, not only the satellite dishes
• RCA and S-video ports and always-open mini-jacks for multimedia speakers
• Four sets of gold-plated audio/video jacks

DESIGNERS: Industrial-design team, Terk Technologies Corporation, Commack, New York, USA
MANUFACTURER: Terk Technologies Corporation, Commack

The "VS-4" selector has four switches with four LED "on" indicators above, for four separate audio-video components.

Line-level output.

"TV SERVER"

The profile of this television, recorder, and editing unit is aggressive and unorthodox. The technological features of the "TV Server"—one of the products produced by the young company Fast Multimedia—are as unusual as the aesthetics of the housing.

FEATURES:

• Server that makes digital-quality video recordings without cassettes—from the Internet or directly from television broadcasts
• Two independent channels that can be received simultaneously
• Delayed replay of live-time broadcasts
• Viewers allowed to edit their own programs
• Circular air intake and outlet vent
• Casing in an anthracite-colored plastic material
• Vertical or horizontal placement
• 90° swiveling mini-screen
• Removable base

DESIGNERS: designafairs, Munich, Germany
MANUFACTURER: Fast Multimedia, Munich

Photography by Studio Köller, Munich

CAMERAS AND PHOTOGRAPHY

"WQV1D-8CR"
DIGITAL WRIST CAMERA

An innovator in miniaturized wearable electronic gear, Casio introduced the first wrist-type digital camera. The "WQV1D-8CR" takes still pictures that can be transferred via e-mail to friends and family. Up to 100 images can be stored in the watch's 1 MB of built-in semiconductor memory. You can take a picture, look at it, and then decide to keep it or not—as many times as you wish. The auto-date stamp feature automatically records the minute, hour, day, month, and year along with the image.

FEATURES:
- Built-in 1 MB memory
- Memory capacity: 100-image memory
- Recording element: 1/14 inch monochrome sensor
- 28,000 total pixels (24,334 pixel yield)
- Light metering system, full-screen average, ALC (average luminance control) with exposure compensation
- Auto-date stamp: up to 24 characters
- Image data exchange with a computer or other Wrist Camera
- Three recording modes: "normal" for a 16-grayscale monochromatic image, "art" for two-tone images, and "merge" for two different images into a single image
- Infrared-data-transfer unit attaches to a CPU but not to the watch—for wireless exchange of image data up to 100 mm distance between the watch and the transfer unit
- 115,200 bytes/sec. data speed
- Dimensions: 20 x 52 x 16 mm (case), 20 x 20 mm display face
- Weight: 32 g

DESIGNERS: Staff designers, Casio Computer Co., Ltd, Tokyo, Japan
MANUFACTURER: Casio Computer Co., Ltd, Tokyo

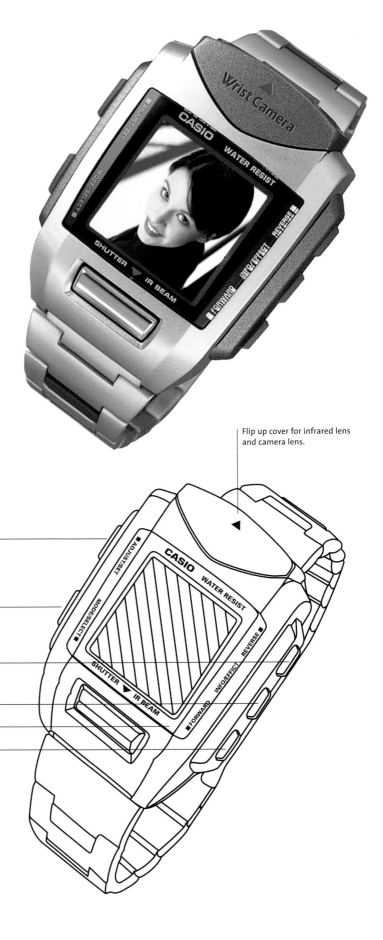

Flip up cover for infrared lens and camera lens.

Set.

Mode.

Forward.

Change.

Shutter.

Reverse.

"STYLUS PHOTO 870"
PHOTOGRAPHY PRINTER

The "870" printer, one of three models in Epson's new line of advanced printers, produces prints equal to refined color photography, successfully solving the problem of light fading. The solution involved dye-based photo inks. Extensive research resulted in the printers' being able to produce, through the use of a PC, gallery-ready prints that last for many years when properly stored or displayed.

FEATURES:
- Production of six-color (CMYK) photo-quality prints
- Light-fast inks and papers
- Fast photo printing at 1440 x 720 d.p.i.
- Windows or Macintosh driver
- Accommodation of paper sizes up to 216 x 1118 mm and a very wide range of paper types including transparencies, glossy stock, and envelopes
- 256 KB input buffer
- Dimensions: 470 x 285 x 175 mm
- Weight: 5.6 Kg

DESIGNER: Alexis Tricoire, Paris, France
MANUFACTURER: Epson France S.A., Levallois-Perret, France

Black ink cartridges print 540 pages of stationery-size paper.
Color ink cartridges print 220 pages of stationery-size paper at 25% (5% for each of 5 colors) at 360 d.p.i.

Continuous roller paper on a roller attachment (below left) as well as single-sheet-fed paper (below right) is accommodated. The cabinet is available in Klein blue (shown) or ultra violet.

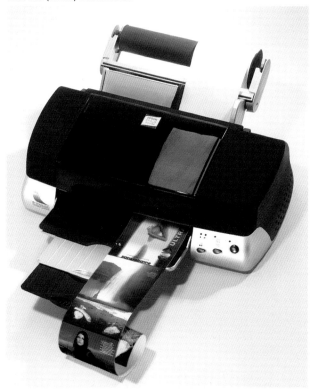

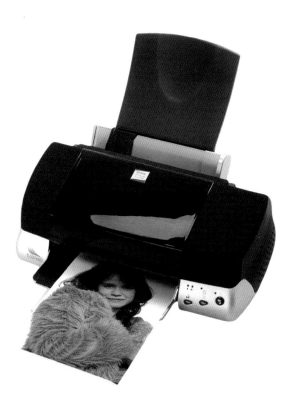

"DC240i ZOOM" DIGITAL CAMERA

Kodak has entered the youth and digital-camera market with a number of models including the version below. The cases are produced in the lively colors of lime yellow, strawberry red, blueberry, grape, and tangerine. Polypropylene has made the transparency possible and is compatible with the image of earlier versions of Apple's iMac computers, certain office equipment, and corollary accessories. An easy-to-use camera, it interfaces with computers through a USB port, making transference and downloads of images faster than IrDA (infrared rays) or serial ports.

FEATURES:

• Operative speed of 12 MB/sec.
• Photo-realistic 126 x 177 mm prints at 1280 x 960 d.p.i
• 3x optical plus 2x digital zoom lens with no loss of image clarity
• Macintosh and Windows USB support (or PC card reader) for fast picture downloads, quick power-ups, and short shutter lag times
• USB cable
• Behavior of a traditional camera with an auto focus and exposure control
• 70 MB hard-disk space and 16 MB or more of RAM required for a download to a PC
• AC adapter
• CD-ROM software
• Batteries
• Dimensions: 133 x 51 x 76 mm
• Weight: 3.3 Kg

MANUFACTURER: Eastman Kodak Company, Rochester, New York, USA

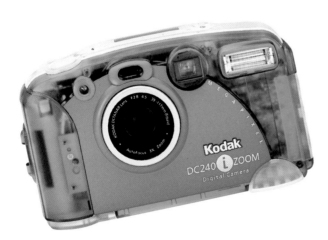

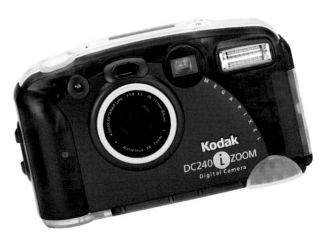

"DC215 ZOOM" DIGITAL CAMERA

This inexpensive digital camera is intended for aim-and-point users. The simple interface capability, real-image optical viewfinder, and LCD display makes this camera desirable to amateur photographers interested in basic snap shots.

FEATURES:

- 1182 x 864 or 640 x 480 d.p.i. resolution
- Fixed-focus 2x optical lens
- 29–58 mm equivalent focal length
- 45 mm LCD display
- Flash modes: automatic, fill, red-eye reduction
- Power: four "AA" alkaline, NiCd, NiMH batteries, or the Kodak-specified AC adapter
- JPEG image capture; NTSC or PAL video out
- 10-second self-timer
- Digital print order format compatible
- Serial RS232C file transfer: 115 KB per second data transfer
- Attached wrist strap and lens cap
- Compatible with Windows and Macintosh systems
- CompactFlash memory; various capacity memory cards
- Dimensions: 115 x 43 x 68 mm
- Weight: 3 Kg

Menu button.

View screen.

20 MB Kodak picture card for storage.

Turn-dial adjustments (clockwise):
Camera setup
Connect
Review
Capture

Forward and backward picture selectors.

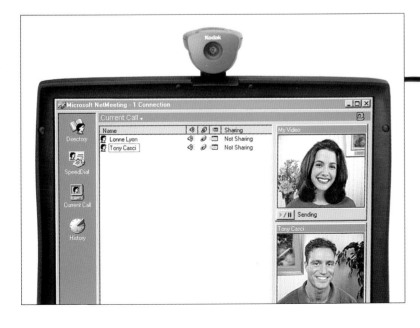

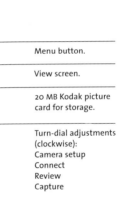

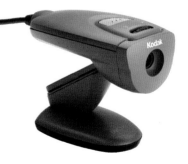

Camera, connected to a PC, can perch on top of a monitor (left).

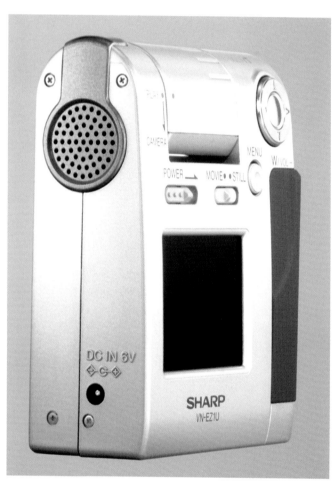

"VN-EZ1U DIGITAL VIEWCAM SLIM"

At the time of its introduction in fall 1999, the "VN-EZ1U" model became the smallest digital camcorder and the first to offer a built-in MPEG-4 data-compression capability. In other words, it was the first to generate video automatically in a streaming format, making it possible to distribute video files easily, with little technical knowledge. The user can playback videos almost instantly. However, the streaming video playback requires a phone-line connection with a faster-than-recorded video-transmission rate.

FEATURES:

• Easy to use
• Lightweight
• 62 mm LCD color monitor (200,000 pixels); 10 x 47 mm lens
• 20 mm diameter speaker (100 mV, monophonic)
• Access to the POPcast.com Web site for video file acquisition by clicking on a mouse to upload streaming media
• Ability to distribute video as an e-mail attachment and to incorporate it into home pages and Internet broadcasts
• Playback of streaming video via the Windows Media Player, also convertible to ASF files (Microsoft's Advanced Streaming Format)
• Availability of 2–32 MB SmartMedia memory cards for up to an hour's video playtime
• JPEG still-image compression format
• Shutter speeds: 1/15–1/4000 video, 1/4–1/400 still image
• Up to four hr recording time on four "AA" alkaline batteries, about 15 hr with the optional high-capacity battery, or infinite time with the optional AC adapter
• Dimensions: 79 x 88 x 42 mm
• Weight: 148 g (with a SmartMedia card and alkaline batteries)

MANUFACTURER: Sharp Corporation, Tokyo, Japan

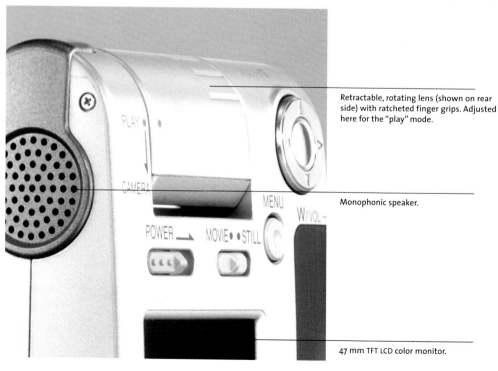

Retractable, rotating lens (shown on rear side) with ratcheted finger grips. Adjusted here for the "play" mode.

Monophonic speaker.

47 mm TFT LCD color monitor.

MUSIC PLAYERS
AND COMPONENTS

"DISCMAN®" PLAYER

Sony celebrated the 15th anniversary of the Walkman® with the introduction of the "Discman," a highly advanced, digitally based system that provides appreciable fast recovery from shock compared to many other players. It became the first portable player to accommodate a slide-in CD. The side-insertion feature eliminates the need for hinges and, therefore, makes a very thin profile possible. The housing, in a cutting-edge lightweight material, is a mere 21.5 mm deep and only a little wider in diameter than a disk itself. As part of the standard equipment, Sony's "MDR-ED268LP" super-light in-the ear (or earbud) headphones are supplied.

FEATURES

• 10-times-faster shock protection than conventional systems
• Slide-in disk loading
• Mega Bass® sound
• Up to 62 hr operating time with two "AA" batteries, or rechargeable by a supplied unit; exceptionally long battery life (62 hr) (two NH-14WM batteries supplied)
• 11 playback modes for custom repetition; 64-track RMS programming
• MD-optical-link output for digital connection to a mini-disc recorder
• Digital volume control; remote controller
• 1 bit digital-analog conversion
• 20–20,000 Hz, +1/-2 dB frequency response
• 4.5 volt DC input
• Dimensions: 138.5 x 21.5 x 136 mm
• Weight: 220 g (without batteries)

DESIGNER: Nakamura Mitsuhiro, Creative Center, Sony Corporation, Tokyo, Japan

MANUFACTURER: Sony Corporation, Tokyo

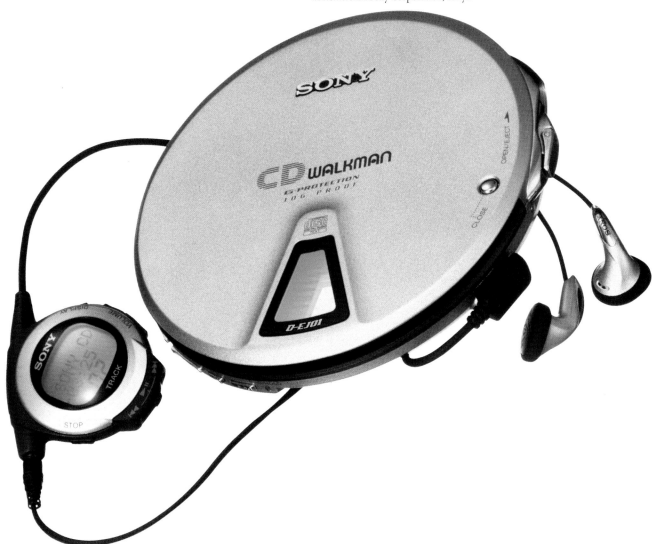

LCD remote controller with the luminous Backglow™ window shows CD-text track name and disk title.

Lightweight die-cast magnesium alloy case.

A disk is inserted into the side edge of the case, which does not open up with a hinge, thereby making super-thinness possible.

Stereo "MDR-ED268LP" bud-type headphones (7 g without cord) with sapphire-evaporated diaphragms, tangle-minimizing cord bushings, high-power neodymium magnet, gold-plated plug, 16 mm drive units, groove-designed Bass Booster earpiece shade.

"BIOSOUND 1" CD/RADIO PLAYER

Easily movable rather than truly portable, this CD/radio player was developed to be shuttled from room to room in a house or apartment. It was also created to introduce the brand to potential customers who had heretofore been unaware of Bang & Olufsen, a 76-year-old Danish firm committed to good design with lasting appeal. This non-stationary audio system was introduced in Europe in 1995 and in the USA in 2000.

FEATURES:
- High-quality sound
- Portability
- Ease of operation
- Aesthetic appeal
- CD player with an extending receptor
- FM radio
- Retractable antenna when the radio is not in use
- Mini-jack for stereo headphones
- Remote operation with the optional Beo4 controller
- Cabinet: black plastic body; black, blue, green, red, or yellow aluminum face
- Dimensions: 510 x 345 x 167mm
- Weight: 7 Kg

DESIGNER: David Lewis, Copenhagen, Denmark
MANUFACTURER: Bang & Olufsen, Struer, Jutland, Denmark

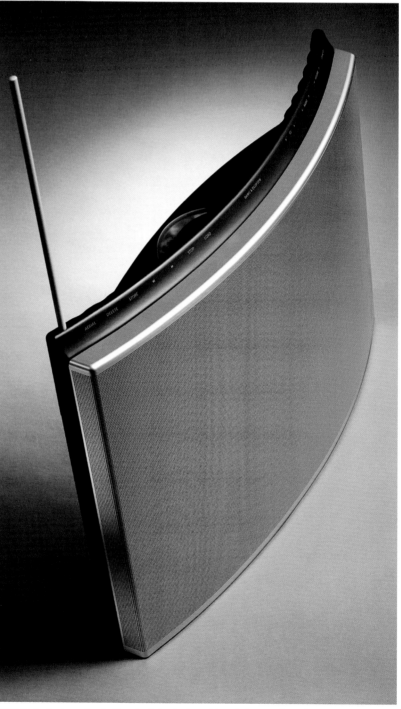

The motorized antenna (75 ohm) is extended and retracted by a slight touch (above), as is the CD receptor which projects upward from the rear side (facing page).

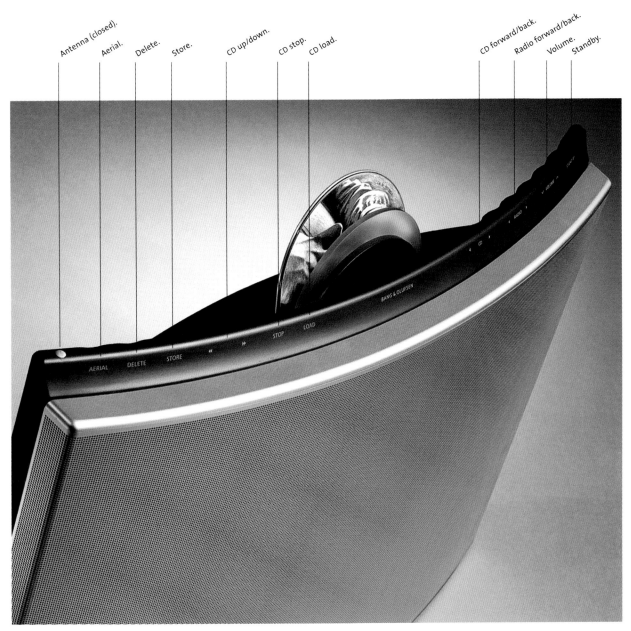

Antenna (closed). Aerial. Delete. Store. CD up/down. CD stop. CD load. CD forward/back. Radio forward/back. Volume. Standby.

The operational indicators are located on the front of the frame. The touch controls are located on the rear side. Five speakers (one woofer, two mid-range speakers, and two tweeters in an active three-way closed box) are located inside the unit at 3 and 9 o'clock positions (mid-range speaker and tweeter) and the 6 o'clock position (woofer).

"FPR2" RADIO

British inventor Trevor Baylis was inspired to create what became "The Clockwork Radio" after watching a TV program about the spread of Aids in Africa. Based on knowing that batteries are expensive there and electricity frequently unavailable, Baylis's device, which called on the craft of clockmaking, featured a hand crank to store human energy into a built-in spring. The energy could later be released on demand and converted into electricity. However, he had difficulty finding a manufacturer until British entrepreneur Chris Staines saw another BBC program in 1994, this time on Baylis himself. With South African Rory Stear, Staines formed BayGen, later reorganized as Freeplay Energy, to exploit the radio's potential, and rallied the assistance of various public and private organizations. The current models of the wind-up radio are far more technologically sophisticated. Freeplay radios (only one model shown here) continue to be operated by hand cranking but now feature AC adapters and, in some versions, built-in solar panels. (See the Freeplay "20/20" flashlight on pages 46–47.)

FEATURES:
- Environmentally friendly
- Three-way power system:
 (1) wind-up B-motor textured carbon-steel spring, driving a DC generator through transmission; 30-second hand wind-up for up to one hour's play
 (2) thin built-in amorphous-film solar panel to draw energy from available light with unlimited play time
 (3) AC adapter (3–12 volts DC/100mA or optional 9 volts DC) for regular electrical plug-in
- Cranking spring, in the gearbox, that returns to its original position
- Built-in AM ferrite bar antenna
- Telescopic FM antenna
- Optional: stereo-by-mono adapter
- Broadcast bands: 500–1700 KHz AM; 88–108 MHz, FM
- Use as a portable and emergency radio
- 102 mm speaker for high-quality sound
- Colors: clear, transparent blue, transparent green, clear and transparent red (not shown)
- Dimensions: 290 x 200 x 200 mm
- Weight: 2.4 Kg

DESIGNER: Syzygy, Cape Town, South Africa
MANUFACTURER: Freeplay Energy Ltd, London, United Kingdom

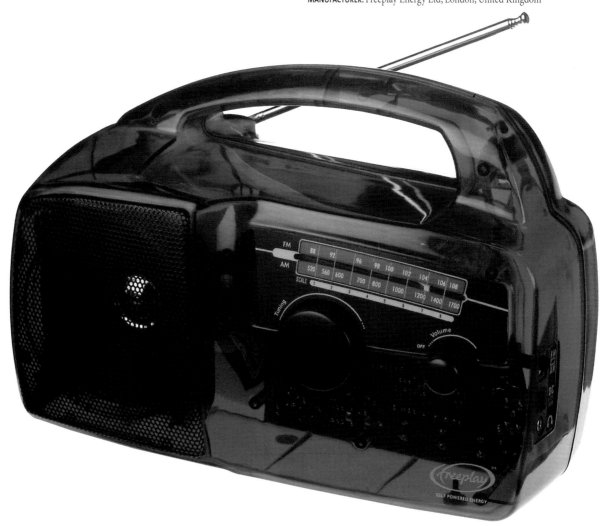

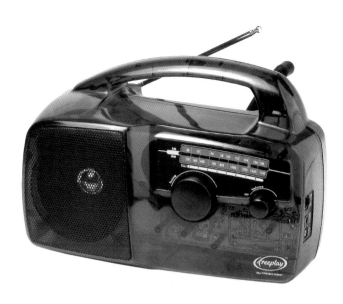

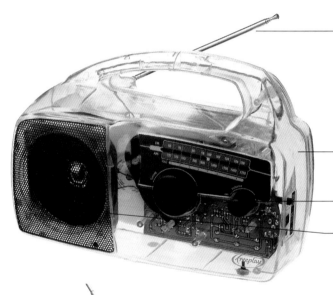

FM telescoping antenna.
(An AM ferrite-bar
antenna is built in.)

Clear or tinted
polycarbonate case.

Solid matte ABS fittings.

102 mm Silverdome,
maximum 5 watt, 8 ohm
speaker.

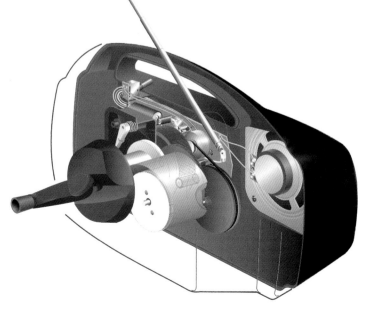

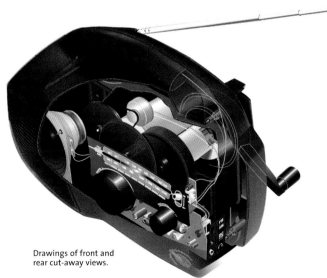

Drawings of front and
rear cut-away views.

"NW-E3" MP3 PERSONAL STEREO PLAYER/RECORDER

The "NW-E3" is yet another hand-held recorder that puts Internet music in the palms of our hands. But this one is particularly diminutive. Sony, creator of the Walkman®, introduced this tiny network version of the Walkman in the year 2000. It downloads high-quality digital audio into an embedded 64 MB flash-memory chip.

FEATURES:
- No skipping and no moving parts, appropriate to use during vigorous sports activities
- Brushed aluminum case
- Downloading of Internet music and CD recordings via MP3 technology
- High speed transference—1 hr downloads in about 1.5 minutes
- Copyright-protection compliance via the SDMI (Secure Digital Music Initiative) for secure digital-music downloads
- "AAA" batteries for 5 hr of playback
- Dimensions: 83 x 32 x 16 mm
- Weight: 1.6 oz

DESIGNERS: Staff designers, Sony, Tokyo, Japan
MANUFACTURER: Sony, Tokyo

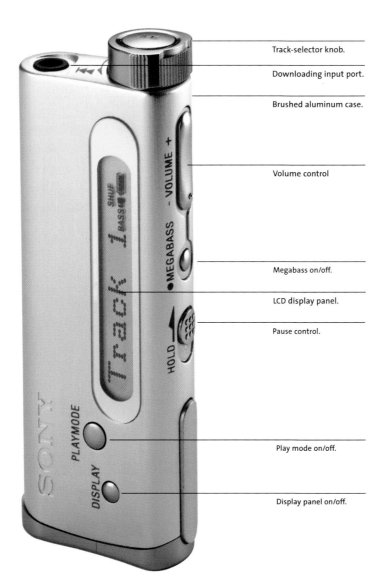

Track-selector knob.

Downloading input port.

Brushed aluminum case.

Volume control

Megabass on/off.

LCD display panel.

Pause control.

Play mode on/off.

Display panel on/off.

"RIO® 600" MP3 DIGITAL PLAYER

The revolutionary "Rio 300" and the successful "Rio 500" were the first MP3 digital-audio players to enter the marketplace. The shape of the first model was a squared-off form with a small amount of memory, a far cry from the curvaceous, sophisticated "Rio 600." This current model, designed in 1999 and produced from 2000, has no moving parts, so skipping will not occur. The basic unit holds up to 60 minutes of digital music or 16 hours of spoken words.

FEATURES:
- Storage of 1 hr of music on built-in 32 MB, or 32, 64, or up to 11 hr with 340 MB snap-on memory packs.
- Optional FM tuner, car-cassette adapter, removable color face plates, and a travel case
- RioPort Audio Manager software for transference of CDs to the MP3 and WMA formats
- One simple connection for USB transfers, headphones, wired remote control, and FM tuner
- USB connector for fast downloading
- On-board custom playlist
- CD-ROM drive for encoding from CDs
- Headphones
- Compatible with a PC and Macintosh
- Dimensions: 102 x 63 x 38 mm
- Weight: 68.6 g

DESIGNERS: Staff designers, Rio®, Vancouver, Washington, USA
MANUFACTURER: Manufacturers' Services Ltd, Concord, Massachusetts, USA, for Rio, a division of SONICblue™ Incorporated, Santa Clara, California, USA; "Rio," a trademark of RioPort, Inc., used by SONICblue under license

"SOUND FEEDER SF120" CD AND MP3 BROADCAST ADAPTER

The sound quality of the "SoundFeeder" does not diminish over time, a characteristic which distinguishes it from traditional cassette-to-CD adapters. When combined with an MP3 like the "Rio 600" (above), a portable CD player, or a MiniDisc device, its use becomes advantageous in newer model automobiles not equipped with a cassette deck. Of course, the main feature of the "Sound-Feeder," first introduced in 1987, is the elimination of wiring to dashboard audio equipment from a hand-held player. This is made possible by an FM-modulated device that transmits sound wirelessly and directly to an unused station-call number on a car's FM radio.

FEATURES:
- Optional DC adapter that plugs into the cigarette-lighter socket
- 88–108 MHz FM-tuning frequencies
- 1 ohm maximum input impedance
- 50 Hz–15 KHz audio response (+/- 3 dB)
- Dimensions: 89 x 50 x 20 mm
- Weight: 100 g

DESIGNER: Arkon staff, Arkon Resources, Inc., Arcadia, California, USA
MANUFACTURER: Made in China for Arkon Resources, Inc.

"SOULMATE™" MP3 PLAYER/RECORDER

This portable downloader acquires music via the Internet with a PC and is inserted into the compatible "MusicStore" unit (facing page) for play.

FEATURES:

• Insertion into the MusicStore unit to play music captured from the CD players or MP3 music captured through a CPU
• No jumping or skipping
• Inclusion of "MusicMatch" 4.3 digital audio software, earbud headphones, and an AC adapter
• Requirement of two "AAA" batteries
• 1, 2, or 3 hr recording time, depending on the model (SM-48, SM-64, or SM-96, respectively)
• Will not store "SoulMate" music in the "MusicStore" (circum-venting copyright and artist-protection issues)
• Unlocking of music when connected to the "MusicStore"
• Dimensions: 108 x 57 x 16 mm (without the snap-on USB interface unit)
• Weight: 100 g

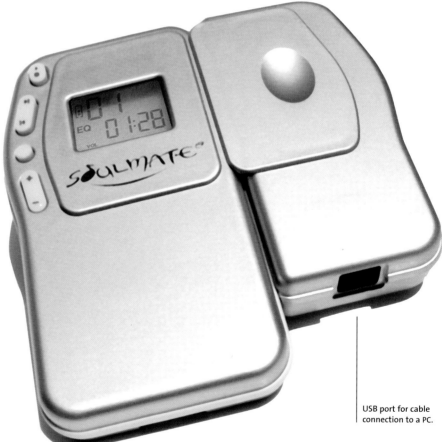

USB port for cable connection to a PC.

SoulMate (left) with the snap-on PC interface unit (right).

"MUSIC STORE™" JUKEBOX

This non-computer jukebox plays and records CDs as well as music from the insertable "SoulMate" unit (facing page).

FEATURES:
- Inclusion of a play/write CD device
- Storage of up to 200 full CDs at FM quality or CD-Rs onto its 5.4 G memory (or up to 107 hr)
- Naming of CDs and the type of music (but no Rap music category)
- Listenable with headphones or through external powered speakers
- Use of digital files through a CPU by connecting the USB cable to a PC, thence the PC's speakers
- Tracks played at random with the "Lucky Dip" indicator
- Accommodation of Rio MP3s for music fill-ups
- Dimensions: 325 x 165 x 51mm
- Weight: 1.18 Kg

MANUFACTURER OF "SOULMATE" AND "MUSICSTORE":
DigMedia™ Inc., San Diego, California, USA

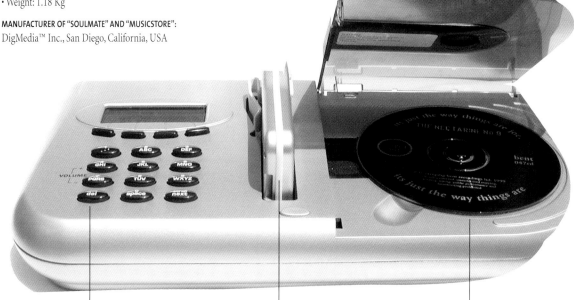

In addition to telephone-type numerical and alphabetical controls, others regulate the sound.

The SoulMate self-docking station (see facing page for the SoulMate unit).

CD player and writer (in addition to SoulMate recorded music).

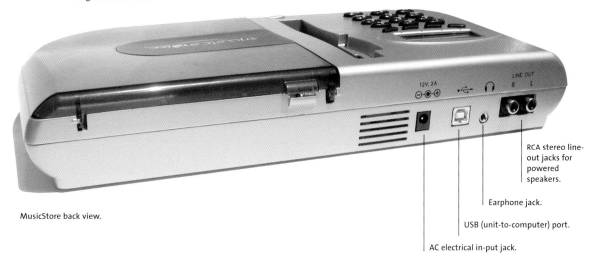

MusicStore back view.

AC electrical in-put jack.

USB (unit-to-computer) port.

Earphone jack.

RCA stereo line-out jacks for powered speakers.

"RAVE:MP™ 2300"
MP3 PLAYER/RECORDER

Sensory Science Corporation, formerly Go-Video, was one of the first manufacturers to produce MP3 players. This diminutive unit became the first MP3 player to provide inexpensive memory with advanced technology. Unlike other units, the "rave:mp" accepts 40 MB "Iomega clik!" disks onto which music from the Internet can be downloaded. Or CDs can be transferred to the unit and then transferred to a CPU or another MP3 player.

FEATURES:
- 64 MB of built-in flash memory
- SmartMedia™, and USB ports for fast downloading
- FM radio
- 90 minutes of Internet music or storage of 40 MB of data on a single "Iomega clik!" disk
- USB interface for easy connection to a CPU and fast downloads of 350 KB per second
- 12 hr of continuous play with a single charge on the lithium-ion battery
- Five EQ modes for normal, jazz, rock, classical, and pop music
- Audio software for managing, playing, and encoding audio-file data

DESIGNERS: Varo Vision, Seoul, South Korea
MANUFACTURER: Sensory Science Corporation, Scottsdale, Arizona, California, USA

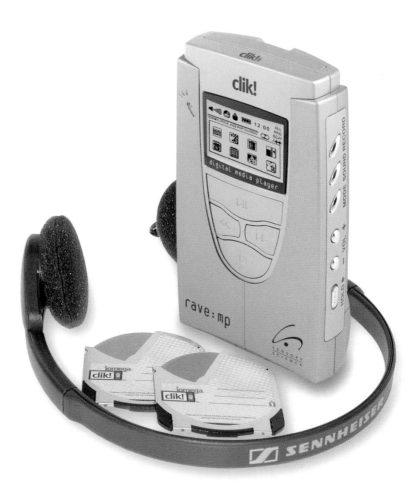

USB male plug (shown) connected to a PC or other music source is inserted into the USB jack at the top of the "click!" (not shown).

Icons indicating departments for captured-music files, trash bin, address book, calendar, local time, world time, and other features.

Buttons for playing, forward movement, back movements, and stop.

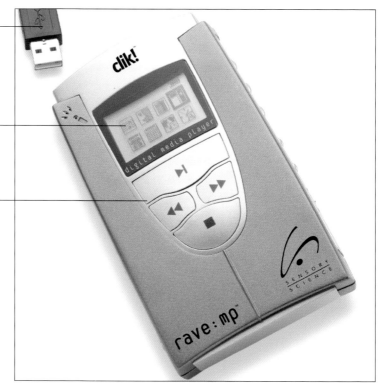

"SONICBOX iM BAND" WIRELESS RADIO TUNER

This new wireless device, launched in the year 2000, is a portable Internet radio that eliminates the necessity of having to listen to radio broadcasts through the speakers of a CPU. A small, adjunct unit, about the size of a hockey puck, is connected to a CPU or other device that will access Internet radio broadcasts via a USB cable and a sound card. The signal is broadcast just like a cordless telephone. The wireless, rechargeable, pager-like receiver outputs the radio signal to a pair of wireless headphones or to a stereo receiver/amplifier.

FEATURES:
• Inexpensive
• "SonicBox iM Band™" that will transfer, even through walls
• "SonicBox iM Remote™" that uses a USB connection from a CPU to wirelessly play radio or MP3 files through a home stereo system
• Access to the iM™ Tuning Service, supporting major streaming format for acquiring music from radio stations around the world via the Internet
• Free downloadable software
• 32 programmable radio stations in the user-customizable "Z" band—from the "iM Remote" or from a CPU
• Or pre-programmable with the 800 Web radio-stations directory that is organized into 25 categories by genres, but fewer stations with a 99 KB/sec. or slower Internet connection
• Requirements: Pentium CPU or equivalent, running Windows, RealPlayer 7 or Windows Media Player 6.4; a broadband Internet connection; USB port; Direct Sound compatible sound card; CD-ROM drive
• Also available as the "iRhythm™ L.E." (same unit as the "SonicBox iM Remote" by Acer NeWeb, a "knob only" iM-type tuner)

DESIGNERS: SonicBox staff, iM Networks™, Inc., Mountain View, California, USA

MANUFACTURER: iM Networks, Inc., MountainView

"SonicBox iM Remote" receives through walls and is customizable to broadcast 32 pre-selected stations or to access a directory of 800 Web radio stations.

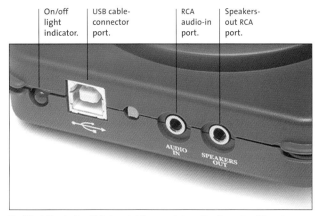

On/off light indicator. USB cable-connector port. RCA audio-in port. Speakers-out RCA port.

The "SonicBox iM Band" (below right) connects to a CPU via a USB cable and transmits to the "SonicBox iM Remote" unit (below left).

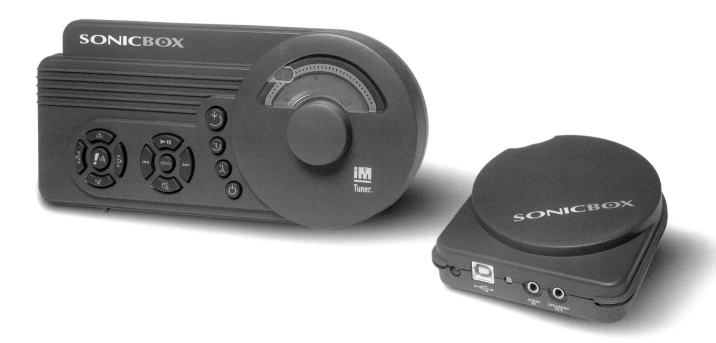

"AM ADVANTAGE AM-1000" RADIO ANTENNA

The four antennae here illustrate the possibilities that are being economically realized through advanced technology. For example, the passive indoor "AM Advantage" antenna provides superior radio reception from long distances. Its configuration allows the user to adjust the antenna to specific AM frequencies by adjusting the integrated purple-color dial in the base. The dial must be adjusted to the desired AM station call. Placed on top of the radio or next to it, no wires are required.

FEATURES:
- Wireless even though a directly wired connection to a radio will enhance the performance
- Elimination of noise and interference in AM signals made possible by the Pin-Dot™ pre-tuning system that adjusts the antenna to receive a specific AM frequency
- Frequency range: 540–1700 KHz
- Impedance: 300 ohms
- Voltage-standing-wave ratio: <1.4
- Dimensions: 241 x 241 x 63 mm

DESIGNERS (THIS PAGE AND FACING): Industrial-design team, Terk Technologies Corporation, Commack, New York, USA
MANUFACTURER (THIS PAGE AND FACING): Terk Technologies Corporation, Commack

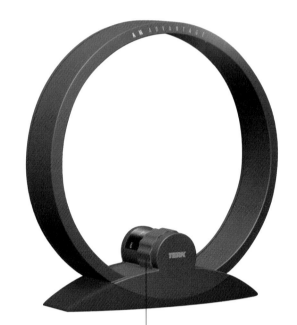

Adjustable tuning knob for best reception results.

"AM/FM Q AF-1" RADIO ANTENNA

The manufacturer's top-of-the-line antenna features high performance and advanced technology. It can handle a number of conditions. Calling on the same pre-tuning feature as the "Advantage" model, the user can regulate the antenna to specific frequencies by adjusting the dial to match the radio call; thus, static is appreciably eliminated.

FEATURES:
- Omnidirectional
- Placement of the AM antenna behind the FM antenna so that negative-impact reception is eliminated
- Non-Conduction™ circuitry that isolates the AM and FM antennae from one another and preserves signal reception
- Elimination of noise and interference in AM signals through the Pin-Dot™ pre-tuning system that adjusts the antenna to receive a specific AM frequency
- Amplification controller to optimize the signal reception
- LED indicators on the face of the unit to facilitate both reception and amplification
- Accessories: separate transformers for 75-ohm antenna input and for 75 and 300 ohm inputs
- Frequency range: 540–1700 KHz for AM, 88–108 MHz for FM
- AM gain: +15 dB
- Noise figure: 1.5 dB for AM, 3 dB for FM
- Voltage-standing-wave ratio: <1.2
- Dimensions: 121 x 152 x 117 mm

LED pin lights indicate the level of amplification and signal reception. As indicated above by the red light, for example, the amplification is at 75%.

Knobs (one above the other) adjust the amplification and the signal.

"FM EDGE FM-4000" RADIO ANTENNA

Purportedly this economically priced antenna provides more dramatic reception than most other antennas in the same price range and is omnidirectional no matter where it is placed in a room. The manufacturer claims that the dual-drive "Edge" will reduce noise and static to an absolute minimum and receive a large number of stations with clarity. The black gain knob is used to adjust the optimum level of each station.

FEATURES:
- Dual-drive amplifier (DDA) with 36 dB gain to filter out noise prior to amplification, adjustable for optimum reception of weak or strong stations
- LED indicators that signal amplifier gain
- Positions for omnidirectional reception (when placed vertically) or directional (when placed horizontally to zero for difficult-to-receive stations)
- FM impedance: 75 ohms (or 300 ohms with a supplied adapter)
- Skid-resistant base
- Accessories: an amplifier of 75–300 ohms, "F" connector of 75 ohms to a screw-type connector of 75 ohms, AC/DC power adapter
- Dimensions: 70 x 70 x 110mm

The control knob (+ to -) adjusts amplification for relatively weak signals.

"AM/FM+ AF-2500" RADIO ANTENNA

Appropriate for clear local reception of AM or FM radio stations, this antenna claims to reduce reception noise and static to an absolute minimum. It can be placed anywhere in a room and will require no repositioning. Wall mounting may improve reception, and, by increasing the antenna's distance from audio components, noise and interference may be reduced.

FEATURES:
- Table-top or wall-mounted placement
- Small size
- Omnidirectional
- Gamma-Loop® technology and specialized noise-reducing antenna elements that provide clearer reception of a greater number of nearby stations
- Frequency range: 540–1700 KHz for AM, 88–108 MHz
- Output impedance: 300 ohms, twin-lead for AM; 75 ohms (or 300 ohms with the supplied transformer) for FM
- Independent AM and FM circuitry
- Accessories: separate transformers for 75-ohm antenna input and for 75- and 300-ohm inputs
- Dimensions: 127 x 127 x 25 mm

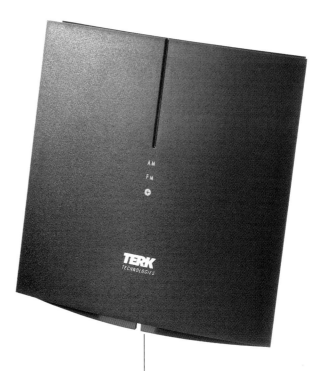

Slide adjuster to regulate the amplification and the signal.

"NOMAD JUKEBOX"
MP3 DIGITAL AUDIO PLAYER/RECORDER

The word "jukebox" conjures images of a music player far different from the "Nomad." This MP3 player/recorder, essentially an Internet appliance introduced in the year 2000, has the ability to store every piece of music that most people own in one hand-held portable device. The unit, the size of a typical CD player, will hold 150 CDs of digital MP3 audio. When linked to a CPU via a USB cable, the recorder can download 100 hours of stored MP3 audio.

FEATURES:

• 6 GB shock-resistant hard drive—for storage of 100 hr of MP3 music or 2,600 hr of spoken-word files (reading multiple sound-file formats such as WMA and WAV)
• Backlit LCD 132 x 64 pixel display
• USB port for fast digital transfer rates
• Built-in EAX™ audio technology and FourPoint-Surround™ speaker support to customize music for most immersive desktop or home-audio systems
• Headphone-out jack for headphone spatialization effects, environmental effects; adjustment of reverb, bass, treble; and mid-frequency amounts
• Dual-band recording up to 48 KHz, replacing a DAT
• PC input with bundled Creative PlayCenter™ 2 software for editing, encoding, and cleaning up with production tools; SoundJam™ MP recorder for Mac interface
• Colors: blue and blue/silver
• Dimensions: 127 x 127 x 40 mm
• Weight: 400 g (without batteries)

MANUFACTURER: Creative Labs, Inc., Singapore

Backlit LCD (132 x 64 pixels) panel. Controls on the face of the unit include those for library/main screen/queue, EAX™/recording/advanced settings, scrolling, scan/fast forward/next track, play, stop/pause, and scan/reverse/previous track. INFRA™ port for future support.

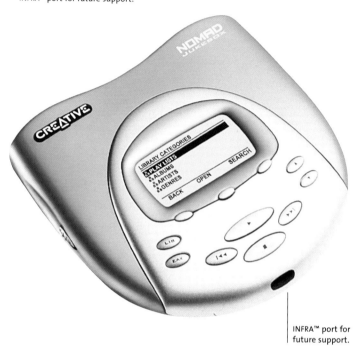

INFRA™ port for future support.

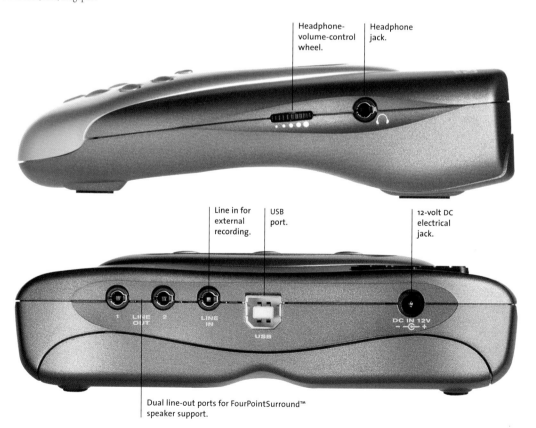

Headphone-volume-control wheel.

Headphone jack.

Line in for external recording.

USB port.

12-volt DC electrical jack.

Dual line-out ports for FourPointSurround™ speaker support.

WRIST-HELD AND WEARABLE DEVICES

"WMP-1V" WRIST AUDIO PLAYER/RECORDER

It is now possible to play and record music on a miniature wrist device. The combination watch and MP3 player by Casio will play audio files that have been downloaded from a CPU through a USB connection. A four-minute song, for example, requires 70 seconds to download. The watch itself stores 33 minutes of CD-quality music, or about 66 minutes of FM-quality music, which you can listen to through the earbud headphones that are included. Power is provided by the interface/charger unit into which the watch is snapped. The "WMP-1V" is only compatible with an IBM-type CPU with a Windows system.

FEATURES:

• Watch with a timer (12/24 hr), calendar to 2039, alarm, and lapse-time modes
• Accessories: interface/charger unit, AC adapter, stereo headphones, headphone attachment, USB cable, Link Soft CD-ROM software
• LED backlit face
• Rechargeable lithium-ion batteries, operating up to 4 hr
• Distortion: 0.1% maximum
• S/N ratio: 70 dB minimum
• Output: 40 mW x 2
• Dimensions: 54 x 49 x 19 mm (case)
• Weight: 70 g (case and band)

MANUFACTURER: Casio Computer Co., Ltd, Tokyo, Japan

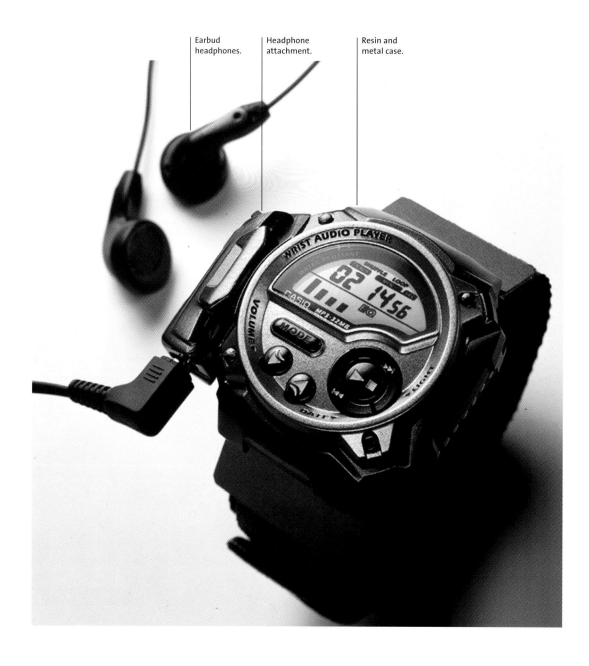

Earbud headphones.

Headphone attachment.

Resin and metal case.

"SATELLITE NAVI PAT2GP-1V" GPS WATCH

Casio's geographic navigational watch calls on the constellation of GPS satellites that circle the Earth. More compact and lighter in weight than the manufacturer's original version, which was introduced in 1999, the "PAT2GP-1V" incorporates a rechargeable lithium-ion battery and high-density mounting that have made the small size of the new GPS watch possible. The software permits plotting and the management of GPS data from the watch onto an IBM-compatible CPU with a Windows system. It will also import and display raster map images (BMP or JPEG) on a computer screen and keep track of present and remaining destinations and current bearings. (See the GPS telephone on page 59 and the Rand McNally GPS hand-held device on pages 122–123.)

FEATURES:
- Storage of future references and route planning
- Rechargeable built-in lithium-ion battery
- 40% smaller and 50% lighter than the previous model
- 12 channels that receive from three to 12 GPS satellites for calculating present longitude and latitude positions
- Storage of almanac data from satellites, in the watch's EEPROM
- "One shot," "auto," and "continuous" modes, reading every second
- Plot and graphical navigation screen, landmark-memory, track-log memory, and arrival alarm
- CPU linking
- 18 x 21.5 backlit display screen (48 x 31 dots), multi-windowing
- Dimensions: 58.5 x 51.5 x 21 mm (case without the bracelet)
- Weight: 84 g

MANUFACTURER: Casio Computer Co., Ltd, Tokyo, Japan

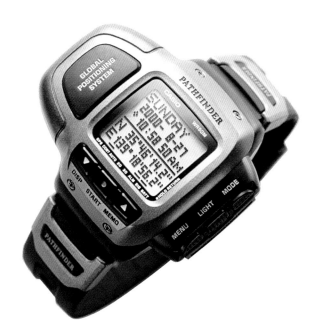

"RELIEF BAND® NST™"
WRIST DEVICE

The battery-powered "ReliefBand," worn on the pulse side of the wrist like a sports watch, emits electrical impulses which provide relief from nausea. The device gently stimulates the nerve endings in the wrist. According to medical reports, the impulses travel up the arm, through the spinal cord, and into the brain. Once in the brain, they prevent nausea signals from being sent to the stomach when a potentially afflicted person is riding in a airplane, travelling in an automobile, or floating on a pitching boat. Thus, sickness and dizziness are eliminated.

FEATURES:
• Alleviation of nausea and vomiting caused by chemotherapy, motion sickness, pregnancy, and post-operative conditions
• Replaceable batteries
• Creation of a pulsing sensation on the palm of the hand and/or the middle fingers
• User-controlled, five-level power intensity regulation
• Reusable
• Not recommended for use by people with cardiac-pacemaker implants
• Several models available (Model NST 600 shown here)

DESIGNERS: Dynapac DesignGroup, San Francisco, California, USA
MANUFACTURER: Woodside Biomedical Inc., Carlsbad, California

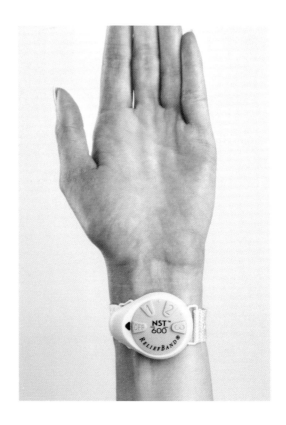

Replaceable batteries last about 144 hr on level two.

Worn with the regulator on the underside of the wrist, between the two tendons, until the stimulation is felt.

Power is increased until the stimulation is felt to be consistent.

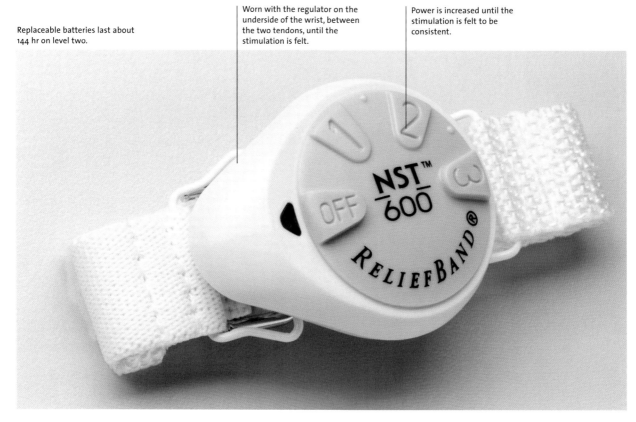

"HRM[TRIAX 100" AND "SDM[TRIAX 100"
WRIST MONITORS

In the year 2000, Nike introduced a range of wireless high-tech tools to augment its sports-wear products. Two are illustrated here. The "SDM[Triax 100" accelerometer is placed on a sports shoe to monitor, via the compatible wristwatch, a runner's speed and distance. The "HRM[Triax 100" chest-applied monitor tracks electrocardiogram heart rates, also via the wristwatch.

FEATURES OF THE "SDM[TRIAX 100" ACCELEROMETER:
• Lightweight accelerometer that attaches to a sports shoe
• Wristwatch: full chronometer, running speed and distance information, graphically displayed information with detailed analyses, auto-lap feature, large dot-matrix screen, scratch-resistant mineral-glass crystal, stainless-steel buckle and back plate, polyurethane strap, Electrolite single-touch backlighting

FEATURES OF THE "HRM[TRIAX 100" HEART-RATE MONITOR:
• Wireless, secure-fitting chest transmitter
• Simple or detailed heart-rate training functions
• Wristwatch: same as for the "SDM[Triax 100," including two programmable training zones with audible out-of-zone alert; lap, split, and maximum/minimum heart-rate information; time-in-training zone; heart-rate recovery time; 100-lap memory

DESIGNER: nike[techlab staff, Nike, Inc., Braverton, Colorado, Oregon, USA
MANUFACTURER: Nike, Inc., Braverton

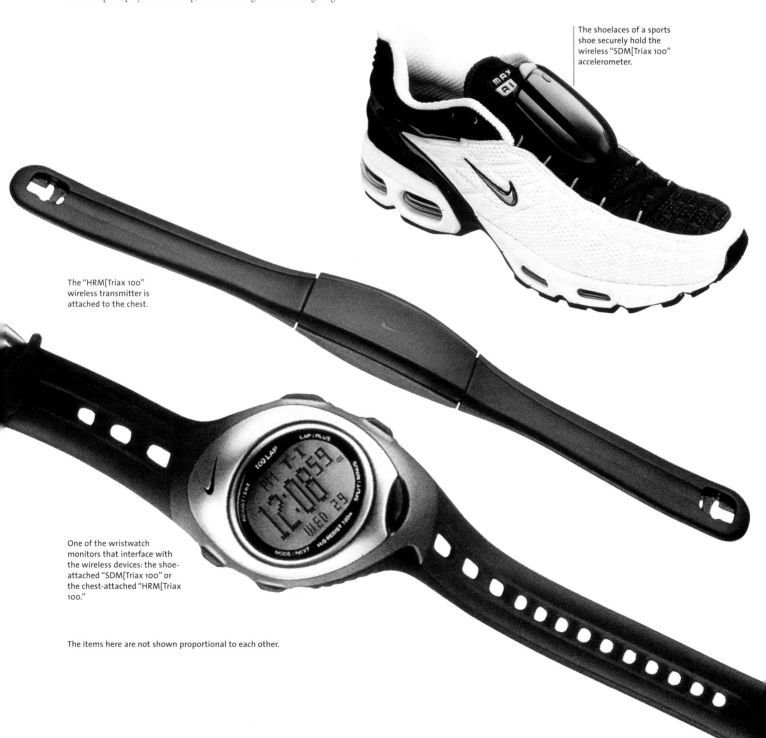

The shoelaces of a sports shoe securely hold the wireless "SDM[Triax 100" accelerometer.

The "HRM[Triax 100" wireless transmitter is attached to the chest.

One of the wristwatch monitors that interface with the wireless devices: the shoe-attached "SDM[Triax 100" or the chest-attached "HRM[Triax 100."

The items here are not shown proportional to each other.

GENOME TATTOO AND EYE CHIP

Thanks to the human genome's having now been decoded, every person on the planet will soon be able to have all of his or her three billion units of DNA genetic-sequencing information infused into a single, minute computer chip. The technology is feeding the imaginations of designers like Karim Rashid who has explored the application of tattoo identification and iris-implanted genome information. When personal data is made readily available and easily retrievable in this manner, individually targeted diagnostics, prognostics, drugs, and other therapies can be quickly provided, but privacy will be a thing of the past.

FEATURES:
• Quick identification
• Storage of graphics containing potentially curative or life-saving information
• Fashion and artistic applications

DESIGNER: Karim Rashid, New York, New York, USA
MANUFACTURER: Concepts by the designer

Iris-implanted genome data information (below on the designer's own eye) and tattooed (top and right).

"P-TAG" WEARABLE IDENTIFICATION

Soldiers of the future will no longer wear dog tags. The
newest interpretation of wearable identification is
SanDisk's "Personal-Tag," shortened to "P-Tag." The
electronic card, introduced in 1999, can store the long
and complicated medical history of a solder, or anyone
else, on a memory disk that is worn around the neck and
can be retrieved by medical personnel with a PC and a
range of peripheral readers. The "P-Tag," which can even
store thumbnails of X-rays and other visual information,
is being tested by the US Army for which the card was
originally developed.

FEATURES:
• Wearable all day and every day
• Tough, non-volatile flash-memory-based storage card
 able to withstand being dropped 3 or 4 m onto a
 concrete surface
• Retention of stored data for over 100 years, eliminating
 the need for batteries
• Serial-interface capability with 10-pin serial readers
• Card capacities from 8 to 96 MB
• No moving parts
• Dimensions: 46.2 x 30.5 x 2.8 mm
• Weight: 2 g

MANUFACTURER: SanDisk Corporation, Sunnyvale,
California, USA

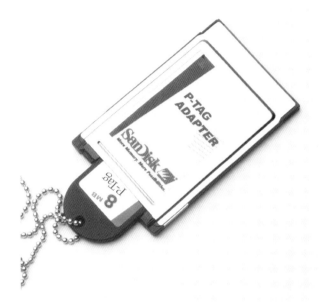

Supporting the industry-standard ATA interface, the "P-Tag" Adapter attaches
to and is compatible with practically all IBM-type PC-card-based computers. No
additional software is required, and the technology will interface with a range
of hand-held organizers, laptops, and other portables that run Windows CE or
Symbian's EPOC.

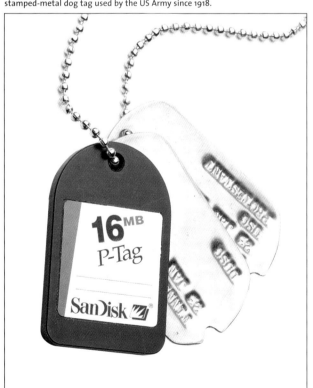

A 16 MB flash-memory-based storage card is the same size as the traditional
stamped-metal dog tag used by the US Army since 1918.

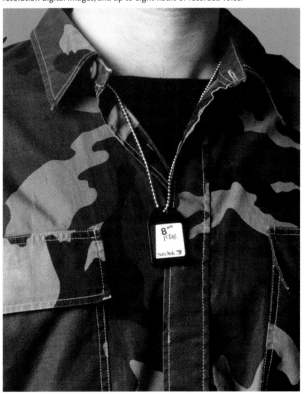

The 8 MB "P-Tag" can store over 5,000 pages of double-spaced text, 50–150 low-
resolution digital images, and up to eight hours of recorded voice.

"SOMNAVUE"
THERAPEUTIC EYEGLASSES

These special eyeglasses provide extra light to people plagued by sleep problems or afflicted by mild depression during winter months. While the conditions may be solved by sitting in front of bright light for an hour or longer, the solution is not desirable because it is time consuming. And there are also other generally unacceptable solutions. The developers of the Somnavue eyeglasses claim that they deliver light therapy more effectively—or efficiently. The system configuration consists of a unit that contains a clock and micro-processor, which projects light through fiber-optic wires attached to eyeglass lenses. In turn, light is projected onto the wearer's pupils and thence to the retinas.

FEATURES:
• Lightweight, regular eyeglass frames
• Projection of light onto the wearer's retinas
• No interference with normal vision
• Control box that fits on a belt or in a pocket
• Clock and microprocessor in a control box, programmable to turn light on and off at specified times of the day and for certain lengths of time
• Adjustable light intensity
• Usable for certain types of jet lag

DEVELOPER AND MANUFACTURER: Enlightened Technologies Associates, Fairfax, Virginia, USA; supported by a grant from the American National Institutes of Health

The battery-powered Walkman-sized control box projects light through fibers to bundles attached to the eyeglass earpieces.

Current time and date.

Starting time.

Duration.

A bundle of six fiber-optic wires is attached to each lens of the eyeglass.

The fiber-optic wires are fed into the energy unit.

HAND-HELD DEVICES AND ORGANIZERS

"MOCCA" (MOBILE COMPUTING AND COMMUNICATION APPLIANCE)

This portable device was designed for general use but may be especially effective when used remotely by an active business person or someone frequently on the go. The "MoCCA" is essentially a small, flexible voice-interactive communicator that will operate in real or delayed time.

FEATURES:
• No buttons, keyboards, or pens
• Pants-belt hanging for freehand use; also usable on a desk top or in the field as a hand-held device
• Prototype introduced in 1998 for what technology might be by about 2003
• Voice activation, scheduling, voice mail, video conferencing, diagnostics, navigation, chat archiving, searching, downloading to a central system, and other features
• Side-by-side view displays

DESIGNER: Richard Watson, Fitch Inc., Boston, Massachusetts, USA
CLIENT: Prototype for Digital Equipment Corp. (now Compax Computer Corporation, Houston, Texas, USA)

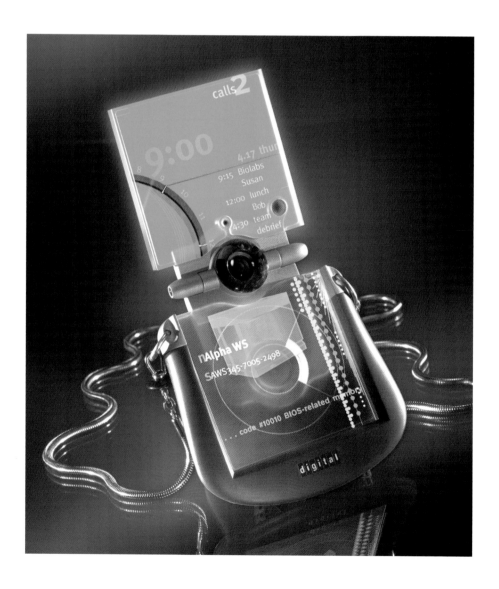

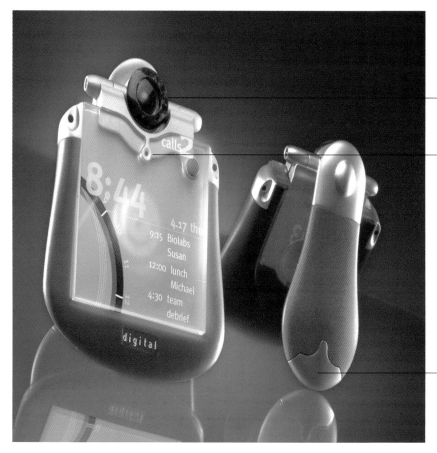

Camera lens.

Microphone.

Easel/handle in soft rubber with a non-skid tip.

When held by the handle/speaker, two display screens can be viewed side-by-side for running multiple functions simultaneously—as live action and/or still images.

Square screens permit 90° rotation.

A speaker, a small earphone for private reception, and antenna for wireless communication are in the handle.

"TRAVELPILOT® DX-N" NAVIGATION SYSTEM

Blaupunkt, the firm that became known for its shortwave radios, has introduced a vehicular-navigation and voice-route-guidance system. The video-map display monitor is supported by a computer and augmented by a choice of hand-held remote controllers. But it is the steering-wheel-attached remote controller that offers a significant safety feature by diminishing driver distraction. The unit received a trial run in over 300,000 automobiles, under license to some of the big car makers. The new "DX-N" is flexible and expandable and functions worldwide.

FEATURES:

• A pleasant-sounding voice directs the driver turn-by-turn over the car's audio system
• In addition to the voice instructions, a 128 mm LCD video-monitor display provides directional symbols, moving-map images, and additional information such as estimated arrival times and distances to the next turns
• Trunk-installed computer
• Hand-held remote controllers, including an optional steering-wheel-mounted model

DESIGNERS: Staff, Blaupunkt, a division of Robert Bosch, Hildesheim, Germany
MANUFACTURER: Blaupunkt, Hildesheim

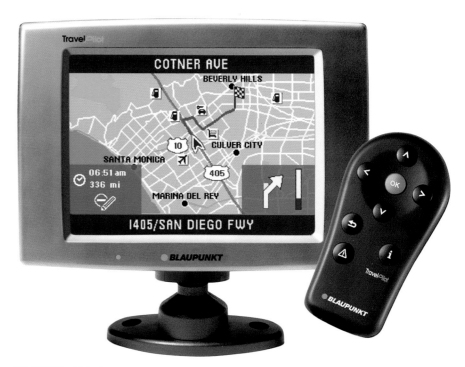

The 128-mm LCD monitor also functions as an in-car television monitor, and the remote controller (right) is standard equipment in the "DX-N" system. A special steering-wheel-lock-on remote controller is optional (above). The vocal instructions are transmitted through the dashboard radio (right).

"CÝBIKO™ INTER-TAINMENT" HAND-HELD WIRELESS COMPUTER

Cýbiko's eponymous computer combines the capabilities of wireless chatting, e-mail sending/receiving, interactive game playing, and a PSA (personal digital assistant)—all in one complete unit for teenage and 'tweenage markets. The company offers free game and application downloads from its Web site. The youth-focused device was designed by its equally young CEO to be easy, fun, and affordable.

FEATURES:
- Interactive multi-player gaming
- Internet access via a CPU link
- Practical applications: an organizer, address book, unique music composer, graphics editor, and others
- Instant e-mail messaging
- Digital, wireless, and portable
- LCD display and a full QWERTY built-in keyboard with an antenna in the top of the unit
- 1 MB memory, expandable to 16 MB
- Choice of five polypropylene plastic colors
- Dimensions: 144 x 72 x 24 mm
- Weight: 109 g

DESIGNER: David Yang, CEO and Chairman of the Board, Cýbiko, Bloomingdale, Illinois, USA
MANUFACTURER: Cýbiko, Inc., Bloomingdale

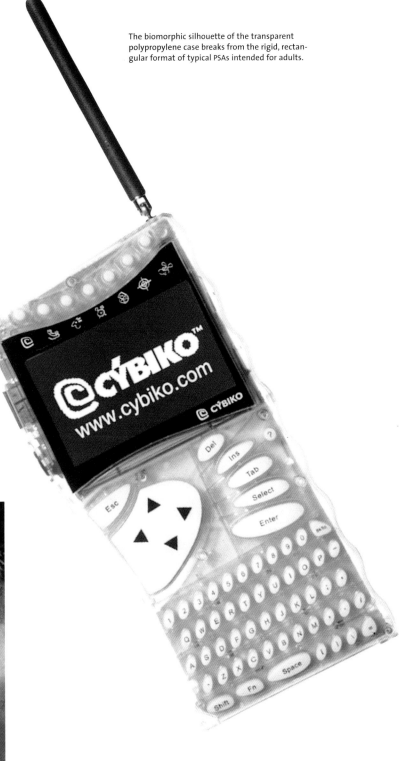

The biomorphic silhouette of the transparent polypropylene case breaks from the rigid, rectangular format of typical PSAs intended for adults.

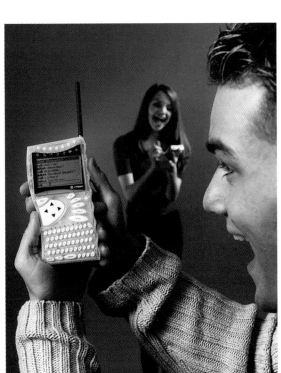

The hyper-enthusiastic actors in this promotional photograph leave little doubt about the age group of the product's intended customers. The "Cýbiko" is being sold by computer-supply companies as well as toy and music stores.

"eBOOK" BOOK READER

The "eBook," introduced in the year 2000, became the first paperback-size electronic book with a built-in modem for acquiring and then storing as many as 5,000 pages in its internal 8 MB of memory. By inserting a SmartMedia card of 64 MB into a slot on the upper right side, storage can be appreciably expanded, to 80,000 pages. No computer or ISP subscription is required for downloading—just plug the extension cord attached to the "eBook" into any telephone jack and download new titles. This book reader is made possible by the technology that was developed by NuvoMedia and Softbook Press, firms later bought by Gemstar. Gemstar in turn licensed the technology to Thomson multimedia, RCA's owner.

FEATURES:

• Built-in 8 MB Compact Flash storage for about 5,000 pages, and expandable
• 140 mm black-and-white display screen for the "REB1100," 215 mm full-color display screen for the "REB1200"
• Built-in modem for downloading directly from a phone line, no ISP account required, via an RJ-11 modular jack; high-speed 10 Base T Ethernet (RJ45) connection for downloading to the "REB1200"
• Weights: 514 g, "REB1100"; 942 g, "REB1200"

DESIGNER: Design-department staff, Thomson Consumer Electronics, Thomson multimedia, Indianapolis, Indiana, USA
MANUFACTURER: RCA, Thomson multimedia

"REB1100" model with a 140-mm-diagonal black-and-white display screen (320 x 480 pixels) is easy to read under bright light conditions (below).

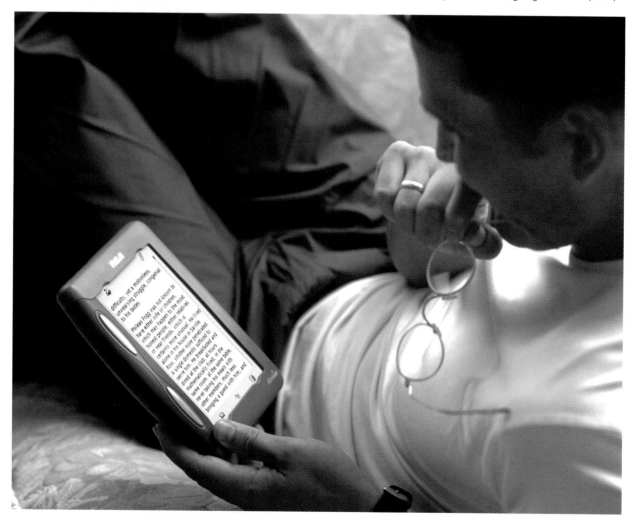

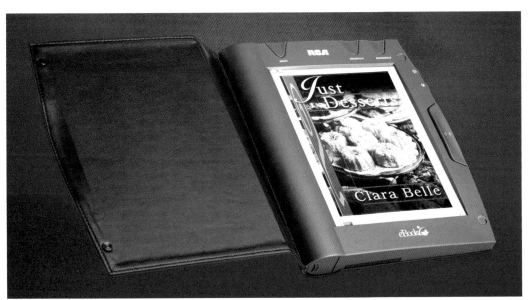

"REB1200" model has a 215-mm-diagonal full-color touch-display (480 x 640 pixels) and Ethernet connectivity for fast telephone download-ing. This color version is appropriate for reading magazines, catalogues, and newspapers. No ambient room lighting is required for reading.

"VISOR™ DELUXE" ORGANIZER, COMMUNICATOR, AND PLAYER

If the "Visor" organizer/communicator/player looks like the original PDA by Palm™, it is because the core team that created the "Visor" also developed the "PalmPilot™" and PalmOS™ platform before leaving the 3Com Corporation to found Handspring™. In addition to the standard features of a hand-held organizer, the Springboard™ device (facing page) offers numerous other features. For example, when an MP3-player application is inserted into the slot of the Springboard module, the MP3 application will appear on the "Visor" display screen. (In 2001, Handspring introduced a thinner [11 mm], bigger [8 MB], more powerful [33 MHz] tinted-aluminum-case PDA—called the "Visor Edge™" to compete directly with the "Palm™ V." However, at the time, Palm—now a separate corporation, not part of 3Com—realized more than 70% of PDA sales worldwide. But the attention first paid to Handspring was spurred by the original "Visor" concept, shown here.)

FEATURES:
- 8 MB RAM, upgradable
- Immediate plug-in-play ROM-based software
- PalmOS 3.1 H software compatible with a vast number of existing applications
- Snap-on Springboard expansion slot to hold plug-and-play expansion modules by second-party compatible products for wireless communication, e-books, global positioning, use as a mobile phone, games and sports, MP3 capability, digital camera, remote controller, voice recorder, memory, and storage
- HotSync USB cradle, connecting to a CPU for backups, updates, and exchanged information
- Transference of data between a Palm-type device or another Visor
- Windows and Macintosh compatibility
- Colors: graphite, ice, blue, green, orange
- Dimensions: 123 x 76 x 18 mm
- Weight: 154 g

DESIGNERS: IDEO, Palo Alto, California, USA
MANUFACTURER: Handspring, Inc. Mountain View, California

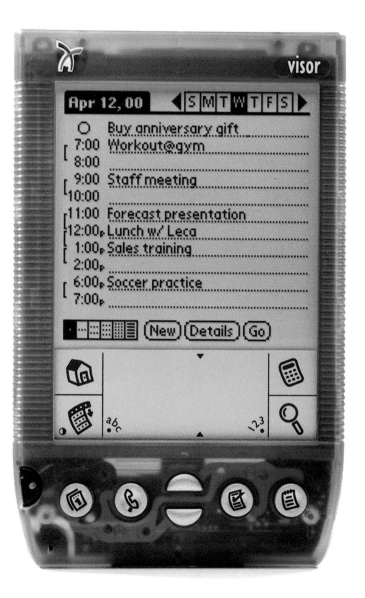

Available in five colors: blue (shown), graphite, ice, green, or orange

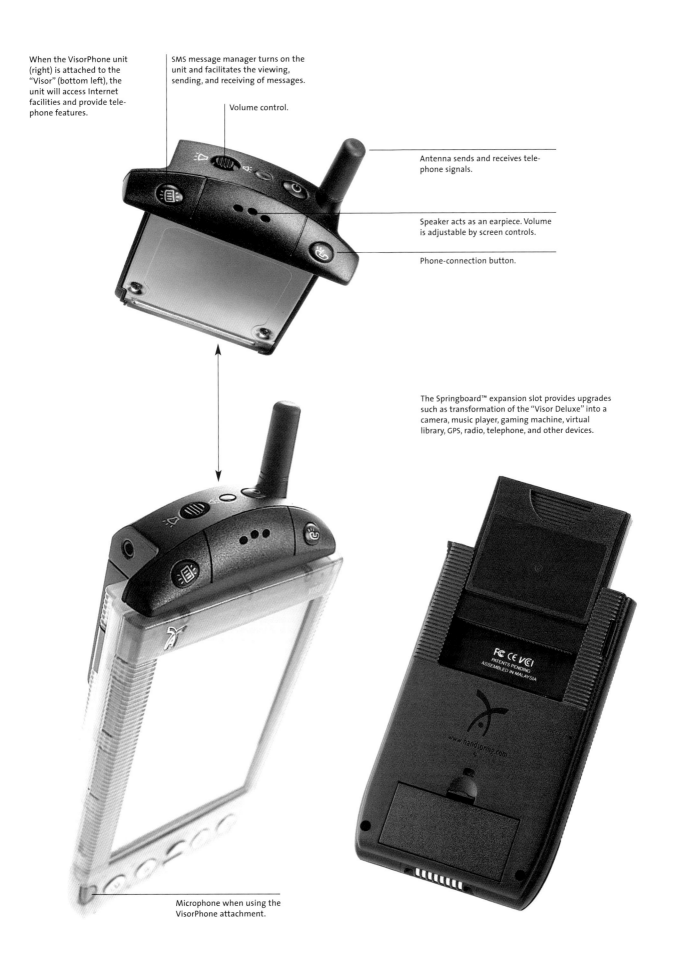

When the VisorPhone unit (right) is attached to the "Visor" (bottom left), the unit will access Internet facilities and provide telephone features.

SMS message manager turns on the unit and facilitates the viewing, sending, and receiving of messages.

Volume control.

Antenna sends and receives telephone signals.

Speaker acts as an earpiece. Volume is adjustable by screen controls.

Phone-connection button.

The Springboard™ expansion slot provides upgrades such as transformation of the "Visor Deluxe" into a camera, music player, gaming machine, virtual library, GPS, radio, telephone, and other devices.

Microphone when using the VisorPhone attachment.

"STREETFINDER® GPS" DEVICE

The "StreetFinder" is a Palm™-compatible GPS (global position system) device that can fit in a pocket or purse or be placed on the dashboard of a vehicle. This version was developed for Rand McNally, the firm that began as a printer in Chicago in 1856 and subsequently became known for mapmaking. The StreetFinder is purportedly simple to attach to a Palm organizer and easy to use, but it is only compatible with certain NMEA-0183 software. (This device contains maps for the US only. For the systems for other locales, see the Casio GPS wristwatch on page 107 and the GPS telephone on page 59.)

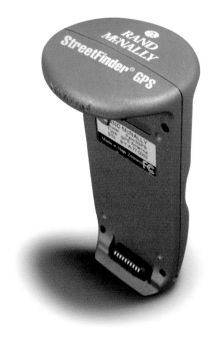

FEATURES:

- Lightweight clip-on GPS receivers in three models to interface with Palm III™, IIIc™, or V™ organizers; Windows and IBM-type CPUs required
- StreetFinder City Centers (full-color downtown maps) for five of 35 key US cities, over one million business addresses, and address-to-address information accessible from an Internet site
- No external wires
- StreetFinder Deluxe software (three CDs and no activation or monthly fees)
- Vehicular dashboard mounting, rechargeable lithium-ion battery, and cigarette-lighter and AC-electricity adapter

MANUFACTURER: Rand McNally, Skokie, Illinois, USA

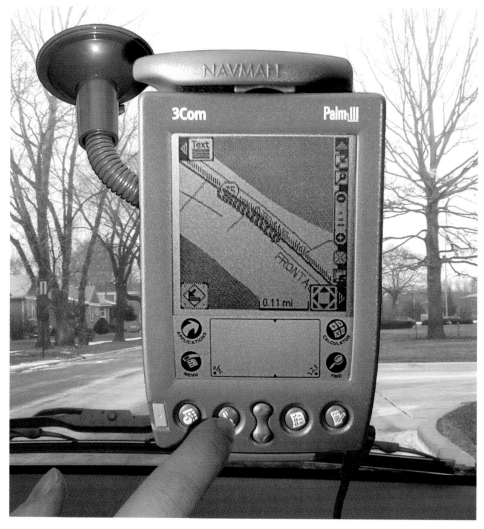

StreetFinder GPS model designed for use with the Palm III.

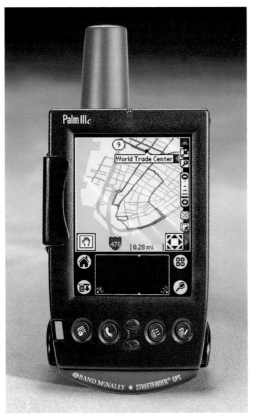

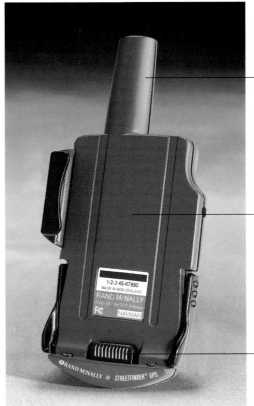

Antenna.

StreetFinder model designed for use with the Palm III and IIIc.

The serial connector of the StreetFinder fuses with the serial connector of the organizer.

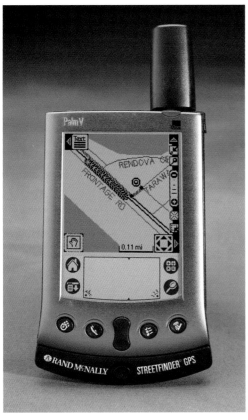

StreetFinder model designed for use with the Palm V.

"MOBY 2000 AND 5000" AND "MOBYGO!" REMOTE CONTROLLERS

The Nice company, founded in 1992 in a village in northeastern Italy, produces automation systems that remotely open doors and gates. Its devices, like the gate motors here, are easy to install, ergonomically designed, functional, innovative, and intelligent. The diminutive "Very VR" and "Very VE" transmitters (see facing page) control Nice's "Moby" motors that swing open gates—fast or slow.

FEATURES OF THE "MOBY 2000 AND 5000":
- Surface mounted electromechanical gear motor, 230 AC volts or 24 DC volts
- Electrical or mechanical limit switch for opening or dual limit switch for opening and closing
- Strong and silent running
- Aluminum case
- Simple and easy servicing
- Waterproof snap-on connector and built-in capacitor
- Aluminum locking system with a key
- Weight: 6 Kg

FEATURES OF THE "MOBYGO!":
- 24 DC volts
- Appropriate for heavy-duty use
- Intelligent clutch with anti-crushing safety feature
- Easy single-key programming
- Memorization of opening and closing limit-switch position
- Pause time
- Pedestrian gate function
- Weight: 7 Kg

DESIGNER: Roberto Gherlenda, Oderzo (TV), Italy
MANUFACTURER: Nice S.p.A., Oderzo (TV)

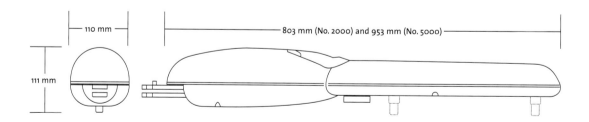
110 mm

111 mm

803 mm (No. 2000) and 953 mm (No. 5000)

"VERY VR" AND "VERY VE" REMOTE CONTROLLERS

The performance of a large transmitter has been incorporated into the "Very." Its name is derived from its "very" small unit size. The device, designed in 1998, has received several design awards and has been included in museum exhibitions.

FEATURES:
• Protection against accidental operation
• Shockproof
• Vast number of combinations, virtually eliminating duplication or fraud
• Various applications, but specially designed to control Nice motors for gates and doors
• Rolling codes: 433.92 MHz, "Very VR"; 433.92 MHz, programmable code with two transmission buttons, "Very VE"
• Ranges: 150–200 m, "Very VR"; 100–150 m, "Very VE"
• Colors: blue and black; either with a tuning aerial in free space
• Coding: digital, 52 bits (4.5 million billion combinations), "Very VR"; digital (1,024 combinations), "Very VE"
• 6 DC volt power supply with lithium batteries
• 10 mA average absorption
• Dimensions: 66 x 30 x 10 mm

DESIGNER: Roberto Gherlenda, Oderzo (TV), Italy
MANUFACTURER: Nice S.p.A., Oderzo (TV)

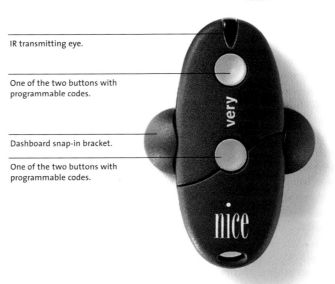

IR transmitting eye.

One of the two buttons with programmable codes.

Dashboard snap-in bracket.

One of the two buttons with programmable codes.

EURO-FRANC CURRENCY CONVERTER

Many Europeans are not yet accustomed to the equivalence of the euro to their former national currencies. Therefore, Caisse Nationale de Crédit Agricole, a French bank, commissioned the design studio Plan créatif to develop a euro-franc money converter that would be used as a promotional gift to its customers.

FEATURES:
• Quicker and easier to use than a calculator
• Small, handy, and inexpensive
• Clip-on belt attachment
• Neutral colors
• LED display screen
• Usable with one hand
• Materials: ABS and elastomeric plastic

DESIGNERS: Christophe Rebours and Olivier Beune, Plan créatif, Paris, France
CLIENT: Caisse Nationale de Crédit Agricole, France
MANUFACTURER: Columbia Finance

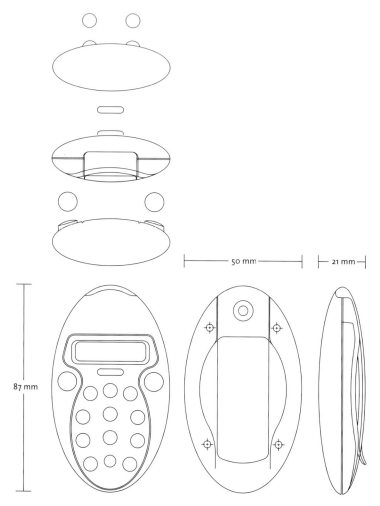

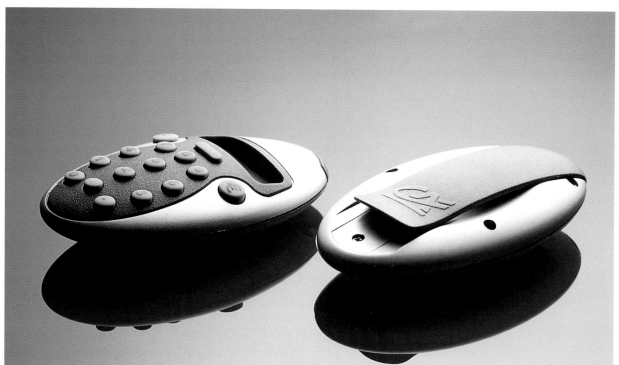

COMPUTERS

IBM HEAD-SET PC

Introduced at the 1998 IBM Fair and since refined, this wearable PC-based computer is derived from IBM's ultra-portable "ThinkPad 560." This fully functional prototype is part of a new class of IBM devices called "EON." The image of the micro-display appears to exist, floating in space, just in front of your face. Because the image is viewed with one eye while the other eye sees a real image, one is superimposed on the other. This feature may be particularly valuable, for example, when viewing geographical instructions acquired wirelessly via the Internet—you will see where you are going while a superimposed map also appears in front of you. Of course, the mini-system operates in the same manner as any PC. GE Power Systems was an early adopter for use by its power-station workers. (The original head set specifications are provided here.)

FEATURES:
- Walkman-size CPU
- Operation of Windows 98, Windows 2000, SoundBlaster Pro, and other software
- Connectivity to wire devices (mobile phone in development), external hard drives, a mouse, a keyboard, a standard monitor
- Navigation via a mouse or IBM's ViaVoice voice-recognition software
- PC card slot and USB port
- Monocle color display, worn over one eye
- Capability of a wireless-network connection, Web browsing, e-mail sending/receiving
- Dimensions: 510 x 345 x 167 mm

DEVELOPERS: IBM T.J. Watson Research Center (head-mount display); Personal Systems Group, IBM (CPU pack)

MANUFACTURER: Prototype by International Business Machines, Armonk, New York, USA

Photography courtesy International Business Machines Corporation. Unauthorized use not permitted

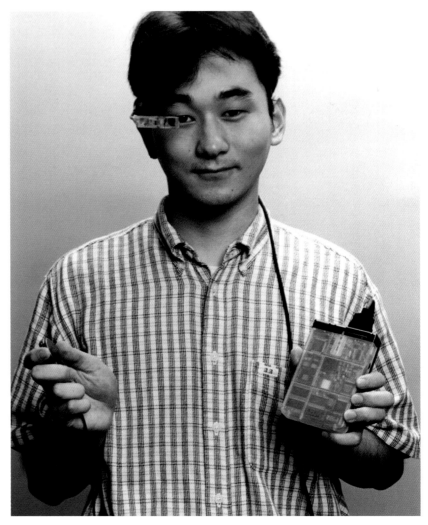

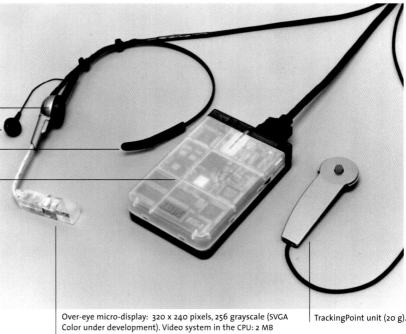

Earphone: SoundBlaster compatible (in the CPU).

Microphone: ViaVoice compatible (in the CPU).

Headset (50 g with micro-display).

Miniaturized CPU (120 x 80 x 26 mm, 299 g with battery): Intel MMX Technology Pentium, 233 MHz, 256 KB External L2 Cache, 64 MB memory, USB port, type 2 x 1 flash-card port, lithium-ion battery (1.5–2 hr) (battery not shown here). IBM micro drive: 340 MB, 25 in diameter, 5 mm.

Over-eye micro-display: 320 x 240 pixels, 256 grayscale (SVGA Color under development). Video system in the CPU: 2 MB video RAM, Subsystem NeoMagic MagicGraph 128XD.

TrackingPoint unit (20 g).

"MEDIA BAG" INTERNET-TELEVISION LAPTOP

This portable interactive television was made possible by the quest to produce flat display screens that are more mobile and user friendly. However, mass production is still too expensive to encourage retail sales. Thomson multimedia collaborated with V.I.A., the French philanthropic designer-support organization, and Christian Biecher to realize the "Media Bag" shown here. In order to solve the problem of flat TV and CPU in one unit, a monitor had to be developed that would, of course, be thin and lightweight enough to offer real portability. Designed in 1999, the prototype was produced in 2000.

FEATURES:
• 299-mm-wide full-color screen
• Combined television and computer operations on a single screen
• Laptop, desktop, or wall-mounted use
• Color: grey
• Dimensions: 360 x 402 mm, monitor component; 402 x 900 mm, open and flat

DESIGNER: Christian Biecher, Christian Biecher & Associés, Paris, France
MANUFACTURER: Prototype by Hazard Products, case and mounting; Model's Concept, case cover; Thomson multimedia, WEB TV including the LCD monitor, keyboard, remote control, and bag. Prototype sponsored by the V.I.A. Carte blanche award

Photographs by Christophe Fillioux

The case cover is made of a fabric called Method (27% cotton, 6% polyurethane, and 67% PVC) by Limonta, Italy.

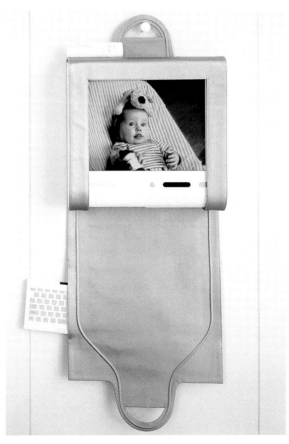

"ALLEGRO" COMPUTER PORTFOLIO

This portfolio, designed in 1999, combines virtual and real tools. Immediate, traditional paper and pens keep company with versatile, condensed computer technology. A working professional, for whom the unit is intended, can access the Web and also be able to use a larger-than-a-hand-held-organizer keyboard. This PIM (personal information manager) is a new type of product conjured by a team of social scientists, design planners, and designers who have acknowledged the need by people on the go for the supplies of a full office at their fingertips.

FEATURES:
• Portability that is facilitated by a thin CPU
• Hot button for quick access to the software, calculator, agenda, etc.
• Use of leather that suggests familiarity and elegance
• Internet access and PCMCIA card slots for connecting cord-connected peripherals such as modems and storage devices
• IR window for connecting wireless peripherals for information transference and other interface functions
• Appropriate for frequent or infrequent use
• Rechargeable battery
• Dimensions: 320 x 234 x 33 mm

DESIGNERS: Ziba Design, Portland, Oregon, USA
MANUFACTURER: Prototype for Vadem, San Jose, California, USA

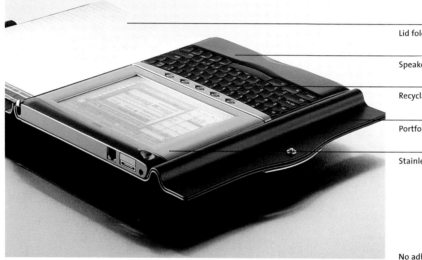

Lid folds back 360° under the base to save space.

Speaker is located in the wrist rest.

Recyclable ABS.

Portfolio is biodegradable natural leather and fiberboard.

Stainless-steel housing of the 18-mm-thick CPU.

No adhesives were used in the construction.

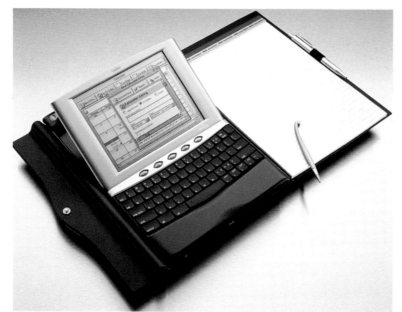

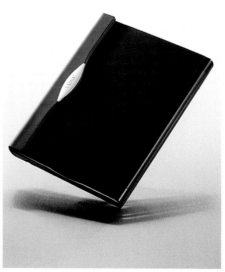

"BOUND PACKET COMPUTING" PORTABLE COMPUTER

This portable computer marries five essential components—screen, keypad, motherboard, drive, and battery. The user is encouraged to customize the size and configuration of each of the components, such as the quality and dimension of the monitor, the characters and graphics of the key pad, the memory capacity in the motherboard, the type of drive, and the voltage and kind of battery. Also, in the future, various elements, housed within clear plastic sleeves, can be replaced and updated. Of course, rather than the practicality of the unit, the design of the binder and the individual see-through sleeves are features that will immediately garner attention.

FEATURES:
• Five components stacked and bound into the binder
• Spine that locks the components in place on the inside, and offers essential peripheral ports and the electrical receptacle on the outside
• Flexible, varied, and customizable
• Dimensions: 230 x 280 x 45 mm

DESIGNER: Gary Natsume, Brooklyn, New York, USA
MANUFACTURER: Prototype by the designer

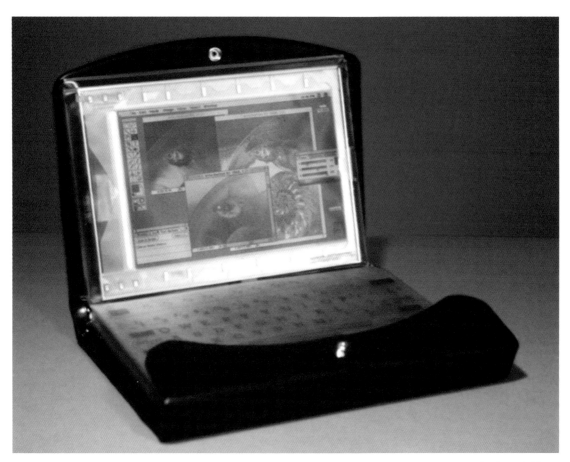

Peripherals, telephone, fax machine, scanner, printer, alternative-electricity, and other interfaces are connected through the seven ports in the binder's spine.

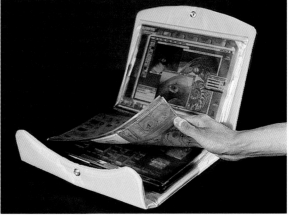

Five clear plastic leaves, like the pages in an ordinary ringed binder, contain the computer's components. Even the keyboard (above, top), the display screen (above) and the CD-ROM are housed within individual leaves.

"DATA POND" COMPUTER

Though conceptual, this computer could be put into production. However, understanding the way it works—biologically as well as mechanically—may require some leap of faith. The "Data Pond," or storage table, that was created in 1997, is essentially a reservoir from which individual digital "fish" capture pieces of information. The table is a gelatin-like case that reacts to hand pressure. A user is able to operate the computer through touch and stroking, somewhat like massaging. The "Data Cells" capture but do not transmit data. The "Hyper Components"—such as the camera, IR transmitter, and satellite receiver—are elements with individual functions. A user holds the "Data Cell" and one or another of the six "Hyper Components" in his or her hand, wraps them together with the matrix skin (somewhat like plastic-wrap film for food storage), and then places the package on the wrapping plate where it is sealed by heat and radiation. The results is a "Hyper Personal Assistant," which is different every time it is assembled, even though the same elements may be included in the "package." The skin is transformed into an electrical connector for all the assembled components and also serves as the display, like an LCD screen.

FEATURES:
- Design and technology on a genetic level
- Physically manipulatable components that directly interface with a user's body
- Tactile and metaphorical
- Dimensions: approximately 600 x 1200 mm, "Data Pond"

DESIGNER: Gary Natsume, Brooklyn, New York, USA
MANUFACTURER: Prototype by the designer

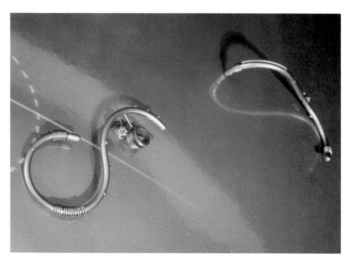

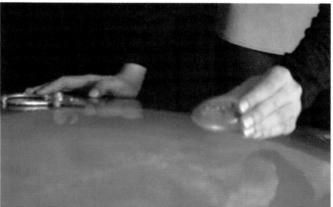

Individual "fish" (top right) represent pieces of information.

Massaging the surface of the furniture-scaled "Data Pond," searching for information.

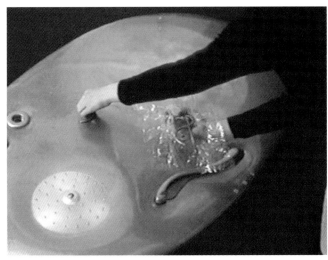

For data transmission, each of the "Hyper Components" (like those on the bottom row, left and right) are wrapped in a matrix skin (left, top), heat- and radiation-sealed like food in plastic wrap (middle row, left), and placed on top of the wrapping plate (middle row, right).

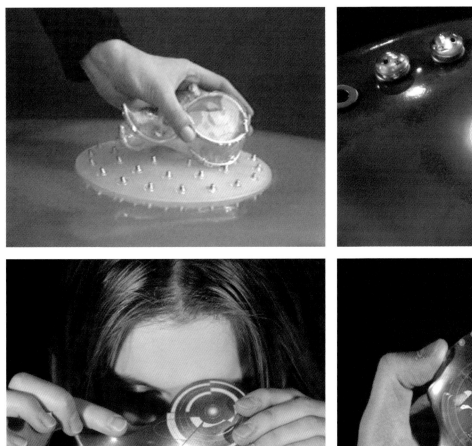

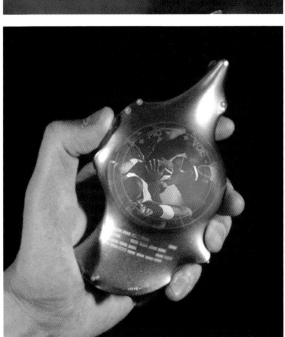

The virtual camera (left) , telephone (right), and other tools (not shown) are wrapped to form a "Hyper Personal Assistant," sealed, and then transmitted.

"ZUZU PETALS" DIGITAL DEVICE

This unit is essentially a docking station with "Zuzu Petals." And each "petal" is a computer-type peripheral. The idea, developed in 1998, was to create a PDA (personal digital assistant) that could grow and change without soon becoming obsolete. "Zuzu Petals" and the "Gooru" on the facing page were designed by the same office.

FEATURES:
- Digital camera with a rotating lens and moveable shutter button
- PDA with an integrated stylus that fans open
- Digital audio assistant that records, stores, and organizes digital sound; delivers voice messages; and plays music
- "Digital Dirt," an element in the base that contains imbedded solar cells to serve as the power source
- Dimensions: 152 x 380 mm

DESIGNERS: Josh Goldfarb, Simon Yan, and Jon Lindholm, industrial designers; Peter Kopec, prototype specialist; all of Herbst LaZar Bell Inc. (HLB), Chicago, Illinois, USA
MANUFACTURER: Prototype by Herbst LaZar Bell Inc. (HLB)

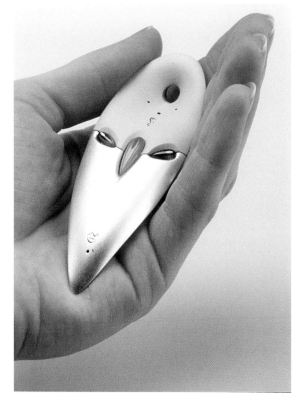

The unit is a combination of injection-molded plastic parts and hand-assembled accessories. Materials include aluminum, Santoprene, LEDs, and acrylics.

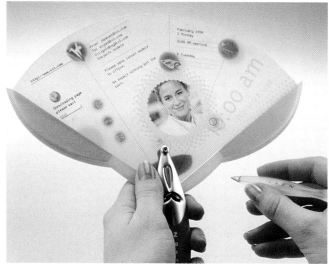

The screen of the PDA "petal" (above and top right) fans out to receive satellite transmissions, wireless communications, or solar charging.

The four components are attached to the "stalk" like "petals," and the stalk acts as an information downloader and transfer component. Located in the "pot," individual chargeable modules absorb solar energy and power the unit.

"GOORU" BACKPACK PC

The "Gooru," designed in 1999 and intended for children aged seven to eleven years, is composed of three elements: the "GooBall" interactive device, a backpack, and a screen. The device is supposed to replace books, pens, traditional PCs, and other classroom supplies.

FEATURES:
• "GooBall" communications device that has its own "personality" and provides entertainment, educational advice, and personal guidance
• Backpack (with a fingerprint-recognition zipper-opener) that contains the system's storage and power supply
• Flexible, removable display screen, usable with the backpack or alone or attached to the classroom peripherals
• Communication with a teacher or parent at any time
• Monitoring of a child's learning while allowing for individual development
• Dimensions: 304 x 229 x 115 mm, backpack; 89 x 89 x 50 mm, "GooBall"; 254 x 254 x 50 mm, display screen

DESIGNERS: Elliott Hsu, Jason Billig, and Jason Martin, Stefan Andren; all of Herbst LaZar Bell Inc., Chicago, Illinois, USA
MANUFACTURER: Prototype by Herbst LaZar Bell Inc.

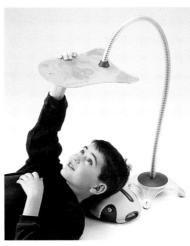

The portable screen (left) is a flexible-polymer LCD display screen. The "GooBall" interactive device (far left), made of neoprene, can be upgraded with more "Goo," or features, to increase the life of the device.

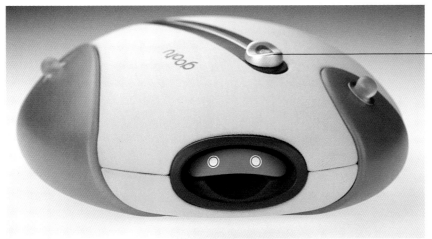

Finger-print-recognizer zipper opener.

The washer-safe backpack is made of neoprene with a Lycra cover. The straps are recycled polyester.

"APPLE® POWERBOOK G4 MAGNESIUM" LAPTOP COMPUTER

Just 25 mm thick and lightweight, the "Powerbook G4" is the first laptop computer to be made of 99.5% pure titanium. In addition to serving as a regular computer with a Macintosh platform, it will show DVD movies on a fairly wide, high-resolution screen at speeds up to 500 MHz.

FEATURES:
• Slot-loading DVD-ROM drive
• 50 watt lithium-ion battery, up to five hours on a charge
• Up to 30 GB hard drive and 1 GB of RAM, ATI RAGE 128 graphics, FireWire (up to 63 different device interfaces), USB, PC card slot, VGA and S-video outputs, built-in microphone and antenna, and stereo-sound output
• 382-mm-diagonal screen (1152 x 768 pixel resolution)
• Movie-making capability with iMovie software and advanced video editing, composing, and special effects with Final Cut Pro software
• Importation and management of digital music with iTunes software
• Ability to show home-made movies on a VGA monitor, large-screen TV, or project system
• Type II PC Card/CardBus that permits the downloading of images from a digital camera or camcorder
• 10/100BASE-T Ethernet for quick access to a network and DSL or cable modem; and 4 MB per second IrDA technology for wireless data transference
• Many other features
• Weight: 2.4 Kg

DESIGNERS: Jonathan Ive and the design-department staff, Apple Computer, Cupertino, California, USA
MANUFACTURER: Apple Computer, Cupertino

Photography courtesy of Apple Computer

25 mm when the lid is closed.

"APPLE® G4 CUBE" AND COMPUTER PERIPHERALS

Hovering in a transparent Lucite vitrine, the silvery "G4 Cube" offers all the power of the mega-computers of the 1960s that occupied the volume of a big room. The new configuration of the "G4 Cube"—made possible by a breakthrough in complex engineering and the development of advanced materials—occupies one-fourth the space of most desktop CPUs. In order to retain an unadorned form, the cooling slots are located at the top, and cables are connected through openings in the rear. The arrangement of the interior components is as well conceived as the exterior; they are arranged around the hot-air vent. Eerily quiet compared to most computers, an interior cooling fan has been eliminated; there is only the gurgling sound of the hard drive. The advancements of the "Cube" are the result of Apple's having called on the efforts of its own engineers rather than those of others. The only visible orifice, in addition to the top vent, is the slot for the DVD/CD drive—the reason the machine has been affectionately compared to a bread toaster.

FEATURES:
• 450 MHz PowerPC™ G4 processor with Velocity Engine™
• SDRAM memory
• 20 GB Ultra ATA hard drive
• DVD-ROM drive with DVD-video playback, or CD-RW drive
• ATI-RAGE 128 Pro graphics with 16 MB
• Harman Kardon audio technology or NVIDIA GeForce2 MX
• Apple Pro Optical Mouse and Pro Keyboard (see facing page)
• Two USB and two FireWire ports
• 51 K V.90 modem
• iMovie2™
• 10/100 BASE-T Ethernet
• Other features

DESIGNERS: Jonathan Ive and the Apple design staff
MANUFACTURER: Apple Computer, Cupertino, California, USA
Photography courtesy of Apple Computer

The items shown here
are not proportional
to each other.

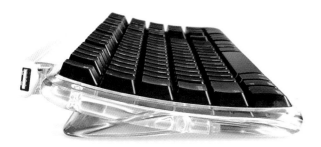

"APPLE® AIRPORT™"

Looking more like a spacecraft than a new kind of modem, the wireless AirPort offers connection to the Internet or other computers without the need for a standard in-wall telephone connection. The separate, non-attached "AirPort Base Support" unit is plugged into a telephone jack. When an "AirPort" card is installed into a newer-model Apple computer, the AirPort is an effective receptor up to 45 m from a wall jack—even through brick walls.

"APPLE® PRO KEYBOARD™"

Featuring a full-size 108-key layout and surrounded by clear Lucite like the "Pro Mouse" (below), the board features an all-new media eject button and a two-port USB hub for mouse connections. The extending brace beneath permits the unit to be tilted toward the typist.

"APPLE® PRO MOUSE™"

The improved tracking of this mouse was made possible by new optical technology. There is no ball to clean and no dirty pad to replace. The clear Lucite casing is a sparkling design feature that mirrors the transparency of the "Cube." An LCD light is powered through the USB connector.

431 AND 382 MM DISPLAYS

431 mm "Apple® Cinema Display" (left), a clear-edged monitor with a wide width-to-height image ratio, features clear oblique viewing angles and 1600 x 1024-pixel resolution. 382 mm "Apple® Flat Panel Studio" display, an ultra-thin monitor, features touch-sensitive buttons with visual feedback and 1024 x 768 pixel resolution. Both displays have active-matrix LCD screens and two self-powered USB hubs.

"APPLE® 431 MM STUDIO DISPLAY"

This monitor, with the see-the-mechanics design that was pioneered by Apple, amalgamates high screen quality and a natural, flat Diamondtron CRT picture tube with a 431 mm-diagonal image, 0.25 mm aperture grille pitch, 1600 x 1200 pixel resolution at 65 Hz, flat screen, ColorSync®, and a two-port self-powered USB hub.

"KOI" LEGACY-FREE CPU

The small size of the "Koi" CPU, designed in 1998, was made possible
by the inclusion of a small, legacy-free platform, rather
than a traditional platform with space-consuming and superfluous
expansion bays and card slots. The "Koi" suggests how CPUs might
be shaped and, in turn, offers relief from the traditional beige box.
The name "Koi" was derived from the Japanese fish whose "mouth"
on the CPU's housing directs a user to the DVD drive, the only
interactive opening. (See the other legacy-free CPUs designed by
Ziba on the following two pages.)

FEATURES:
• Plug-and-play quick starting
• Friendly and small housing; fun and easy to use
• Compact size made possible by the smallest motherboard available
 with a high-speed processor and by the legacy-free platform
• Power/sleep button for continuous operation with power saving
• Dimensions: 250 x 240 x 195 mm
• Weight: 3 Kg

DESIGNERS: Ziba Design, Portland, Oregon, USA
MANUFACTURER: Prototype for Intel, Hillsboro, Oregon, USA

Small LED indicator (not shown, see top right photo) for signaling incoming e-mails to the left of the on/off button.

"Mouth" of the DVD drive.

Speakers and vents.

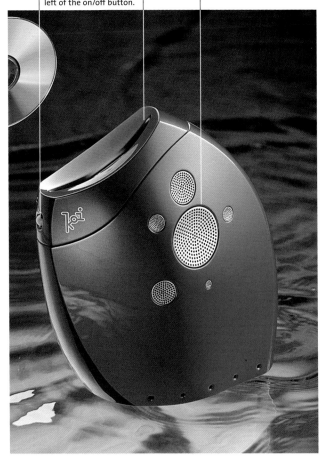

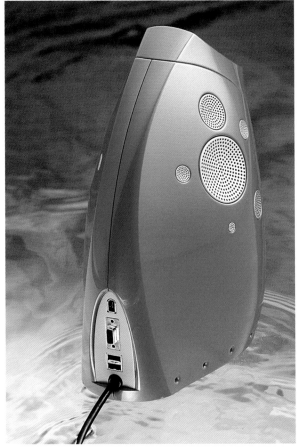

"AZTEC" LEGACY-FREE PC

A legacy-free platform made the small size of this unit possible. The expansion bays and card slots incorporated into most computers—the legacy type that occupy a lot of space—are not important to most computer users. As the Ziba Design staff discovered through its research, most users do not want to open their CPUs, and, when updating is desired or needed, they buy new machines and discard the old ones. The "Aztec" and the other models shown on these pages—three of over 30 different viable configurations explored by the Ziba Design staff—are the fruit of an assignment from Intel to create a new CPU that breaks the mold of old thinking. They presumably answered Intel's question: "What would a consumer PC look like if all it had was a 500 MHz processor and a DVD drive?"

FEATURES:
• Plug-and-play device with only a single power button, two LEDs, and three front-mounted peripheral ports
• Top placement of the DVD drive to save space
• Small super-high-speed processor
• Minimal packed-air space while meeting cooling/shielding requirements
• Dimensions: 250 x 240 x 195 mm
• Weight: 2.7 Kg

DESIGNERS: Ziba Design, Portland, Oregon, USA
MANUFACTURER: Prototype for Intel, Hillsboro, Oregon, USA

Were the red "Aztec" hard drive (background) and the green "Aztec" PC put into production, the housings would include virgin resin, recycled materials, and a machined-aluminum top. No element would need painting.

CONTINUED ▶

"TWISTER" LEGACY-FREE PC

The "Twister" is another in the series of CPU prototypes suggested by Ziba Design for Intel. They are based on legacy-free configurations in which space-consuming expansion bays and card slots have been eliminated, thus making it possible to create a very small unit. The "Twister," essentially a CPU with a "twist" that was developed in November 1998, responds to Intel's request for a plug-and-play computer like no other but still appropriate for the business environment.

FEATURES:
• No elaborate set-up, no complicated cables to connect, no necessity for an instructional manual
• Very simple to operate, with the DVD and the power button as the only interactive elements
• Unique vertical internal-component configuration to make the twisted shape of the housing possible
• Sideways placement of the DVD to save space
• Front and rear USB ports for peripherals and easy networking with other computers
• Prototype created to interest manufacturers and the press in designs that transcend yesterday's beige box
• Technically innovative, very small, high-speed motherboard by Intel
• Dimensions 150 x 210 x 285 mm
• Weight: 3 Kg

DESIGNERS: Ziba Design, Portland, Oregon, USA
MANUFACTURER: Intel, Hillsboro, Oregon

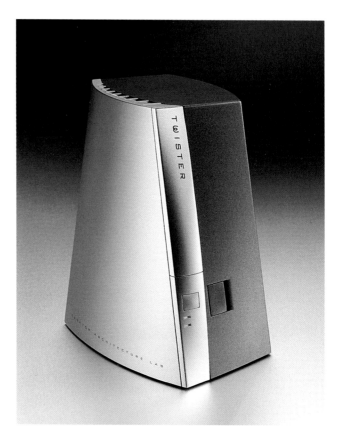

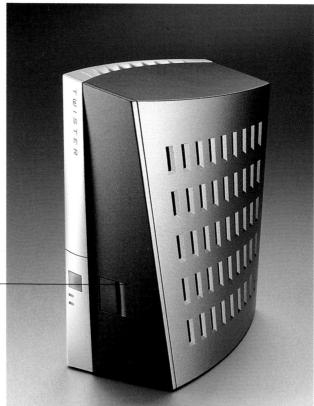

The venting pattern offers function and visual interest.

The light-and-dark color combination of the housing creates the illusion of a unit that is smaller than it really is. The materials used in all three Ziba/Intel CPUs include cast urethane for the cabinet, bent sheet metal for the brackets, EMI coatings and water-based paint.

COMPUTER
PERIPHERALS

"POCKET DRIVE™" PORTABLE FIRE WIRE/USB HARD DISK AND CD-RW DRIVE

When a new technology is introduced, it becomes available to everyone, based only on patent laws. And so it is with the FireWire® and USB universal series buses and CD-ROM hardware that support the connection and operation of external data devices, like the ones shown here, which are connected to CPUs and provide fast transfer rates. The development of the housings of all products like the "PocketDrive" are often placed in the hands of professional designers. Their suggestions might be bizarre or mundane. The cabinets of the units here assume a middle-ground—pleasing and curvaceous but far from the beige angularity of the past. They were designed in 2000 and produced from 2000–2001.

FEATURES:

• FireWire® and USB ports, 4200 RPM max.; audio port in the CD-RW drive
• Transfer rates: FireWire® @ 12–14 MB per second, hard and CD-RW drives; USB @ 4200 RPM max., hard drive; USB @ 650–900 KB/sec., CD-RW drive
• Hard drive: 10, 20, or 30 GB capacities
• CD-RW: reads, writes, erases, and rewrites CDs more than 1000 times
• Hot plugging without restarting the CPU
• Small pocket size
• PC or Macintosh compatible
• Anti-shock silicon housing
• Dimensions: 140 x 84 x 26 mm, hard drive; 150 x 160 x 32 mm, CD-RW
• Weights: 3.5 Kg, hard drive; 7 Kg, CD-RW drive

DESIGNER: Neil Poulton, Poulton & Poulton, Paris, France
CONCEPTION: LaCie Group, Massy, France

A shock-resistant silicon bumper protects the unit and, likewise, the data stored within during transportation. The one-piece body is force extracted from the mold.

Labels are textured polyester, screen printed on the underside, then die cut to size. Standard Pantone® Silver with 4% gold dope creates the sparkle effect.

A groove on three sides holds interface cables and facilitates easy transportation.

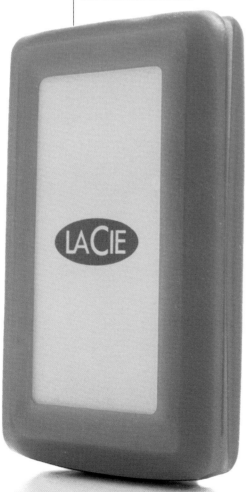

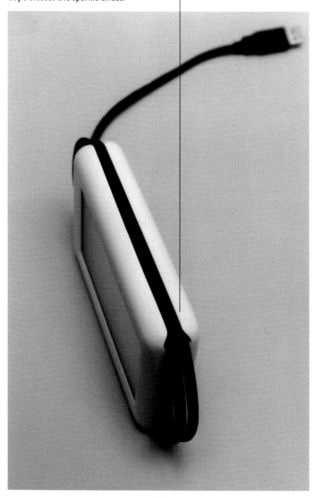

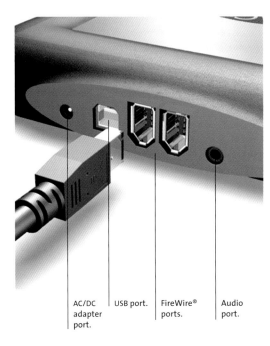

AC/DC
adapter
port.

USB port.

FireWire®
ports.

Audio
port.

One of the advantages of CAD-software drawings (above) is that cabinets can be designed and
infinitely and inexpensively altered before production. They also provide precise instructions
for the tooling and manufacture.

During transport or non-use storage of the
unit, the FireWire® or USB cable can be neatly
wound around the unit.

"MY SOFT OFFICE"
COMPUTERS AND PERIPHERALS

Hella Jongerius's conceptual ideas for a home office include an extra-long bed whose ends can be raised. The foot portion houses an IBM computer/monitor. In her double-bed version (not shown here), two monitors are embedded in the foot, and throw pillows serve as speakers or a mouse. Other ideas the designer has developed for the home office include the eating-bowl keyboard and a fur-pillow computer. These and other prototypes by Jongerius were commissioned by New York's Museum of Modern Art for the 2001 "Workspheres: Design and Contemporary Work Styles" exhibition.

FEATURES:
• Unorthodox materials
• The antithesis of standard computer-design solutions
• New ways of injecting work into home life
• "Free-range design," in the designer's words

DESIGNER: Hella Jongerius, JongeriusLab®, Rotterdam, The Netherlands
MANUFACTURER: Prototypes by the designer

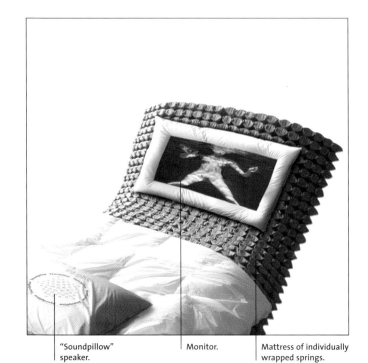

"Soundpillow" speaker.　Monitor.　Mattress of individually wrapped springs.

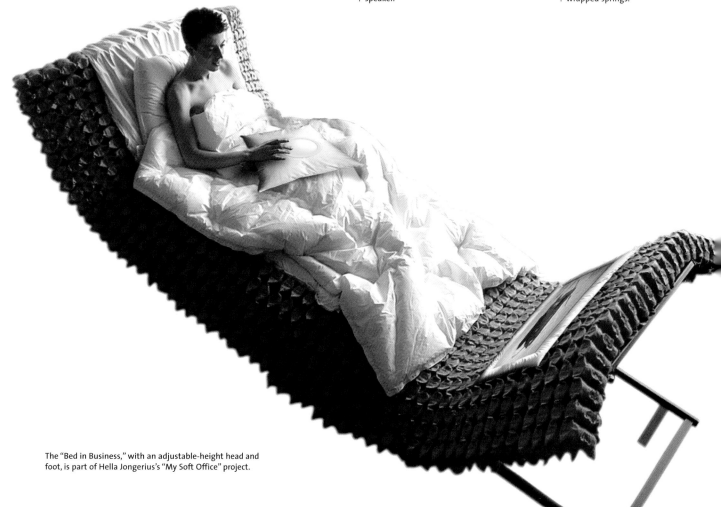

The "Bed in Business," with an adjustable-height head and foot, is part of Hella Jongerius's "My Soft Office" project.

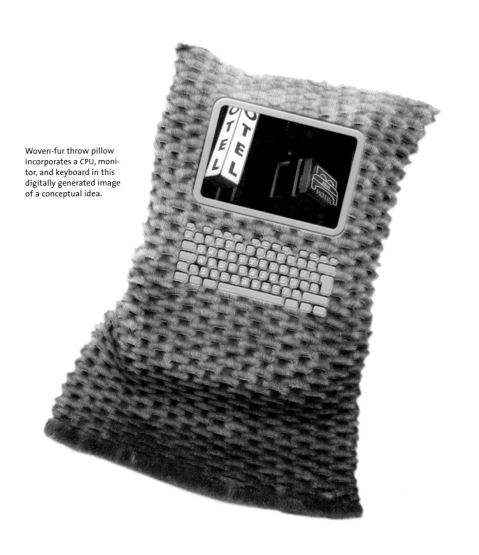

Woven-fur throw pillow incorporates a CPU, monitor, and keyboard in this digitally generated image of a conceptual idea.

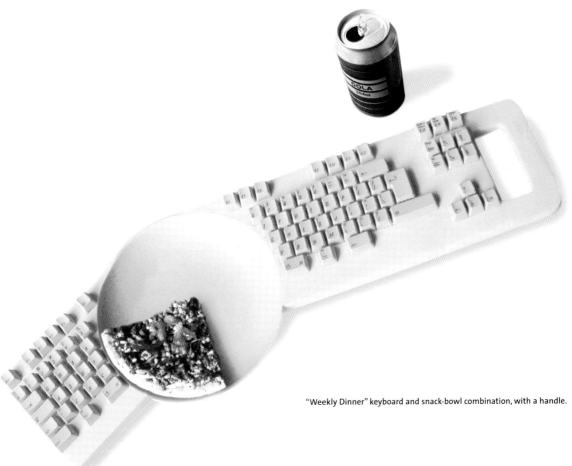

"Weekly Dinner" keyboard and snack-bowl combination, with a handle.

"ARTJET 22" INK-JET PRINTER

Olivetti Lexikon is the only company in Europe to produce a proprietary ink-jet printer which is based on a special nozzle matrix to optimize ink flow. The single print head can print in four colors, as opposed to the usual three-color process. When the black ink runs out, the printing continues with three colors that produce a black effect; a key is pressed, and the printer will begin again. The "Artjet 22" can also print in black only. Michele De Lucchi designs all the firm's products, including other "Artjet" models.

FEATURES OF "ARTJET 22":
• Small, extra-compact
• Active-chip four-color monoblock print head, containing three colors and graphical black
• New-type engine
• Operation can be vertical or horizontal, depending on available surface space
• 13 pages per minute for black and nine pages per minute for full color
• Automatic paper feeding; three paper trays printing on plain or photographic paper, thermal transfers, transparencies, envelopes, greeting cards; supporting US and European formats
• Software: Micrografx Draw and Picture Publisher
• 150 cut-paper tray capacity
• USB port; 2 MB of RAM; 1200 d.p.i resolution
• Dimensions: 200 x 460 x 200 mm

DESIGNER: Michele De Lucchi, Milan, Italy
MANUFACTURER: Olivetti Lexikon, Ivrea, Italy

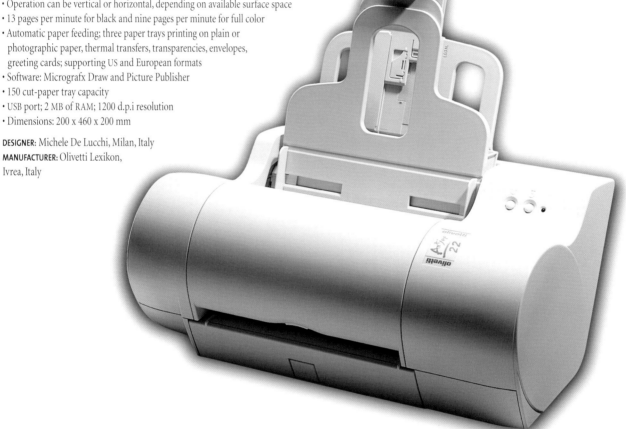

In addition to being physically attractive and built with advanced technical standards, the printers are put through a rigorous testing program.

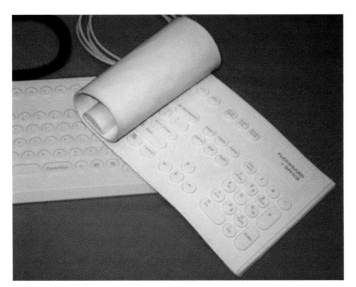

"FLEXBOARD®" KEYBOARD

The "Flexboard," first introduced in Europe in about 1998, is a flexible keyboard for home, office, medical, or industrial use. Because the mechanics and wiring are sealed within the flexible housing (available in five colors), this keyboard is particularly appropriate in marine, boating, and restaurant environments where the possibility of water damage is great. And how many people have spilled drinks on their keyboards, causing short circuitry, loss of data in the CPUs, or permanent damage to the keyboards? The manufacturer also offers the "CoverView" water-resistant LCD monitor (not shown).

FEATURES:
- Resistant to water, moisture, and spills
- Sealed surface that prevents liquid, food, dust, and contaminant penetration by mistake or when the board is being cleaned
- Easily cleaned
- Child-proof
- Roll-up feature for portability along with laptops and other mobile devices
- Flatness to permit wrist and forearms resting on desktops while typing
- Available in basic and industrial models and two sizes
- Colors: light grey, dark grey, blue, yellow, green, glow-in-the-dark
- Dimensions: 497 x 175 x 7.5 mm, standard size; 411 x 175 x 7.5mm, short size

MANUFACTURER: Man & Man Machine, Inc., Landover, Maryland, USA

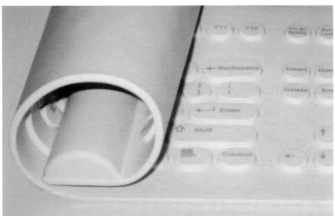

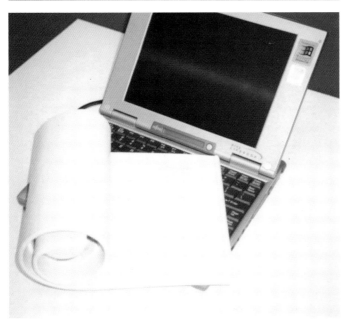

The keyboard can be rolled up for easy storage or transportation with laptops and other mobiles.

"iFEEL™ MOUSE MAN®" OPTICAL MOUSE

This somewhat bizarre mouse by Logitech, the world's largest mouse maker, offers a vibrating sensation. It lets you navigate your cursor over various bookmarks, menus, Web links, and more and records motion optically. Because it is optical, the mouse has no ball to clean or to become loose and it can be operated on any surface. Logitech also produces the "iFeel™" mouse in an optical version that eliminates the pointer (not shown).

FEATURES:
• No special software required; the MouseWare® software already assigns double clicking with single clicking to the buttons
• Pull-down menu of available shortcuts to simplify setting changes
• No ball or roller
• No moving parts
• No cleaning required
• Ergonomically hand-fitting
• Four customizable buttons, including a handy side button under the thumb
• Translucent base and iridescent metallic-blue finish
• Packaged with MouseWare® 9.1 CD-ROM and includes WebWheel™ software
• PS2- or USB-port connection; PC or Macintosh compatible

MANUFACTURER: Logitech Inc., Fremont, California, USA

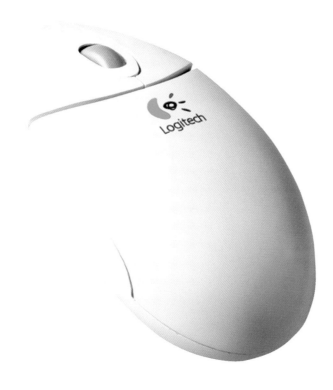

CORDLESS WHEEL MOUSE

The struggle with mouse cords has been eliminated. Calling on radio-transmission technology, this mouse can function up to 2 m away from a CPU without having to be pointed directly at it. It even performs on crowded or messy desks and uneven surfaces.

FEATURES:
• Operation within 2 m
• Usable with the left or right hand
• Three customizable buttons for fast access to repetitive tasks
• Zooming capability
• Easy scrolling on Windows® or the Web
• Packaged with MouseWare® 9.1 CD-ROM and WebWheel™ software
• Web access required for full WebWheel functionality
• PS2- or USB-port connection; PC or Macintosh compatible

MANUFACTURER: Logitech Inc., Fremont, California, USA

"ID MOUSE"
FINGERPRINT DETECTOR

The "ID Mouse" is assembled with hooks and glue but only one screw. Designed in 1999, this mouse became the first product with the FingerTIP™ sensor, based on capacity rather than on optics. Since PC-mouse functionality and fingerprint technology have been combined in one, a much higher security level is offered. This is how it works: the eye on the mouse scans one or more of a person's fingers into the system. No one else can enter a CPU after the user's fingerprint patterns have been fed into the recognition software, not even copied fingerprints. The FingerTIP sensor compares the characteristics of the sensor surface with a finger, and the result is converted into a digital image. Fingerprint characteristics are established by means of special algorithms and then securely saved so that they cannot be compromised. When a finger is placed on the mouse's sensor, the reference data is compared with the original fingerprint.

FEATURES:

• Accessibility to all available PC interfaces
• Right- or left-hand use
• Optimechanical mouse functions
• 224 x 288 pixel resolution, 513 d.p.i., data format, 9 bits/pixel
• 200 +/- 50 mm/sec. tracking speed
• One million button-operation cycles
• Compound USB device that combines two logical tools in one
• High-speed controller and fingerprint recognition
• Comparison data that is never stored as text
• Materials: plastics and rubber
• Dimensions: 125 x 60 x 30 mm

DESIGNER: Giovanna Correra, designafairs, Munich, Germany
MANUFACTURER: Siemens AG, Berlin and Munich
Photography by Studio Köller, Munich

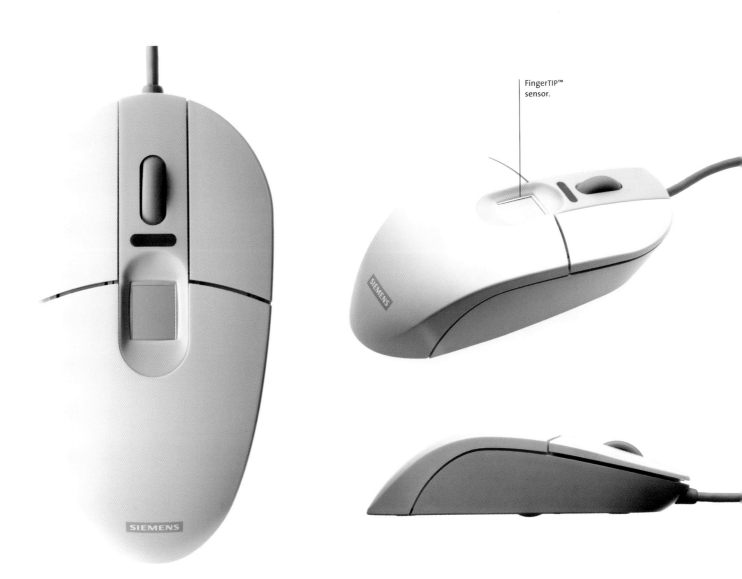

FingerTIP™ sensor.

"EYE D KEYBOARD™"

The "EyeD Keyboard™" is the only existing keyboard with fingerprint recognition and smart-card technology. It is also the first to have offered total PC and network security with the touch of a finger.

FEATURES:
· Durable, even under extreme conditions and climates
· Standard 104-key QWERTY layout for use with Windows® applications
· Rubber-membrane switch type
· 20-million-cycle key switch life
· 5 DC volts
· 50 mA maximum current consumption
· First to offer total PC and network security with the touch of a finger
· PS/2- and parallel-port connections for pass-through functionality
· Extraction of numerous minutia points from an enhanced fingerprint image
· No additional power required for finger imaging or mouse functioning
· Less than one-second verification time
· Proprietary scratch-proof platen
· SEIR (surface-enhanced irregular reflection) optical-design method

DESIGNER/MANUFACTURER: BTC Korea Co. Ltd, Inchon, Korea, for SecuGen Corporation, Milpitas, California, USA

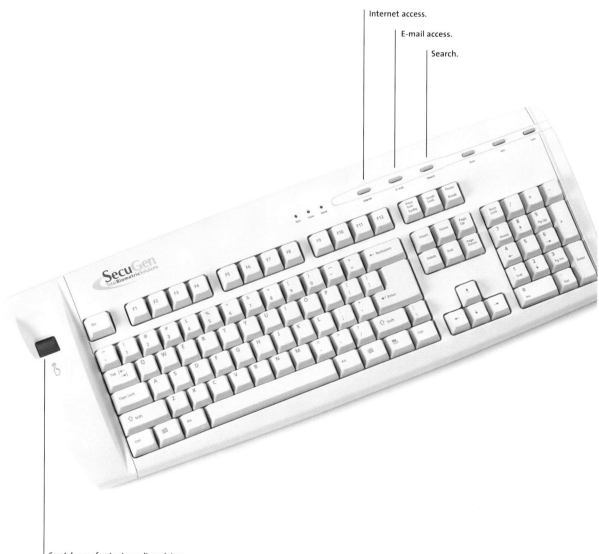

Internet access.

E-mail access.

Search.

Scratch-proof patent-pending platen
where a fingertip is placed for recognition.

"U.ARE.U 2000 FINGERPRINT SENSOR"

Fingerprint detection devices are available from DigitalPersona in several models. The "U.Are.U 2000" is shown here. The detector is a self-contained unit that captures a fingerprint's pattern and transfers it as a digital image to a host processor, normally a CPU, via a USB interface. Since the sensor unit is small, it is particularly appropriate as a peripheral to a laptop computer. It will also interface with desktop CPUs and other PC units.

FEATURES:
· Precision optics
· LED light source
· CMOS (complimentary metal-oxide semiconductor) imager
· In-unit electronic control-image capture, self-calibration, and plug-and-play USB transference
· High-quality image
· Small footprint
· Encrypted image data
· Recognition of dry, moist, or rough fingers
· Resistant to ESD (electrostatic discharge)
· Compatible with POS (point-of-sale) terminals at retail cashier sites when identification is required
· Dimensions: 54 x 65 x 27 mm

DESIGNERS: Montgomery Pfeifer, San Francisco, California, USA
MANUFACTURER: DigitalPersona, Inc., Redwood City, California

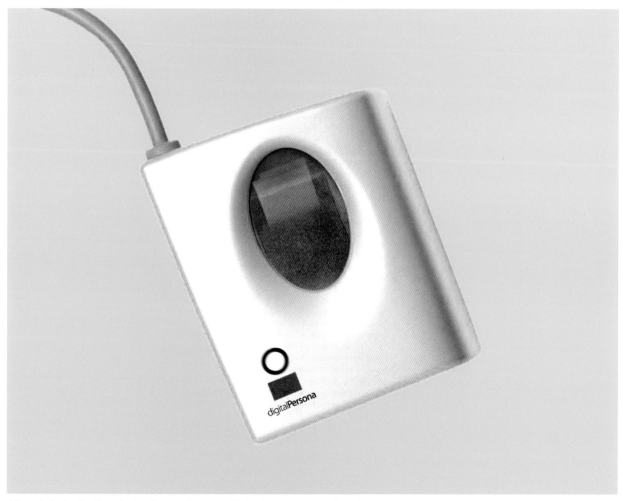

A fingertip is placed on the red LED capture area (13 x 18 mm) to transfer a 480 d.p.i.-resolution image.

TERMS, ABBREVIATIONS, AND ACRONYMS

In addition to the terms and abbreviations below, other, rarely used, terms are accompanied by definitions where they appear in the text.

ABS, acrylonitrile-butadiene-styrene, a tough rigid plastic material.

BLUETOOTH™, short-range (up to 10m) radio technology at a high width band (2.4 GHz) that allows wireless communication among 'Net and Palm-type devices, digital cameras, printers, and mobile phones; developed in 1994 in Lund, Sweden, by Ericsson; to be used free of charge; named for King Harald Bluetooth (or Blåtland, "dark complexion" in Old Viking), 910–940 C.E., who drew together different tribes in Denmark, where he introduced Christianity.

BUS OR EXTERNAL BUS, connects a computer to peripheral devices.

CD, compact disk, usually containing playable recorded music when referred to only as a "CD."

CD-R OR CD-RW, compact disk—reads, or compact disk—reads and writes.

CD-ROM, abbreviation for "compact disk read only memory". It can be read or played but not recorded on.

CHIP, a small (less than 6 mm) semiconductor piece, frequently made of silicon, into which an integrated circuit is embedded and which can contain millions of transistors (or electronic components). Many chips are placed on the printed circuits (or electronic boards) of CPUs.

CPU, central processing unit, the box that contains the brains of a computer; housed in a single unit called a chip (or microprocessor).

CURSOR, the moveable pointer on a display screen guided by a mouse data transfer rates, the speed that data is transferred from one device to another.

DATA, certain pieces of information that are formatted in a special way.

DIGITAL, a system that is based on discontinuous events or data.

DISPLAY MONITOR, same as a monitor.

DISPLAY SCREEN, a monitor attached to a computer, but it may also mean the screen itself only.

DVD, digital versatile disk or digital video disk, a type of CD-ROM disk.

FORMATTED, the preparation of a stored media.

GPS, global position system for navigation and position finding through the use of a hand-held device (or Palm-type device).

GSM, global system for mobile communications, a type of cellular system introduced in 1991, available in 100+ countries by 1997, and now the European and Asian standard for cellular-phone production. GSM is based on narrowband TDMA (time-division multiple access) that permits eight calls on the same radio frequency at the same time.

HDTV, high-definition television.

ICANN, the acronym for the Internet Corporation for the Assignment of Names and Numbers. In 2000, the US government turned over the service of providing domain names to a number of private firms which charge fees for Web-site-assignment names that are preceded by "www." for "World Wide Web" and are followed by ".com," ".org," ".tv," ".cc," etc.—names that used to mean "company," "organization," etc., but not necessarily any longer.

IEEE 1394, very fast external bus that supports data transfer rates up to 400 MB per second.

INTEGRATED CIRCUIT, same as a chip.

IR, written as IR for infrared, frequently used to transmit signals to offer cordless features to peripherals and remote controllers.

IRDA, written as IrDA for the Infrared Data Association, a group of manufacturers that developed certain standards to be used in the construction of devices like remote controllers, computers, and printers, transmit signal via infrared waves.

ISP, Internet-service provider, like ATT Worldnet, AOL, Wanadoo, Noos.

KEYBOARD, a set of keys in a unit that is connected to a computer, operating like a typewriter but signaling instructions to the CPU.

LED, light-emitting diode, a semiconductor diode that is used in electronic display, as in watches and, currently, television screens.

LEGACY, an application in which a company or an organization has invested appreciable money and time. Legacy applications are run on minicomputers (or PCs) or mainframe computers. Certain new software can work with legacy applications or import data from them.

LNB, a technology for receiving certain broadcast band widths from satellites, particularly for HDTV reception.

MEGABYTES, describes data storage of 1,024 kilobytes.

MICROPROCESSOR, a silicon chip that contains a CPU. "Microprocessor" and "CPU" are interchangeable terms.

MMI, man-machine interface.

MODEM, the acronym for modulator-demodulator, a device or program that allows a computer to transmit data over a telephone line.

MONITOR OR DISPLAY MONITOR, a video-screen unit that shows the actions and functions of a computer, whether they be letter writing, still and moving pictures, graphs, and charts, or other more advanced graphics.

MOTHERBOARD, the main circuit board of a microcomputer. The motherboard contains parallel and serial ports, controllers, memory, mass-storage interfaces, etc.

MOUSE, a device that controls the movement of the cursor or pointer on a display screen.

CONTINUED ▶

MP3, a file extension for MPEG (originally derived from the acronym for moving picture experts group) and now known as the device itself that downloads music from a Web site or from other sources of music such as CD players. The "3" is for audio layer 3, for the compression of audio signals and additionally cleaning up the sound.

NETWORK, a group of two or more computers linked together.

OPERATING SYSTEM, a program that runs a computer.

PALM-TYPE DEVICE, a hand-held device, similar to the Palm™ organizer developed by 3Com, and so named because it fits in the palm of a user. It contains software appropriate for organizing schedules such as keeping track of appointments, tending a calendar, or taking notes. Some models can send and receive e-mail messages through the Internet, operate as GPSs, and perform other sophisticated functions.

PC, personal computer, a somewhat small computer appropriate for individual use but which can be connected to a network.

PC CARD, a credit-card-sized computer device that conforms to the PCMCIA standard.

PCMCIA, Personal Computer Memory Card International Association (pronounced as separate letters), a 500-company organization that developed the standard for credit-card-sized devices like PC cards; originally developed so that memory could be added to portable computers and now expanded several times and appropriate for three types of PCMCIA cards (all 85.6 x 54 mm with different widths).

PDA, personal digital assistant, such as a Palm-type device.

PERIPHERAL DEVICE, an external device interfaced, or connected, to a computer, like a printer, disk drive, display monitor, keyboard, and mouse.

PIM, personal information management, or manager; software that organizes the information and files received via a mobile telephone or a hand-held communications device; also, a portable device that is between a Palm-type organizer and a laptop computer.

PMMA, polymethyl methacrylate, a translucent plastic material.

PORT, an interface, or female opening, on a device into which a device can be plugged, like an electrical wall socket. Computers have various types of ports, such as the jacks of RCA, USB, and S-video jacks.

PROGRAM, an organized list of instructions that determines the way a computer operates.

SMART PHONE, a voice-centric device. However, it also offers good unified messaging as well as applications for managing personal information. (See PIM, the abbreviation for personal information manager.)

TDM, time-division multiple access, a technology that delivers digital wireless service, e.g., via a mobile telephone, by dividing a radio frequency into time slots so that multiple calls can be made. (See GSM.)

THIRD-GENERATION DEVICES, cellular communicators that will have excellent data rates (up to 384 KB per second and maybe even higher in the local network) and considerably larger displays than the current generation of phones; also, in accordance with Moore's law, devices that offer much more memory and better execution speed than current models.

USB, universal series bus, external bus standard that supports data transfer rates of 12 MB per second.

VGA, video graphics array, a graphics-display system used by CPUs which was developed by IBM and has since become a standard. VGA systems have a display-screen resolution of 720 x 400 pixels in the text mode and 640 x 480 with 16 colors or 320 x 200 with 256 colors in the graphics mode, and a 262,144-color total palette.

VHS, vertical helix scan or video home system, a process whereby moving video pictures and sound are recorded and played onto a plastic magnetic tape.

WAP, wireless application protocol, a secure specification that allows access to instant information using a hand-held wireless device such as a Palm™-type organizer, mobile phone, smart phone, pager, two-way radio, or other communicator; also see Bluetooth, another type of wireless communication over the somewhat short distance of 10 m or less.

INDEX

CONTINUED ▶